NEW WAYS OF SEEING

For Florence because you are the future

NEW WAYS OF SEEING

THE DEMOCRATIC LANGUAGE OF PHOTOGRAPHY

Grant Scott

BLOOMSBURY VISUAL ARTS
LONDON • NEW YORK • OXFORD • NEW DELHI • SYDNEY

BLOOMSBURY VISUAL ARTS
Bloomsbury Publishing Plc
50 Bedford Square, London, WC1B 3DP, UK
1385 Broadway, New York, NY 10018, USA

BLOOMSBURY, BLOOMSBURY VISUAL ARTS and the Diana logo are
trademarks of Bloomsbury Publishing Plc

First published in Great Britain 2020

Cover design: Maria Rajka
Cover image: Grant Scott.

A catalogue record for this book is available from the British Library.

A catalogue record for this book is available from the Library of Congress.

ISBN: PB: 978-1-3500-4931-4
 ePDF: 978-1-3500-4933-8
 eBook: 978-1-3500-4934-5

Typeset by Integra Software Services Pvt. Ltd.
Printed and bound in India

To find out more about our authors and books visit www.bloomsbury.com
and sign up for our newsletters.

CONTENTS

INTRODUCTION: THE NARRATIVE EYE

Let me put my cards on the table. I came to photography as a fan, a fan of the images I saw in magazines and on record covers in the 1970s and the early 1980s before I started to work as an art director on magazines in the United Kingdom. Magazines that existed to be aspirational, entertaining, informative and, most importantly, profitable. My view of photography was formed within that commercial context; I never studied photography (I studied graphics at art school) so I was never introduced to the sacred tomes of Sontag or Barthes. I had seen John Berger's *Ways of Seeing* – although I had not read the book, as I have now – and Robert Hughes's *Shock of the New* on television – I did however read that book – but this was as intellectual entertainment, not as academic doctrine to support dissection, deconstruction and debate of the image.

Despite this 'commercial background', whilst art directing magazines I commissioned and I became friends with photographers such as Abbas, Leonard Freed, Don McCullin, Richard Avedon, David Eustace, Olivero Toscani, Gian Paolo Barbieri, Jane Bown, Steven Klein, Glen Luchford, Jean Loup Sieff, Gavin Evans, David Bailey, Harry Benson, Terence Donovan, William Klein, Steve Pyke, Jake Chessum, Sylvia Plachy, Chris Steele Perkins, Corrine Day, Herb Ritts, The Douglas Brothers and Kurt Markus amongst many others. Photographers whose work could and does sit as easily within the galleries and auction houses that define successful contemporary art as it did within the pages of a glossy magazine, but most importantly the photographers that I commissioned were those whom I admired, respected and enjoyed from a photographic perspective. They introduced me to new ways of seeing what a photograph was, how it was produced and what it could be. Through conversation and observation, I learnt about photography from photographers and I learnt how to see by looking at their images.

Fast forward to today and I find myself within an academic, a commercial, a photographic and perhaps most importantly an online environment. Photography is intrinsic to all of these, but it is the way in which it is viewed and interpreted in each that I believe creates a series of unnecessary barriers for many to engage with photography and navigate its

highways and byways. Why? Because photographic writing has taken two very diverse paths since photography's earliest days – the theoretical and the technical, both of which are based on a twentieth-century understanding of photography.

Photographic theory came to prominence in the 1970s using established art theory as its foundation and political, social and economic standpoints as the basis for its rhetoric. That basis remains within photographic theory today and the concept of the non-theorized image or the non-theory-engaged photographer as lacking worth or seriousness is still a stand taken, written about and published by many a theorist and academic. This is photographic theory as dogma, practice as theory and an area dominated by non-photographers. As such it can be exclusive in nature, often difficult to understand, navigate and agree with if you do not share the writer's education, reading, political and social views. Please do not think that I am anti-theory; I am not, as you will see throughout my writing in this book. However, I am anti-exclusivity, particularly when it comes to engaging with photography, and I believe that it is time to challenge the approach to understanding the photographic image purely as a theory-supported artefact or throwaway irrelevance.

The mechanical and technical aspects of creating a photographic image have been at its heart since the first experiments with capturing and fixing an image and its advancements in these areas have been intrinsic in its development and growth. However, just as some theory writing has hijacked the medium to create its own genre of practice, so the technical writer mired in lighting techniques, firmware updates, software hacking and post-production workflows and plug-ins has used photography as a vehicle for additional process knowledge outside the immediate capture of the image. The resultant writing can be as dense and inaccessible as the most poorly conceived theory. Two opposite ends of the photographic spectrum falling into the same trap of believing that their view of photography is the correct one and that never the twain shall meet. I do not expect this book to bring those camps together, but just as Berger outlined in his 'Note to the Reader' in his book *Ways of Seeing*,[1] my intention is to start or perhaps extend a process of questioning.

This book is an attempt not only to question theoretical and technical barriers but also to provide a series of possible journeys for the visual storyteller utilizing lens-based mediums to embark upon. It is widely accepted that what we see and choose to document is a direct result of what we know, believe and have experienced through our lives at whatever point

we choose to begin making those documentations with whatever choice of medium we wish to use. This is a basis of all teaching of the creative arts: the need to express the personal is at the root of self-initiated artistic expression. The choice of medium is just as personal, and it is the ubiquity of the camera in our everyday lives that makes it a first choice as a documentary tool. It is a device which the owner has an increasingly personal relationship with outside its photographic functionality and therefore a choice which is both practical and subliminally emotional.

Berger reflected on the fact that although every image created embodies a way of seeing, it is our perception or appreciation of an image that defines our true way of seeing. This perception and appreciation of photography within a digital age is defined by the device and/or platform we experience the image on, the context in which we engage with it, and our own understanding of what photography is. This immediately demands a re-evaluation of how we see and perhaps more importantly evaluate the role of photography as an art form, its role within artistic practice and as a visual language.

These are not new themes in relation to photography, so an assumption that this book has little new to say could therefore be correct, accept that my use of these words is within a new context and it is that context that I believe brings essential new understanding to both photographic capture and consumption. That context is the ongoing digital revolution and a new box in which to capture light, to create and to disseminate images. The smartphone as camera divides opinions. Some believe its impact on photography is negative, a tool that should be held responsible for a devaluation of the photographic image. Others see it as a tool for fun, a smaller version of the compact camera acceptable for 'snaps' but for little if anything more. I disagree with both beliefs.

I am not a smartphone evangelist, but I am a pragmatist and a photographer and filmmaker so to reject or decry any tool that can help me further explore my creativity and visual storytelling makes no sense to me. I have embraced the creative opportunities the smartphone has given me and in doing so rediscovered the fundamentals of photography and reimagined my process of photographic capture. I call this process 'photo sketching', a process aligned with the sketching of an artist exploring juxtapositions, composition, light, texture, form, relationships, colour, tone and mark-making. Just as the invention of the camera changed the way in which everyone saw painting so the way in which photography is perceived is changed by the smartphone.

It is interesting as I write this that I am unsure as to how to refer to this device for recording images we keep with us at all times of the day and night. By referring to it as a smartphone means that most people will understand what I am referring to, but of course that name indicates its principal purpose as being that of a telephone, a functionality that is not most people's primary use for the miniature computer that it is. Its ability to communicate with others through word and image is a far more important functionality to many, as is its connectivity with both radio and film broadcast channels. If you then add its library functionality as a repository for music and images, you will see that the smartphone as camera is just one of its functions in today's digital environment. And yet it is most people's one and only camera. A camera that lets them both share and store their images with a few taps of a screen, that requires no theoretical or technological knowledge to use. A camera which they have a personal bond with, that they would be lost without. A fact brilliantly demonstrated in a series of wry vignettes titled 5 *Films about Technology* created by the prolific video director Peter Huang in 2015.[2]

I will continue to refer to this device as a smartphone and the images created with it as photography for ease of understanding; however, I feel that the term 'lens-based media' is perhaps a better description of the activity of what the first is creating and what the second has become. Whatever we choose to call the multi-functional box in our pockets – as Berger first stated back in 1972 and as I believe is even more true today – we now exist in a world in which there is a language of images and what is important is not the arguments concerning what device was used to create them but what we do with them.

It is therefore the intention of this book to bring together different strands of thinking from the past and present, to question the accepted, to spark debate concerning photography and to understand why and how we have entered a new way of seeing. It has no relationship to the John Berger book, but it does pick up on some of the ideas it put forward, just as it put forward ideas first considered by the German critic Walter Benjamin in his essay *The Work of Art in the Age of Mechanical Reproduction*[3] forty years before Berger wrote his book. In that sense, I suggest that you see this book as the continuation of a conversation bought about by a need to question not provide answers and, just as Berger's book was structured to be read in any chapter order, so this book like a passionate and vigorous conversation can be approached as something to dip in and out of or to engage with from beginning to end. The images included in this book have all been created by

me on a smartphone and are part of that conversation and should be viewed as punctuation points, nouns and verbs that help define the storytelling the words are attempting to convey. They are not created to exist as stand-alone images to be critiqued as such, they are part of my visual language, my visual communication with you the reader.

Whilst writing this book I received a tweet from a well-respected photographer and filmmaker who had been at the forefront of the convergence movement encouraging photographers to embrace the moving image with DSLR cameras. The tweet contained a link to a video extolling the virtues of a computational photography app that gave control of depth of field to smartphone camera users. It also suggested that the app was yet another nail in the coffin of 'real' photography. The tweet made me question why someone who had been so willing to embrace the 'new' just a few years ago was now so reticent to see that photographic image capture remains a constantly evolving practice. It also made me wonder what he meant by 'real', and after much thought and consideration I realized that I have no idea what 'real' photography is. Is it what we knew as photography? Is it how we first experience the medium? I think it may have connections to both of these questions but if so what we are discussing is an emotional relationship with the medium, a subjective not an objective viewpoint. What I do know is that the tweet started an online debate between two sides of the photographic community between the 'Fors' and the 'Againsts' where photography is going. All these beliefs were staunchly held and vehemently argued, but of course no solution was reached.

This book exists as a series of fragmented thoughts, some previously posted online as articles, that are focused on a central theme and as such those thoughts may sometimes feel repetitive as I seek to interpret them across a broad spectrum of implementation. If this is the case, please read it in whatever order you wish. Alternatively, you could start at the beginning and finish at the end and travel the intellectual journey I have followed in writing it. The choice is yours, but I hope that the outcome will be the same – that you begin to question the capture and dissemination of the photographic image in the twenty-first century.

I hope that both the written and visual language contained within this book provoke similar debate to the one that Berger originally instigated, that of conversation and understanding. Berger finished his book with the simple request that it was to be finished by the reader. I share his sentiment. Embrace the serendipity of chance.

CHAPTER 1
HOW DID WE GET HERE?

As I sit writing this chapter we are seventeen years into the twenty-first century and approximately ten years into the mass adoption of digital photography. That ten years has seen digital capture of both still and moving images move from DSLRs to compact cameras and on to tablets and smartphones, whilst social media platforms such as Facebook, Twitter and Instagram have launched, evolved and reached global domination as publishers of self-created and found images. Broadband widths have improved and wi-fi has become an expectation rather than an unrealistic hope. In short, forms of global communication and the role of photography within them have changed dramatically since the year 2000.

The use of the photographic image as a form of communication has become omnipresent and democratic. The days of analogue capture reside in the past now that digital photographic images are being created at a rate and of a quality not seen since the birth of the medium. This digital revolution has happened at such a pace that it seems that there has been little time or perhaps desire to understand the purity of straight photographic capture in the new photographic environment from a twenty-first-century perspective.

It is interesting that those born since the digital revolution – including the students who populate our schools, colleges and universities – seem to have the hardest time reimagining the role of photography in the world today. This is despite their lives as digital natives being shaped by the digital world from birth. However, they are not the only ones who seem to struggle with accepting new forms of photographic capture and consumption. Those whose photographic knowledge and practice were forged in the red light-lit darkrooms of analogue thinking can also seem to be too quick to dismiss the new democracy of photographic capture and dissemination. Similarly, those within academia whose photographic engagement is dependent upon established art theory laid down in a previous century to provide understanding of a continually evolving communication/art form often reject the power of social media out of hand and an online presence as an irrelevance to 'serious photography'.

It has been in the process of trying to address these entrenched beliefs that I started to use the metaphor of language when attempting to explain what photography is and can be, and what it can give a photographer in transferable creative life skills. A metaphor that sits comfortably with the development of the visual aspect of communication that is correctly described as 'graphicacy', a parallel discipline to literacy and numeracy. In a visually intense world the rise in the importance of developed 'graphicacy' cannot be underestimated and neither can the importance of the visual image as a primary form of communication.

I do not claim that this is a new concept or process of thinking. The Palaeolithic cave paintings of Lascaux in the Dordogne region of the south of France and the narrative wall paintings found within the Great Pyramids come immediately to mind as examples of images created as a form of language to tell stories. However, today the marks of the past have been replaced with code just as stone has been replaced by the digital screen.

Photography as art and language

To understand photography as a language opens the door to understanding its role in our lives today and what our relationship with it should be in the future. But as well as seeing photography differently I also believe that those for whom photography is a profession or point of study need to engage with it differently to fully utilize the creative possibilities it can give today's image makers and visual storytellers. To do this requires a reinterpretation of the practice of creating photographic images and a willingness to embrace new forms of image-capturing devices.

Photography today is a medium where art and commercial practice are interchangeable. Where once there were boundaries now there is collaboration; where once there were walls today there are bridges that allow image makers to move from one area of practice to another with little if any condescension from the establishments of either field of work, although the art world still likes to keep some of its fences in place and repaired.

The understanding and acceptance of photography as an art form is a long and often contentious discussion that leads right back to photography's earliest days. William Henry Fox Talbot's experimentations with contact printing as early as 1834 are known as photogenic drawings. Images created by soaking drawing paper in a weak solution of salt, allowing it to dry, brushing it with silver nitrate, and then washing it in a strong solution of

salt. The drawing or photograph – a word reportedly not used in relation to a photogenic image until 1839 by Sir John W. Herschel[1] – was then complete. This semantic association between 'photo' and 'drawing' is for me a starting point in a thought process that leads right up to today, and the ways in which we could see and use photography as part of personal creative development and in turn redefining the terms of criticism that surround the photograph.

Photography as art is not a debate I want to enter but its associations with other visual arts is. The discussion concerning the mechanical aspect of photography has always been an issue in the 'photography as art' wars, and as a result nineteenth-century photographers who considered themselves to be artists with cameras, rather than brushes, attempted to demonstrate the medium of photography as one that could be manipulated manually through light, chemicals and materials outside the camera itself. A reliance on a variety of post-exposure procedures dominated this thinking and in 1861 the painter and photographer Alfred Wall wrote and published a book snappily titled: *A manual of artistic colouring as applied to photographs: a practical guide to artists and photographers containing clear, simple, and complete instructions for colouring photographs on glass, paper, ivory, and canvas, with crayon, powder, oil or water colours.* Post-production on photographic images is not new! And neither is the adoption of new processes and image-capturing equipment functionality within the history of photography.

In February 1900 the American film and camera manufacturer Kodak launched the Brownie, immediately inventing low-cost photography and as a result introducing the concept of the 'snapshot' to the masses. The Brownie was a basic cardboard box with a small and simple lens that sold for just $1 including film and processing and it made photography democratic and available to all. The artist photographers decried its mass market appeal and put their faith in the large-format nature and expense of plate cameras to define the difference between their photographic images as art and those created by the common man, woman and child. Why they felt this need to differentiate their work is an interesting discussion point that I will return to, but the reality was that a tsunami of mass-produced images led by camera innovation had begun and was showing no sign of slowing.

In 1912 Kodak followed the Brownie with their second game-changing camera, the Vest Pocket Autographic Kodak, or 'Soldier's Camera' as it became known due to its use by soldiers to document their personal experiences on the frontline during the First World War. Over 1,750,000 were sold from its

launch until sales ceased in 1926. Small, easy to pocket, easy to use with its own metal pen to write on the negative film whilst still in the camera, the images created by the FVC (Folding Vest Camera) are not derided today as lacking importance because of the camera they were created with; in fact they are recognized as being a direct result of the camera's design, ubiquity and functionality. The images exist because of the camera's democratic nature, a context that helps us to understand the images captured and their subsequent consumption by newspapers eager to avoid government censorship and illustrate the reality of war, as seen from the soldier's perspective. An analogue Instagram before the digital platform existed. To continue this metaphor, the basic functionality of the FVC could just as easily be used to describe it as a smartphone of its time – in fact at the time of writing Kodak are promoting their first smartphone/camera, the Elekta – but just as a photographer working with a large-format glass-plate camera looked down upon those soldiers' images, so today those who profess to be 'serious' about their photographic capture too often look down upon the images that populate Instagram and other online platforms created with smartphones.

The tension between the mass consumption of photography and 'serious' photography is central to the study of the medium throughout the last century, but so is the discomfort many academics have had with the mechanical aspects of photography. The German philosopher of the 1920s and 1930s, Walter Benjamin, wrote in *A Short History of Photography*[2], 'Man is created in the image of God and God's image cannot be captured by any human machine. Only the "divine" artist divinely inspired, may be allowed, in a moment of solemnity, at the higher call of the genius, to dare to reproduce the "divine-human" features, but never by means of a mechanical aid!' A pompous and over blown statement to today's ears, and yet it strikes at the heart of the anti-technical notion of art that theorists of photography have struggled with over the last century. It also clearly states the belief that the artist is creating work at a higher level than the photographer, a belief that still informs some people's thinking today and perhaps explains why so many photographers choose to use the term artist to describe their practice as a photographer.

This is clearly illustrated in a true story told me by a New York-based photographer. Whilst being courted by an established New York gallery, the gallery owner suggested to the photographer that he might like to describe himself as an artist rather than as a photographer if they began to work together. 'What difference would this make?' asked the photographer. About $1,000 a print, replied the gallerist.

From the camera obscura until the present day the artist has seen value in utilizing both the practical and visual opportunities the camera can give their creative progression, and the symbiotic relationship between painting and photography has informed both practices. In a 1916 issue of *Photograms*, Alvin Coburn called for a move from the pictorial obsession of photography and wrote how the photographer should be willing to experiment and embrace the spirit of the times.[3] He asked 'Why should not the camera also throw off the shackles of conventional representation and attempt something fresh and untried? Everyone now has a Brownie and a photograph is as common as a box of matches.'

As the twentieth century unfolded it was artists not photographers who chose to answer Coburn's question, as photography as art aligned itself with the abstract philosophies of the Futurists, Cubists, Dadaists, Russian Constructivists and the Bauhaus. Photographic images were deconstructed, collaged and rebuilt. This was photography as source material, and part of an artistic process. The term 'photographer' became superfluous to this work as the 'artist' looked to exploit the medium in the most creative and radical ways. Photographers/artists such as Man Ray, Moholy-Nagy, Hannah Hoch, Franz Roh, Georges Hugnet, Herbert Beyer, El Lissitzky, Gyorgy Kepes, Willi Baumeister and John Heartfield were at the forefront of this deconstruction and reinterpretation of what photography could be as a base material for expression, but their work was far from the purity of immediate capture that most people would consider to be the essence of straight photography.

These reinterpretations of photography embraced its mechanical qualities and were inspired by the Bauhaus school and a European sensibility responding to the social, economic and political environment of post-First World War Europe. That spirit was given fresh impetus however in 1939 with the publication of Andreas Feininger's *New Paths in Photography*[1] in which photographic creative techniques came to the fore including negative prints, solarized images and reticulated images. Revolutionary processes achieved through chemical experimentation and through a desire to remove the photographic image from its primary function of accurate reproduction that are all too familiar as built-in post-production filters to today's digital image makers.

Of course, the history of photography at this point was not only being written by artists. Photography as a tool to instigate change of both a political and social nature had been established by photographers documenting conflict since the American Civil War. Photographers such as

Lewis Hine had used photography to expose the sordid realities of living conditions for immigrants in New York City. The scientific applications of photography had been explored by Edward Muybridge and others, leading to further understanding of our physical world through the documentation of movement, light, growth and structure. Photography had also become an intrinsic aspect of mass communication aligned with the technical developments of both the printing and publishing industries via newspapers, posters and magazines.

Photographers such as Edward Steichen and Alfred Steiglitz moved between the figurative and post-modern factions as they saw their work showcased in magazines and galleries. The photograph as document was established and omnipresent in people's lives by the 1920s and practitioners seized the opportunity to explore its documentary possibilities.

Cameras as instigators of change

Meanwhile, the technology behind camera development continued at a pace and the desire to make photography easier to achieve and cameras smaller to hold remained a primary motivation for camera designers. Manufacturers had started to use 35 mm film for still photography from 1905, but it was the German Oskar Barnack, who was responsible for research and development at the Leitz company, who decided to investigate using 35 mm cine film for still cameras, whilst attempting to build a compact camera capable of making high-quality enlargements. Barnack built his prototype 35 mm camera – the Ur-Leica – in 1913, but it wasn't until after the First World War that Leica launched their first 35 mm cameras, putting the Leica 1 into production in 1925. Its immediate popularity spawned many competitors, most notably the Contax – introduced in 1932 – and cemented the position of the 35 mm as the format of choice for high-end compact cameras.

The work created with these cameras by photographers such as Henri Cartier-Bresson, Robert Capa, Bert Hardy, Grace Robertson, Wolf Suschitzky and Ilse Bing led weekly magazines such as *Picture Post, Life, AIZ* and numerous others to establish a new way of seeing for the masses from a photographic perspective. They documented everyday life and global conflict, creating images and visual narratives that today fill books of photography, hang on gallery walls and fill auction house catalogues. The Leica camera and the Kodak Retina 1 launched in 1934 – which introduced the 135 film-cartridge that was then used throughout the twentieth century –

helped establish the template for twentieth-century photography and the twentieth-century photographer both professional and amateur. Once again technological advancement had allowed people to develop their creativity, choice of subject and ways of seeing. Photography was now a profession and a hobby and thanks to the revolution in cheap mass-printing methods available to view in magazines, newspapers and books.

The rapid development of camera design and innovation at the beginning of the twentieth century continued, but it was with the development of the Twin Lens Reflex and subsequent Single Lens Reflex cameras that photographic capture in the twenty-first century was established.

The twin-lens Rolleiflex, launched in 1928, was sufficiently compact to achieve widespread popularity and its medium-format TLR design became popular for both professional studio/location work and amateur snapping. More mobile and easier to use than large plate cameras but retaining a high level of quality, these cameras forced a new way of seeing on their users due to their waist-level viewfinders. This camera revolution continued with the early stage development of the SLR design in 1933 with the introduction of the Ihagee Exakta, a compact SLR which used 127 roll film. But it was not until after the Second World War that there was an explosion of new models and innovative features in SLR camera production.

The most important of these innovative features was the introduction of the eye-level viewfinder, which first appeared on the Hungarian Duflex in 1947 and was then refined in 1948 with the Contax S, the first camera to use a pentaprism. The same year saw the introduction of the Hasselblad 1,600F, a camera that set the standard for medium-format SLRs for the following decades and defined the square format as a frame for photographic composition.

Now at this point you may feel as if that's enough camera talk, as if like me you believe that photography should never be led by the equipment used but informed by the appropriate choice of camera based on the work you want to 'create' and I would agree with you. However, photographic creativity throughout its history has been led by the technological advancement of tools available to the photographer. That advancement has always been based upon two ultimate goals, simplicity of use and ease of transportation, and by charting these developments the current conversation concerning the use of non-traditional cameras for photography is not only put into perspective but it can also be dismissed as irrelevant.

In 1952, the Asahi Optical Company – which later became rebranded as Pentax – introduced the first Japanese SLR using 135 film, the Asahiflex.

This was swiftly followed by other Japanese manufacturers including Canon, Yashica and Nikon. Nikon's ground-breaking Nikon F led the way for professional photographers by offering a wide range of interchangeable components, lenses and accessories. An offering that remains today the basic expectation of any professional or enthusiast photographer looking to invest in a camera brand.

The availability and ease of use of both the camera and photographic reproduction saw many post-war artists incorporate photography into their artistic practice. Pop artists such as Andy Warhol, Robert Rauschenberg and Larry Rivers used the photograph as both a source material and component of their work as artists had earlier in the century, whilst photographers such as Arron Siskind used the abstract expressionist paintings of Robert Motherwell, Mark Rothko, Hans Hofmann and Barnett Newmann as a starting point for their photography. However, it was not until Edward Steichen's successor as Director of Photography at the Museum of Modern Art in New York, John Szarkowski –1961 to 1992 – began his pioneering work showcasing the work of photographers such as Andre Kertesz, Dorethea Lange, Brassai, Eugene Atget, Garry Winogrand, Henri Cartier-Bresson, Diane Arbus, Walker Evans, Bruce Davidson and Lee Friedlander, that photography began to be taken seriously as an art form in its own right. Analogue photography as an art form was established and although technological and design advancements continued to be made over the following decades, including experiments with film types, automation of functionality and multiple accessories, its basic premise remained the same until the birth of digital capture.

Then we went digital

It is generally accepted that digital capture began in 1975, when a 24-year-old engineer named Steven Sasson invented digital photography whilst working at Eastman Kodak by creating the world's first digital camera. However, Kodak were not exactly enthusiastic about this potential industry-changing breakthrough. Sasson's camera weighed eight pounds and created 0.01-megapixel black and white images that had to be recorded on to cassette tapes. Each photograph took 23 seconds to create, and the only way to view them was by reading the data from the tape and then displaying that information as an image on a television screen. Sasson showed this slow and cumbersome but revolutionary technology to a number of Kodak

executives, but they couldn't see the potential of what digital photography could become in the future. In an interview with *The New York Times* in August 2015, Sasson[5] commented on their response at the time: 'They were convinced that no one would ever want to look at their pictures on a television set. Print had been with us for over 100 years, no one was complaining about prints, they were very inexpensive, and so why would anyone want to look at their picture on a television set?' At the time, Kodak was the dominant brand in the US photo industry, and they didn't want to cannibalize their film businesses. They did eventually make the big switch to digital, but it took them eighteen years to do so, by which time they were too far behind in the digital revolution to compete with their competitors. Eastman Kodak filed for bankruptcy in 2012.

The digital world we now live in had begun photographically at the end of the 1980s, when the technology required to produce truly commercial digital cameras came into being with the MegaVision Tessera. The camera that had a name that promised more than it could deliver was closely followed in 1989 by the first portable digital camera going on sale in Japan, the Fuji manufactured DS-X. These were early days in making digital capture both affordable and available to all, but just as before in the history of camera manufacture it was Kodak who broke through with a concept that was expensive but had possibilities of further development.

In 1991 Kodak launched the Kodak DCS (Kodak Digital Camera System), the beginning of a long line of professional Kodak DCS SLR cameras that were based in part on analogue camera bodies. It used a 1.3 Megapixel sensor, had a bulky external digital storage system and was priced at $13,000. Early digital was not cheap, easy to use or of high quality and for many it seemed to be no match or competition for the established analogue photographic process. However, the manufacturers sensed a new market and were not going to stop pushing their digital offerings.

The move to a digital format had been aided by the formation of the first JPEG and MPEG standards in 1988, which allowed image and video files to be compressed for storage. But it was with the launch of the Casio QV-10 in 1995 featuring a liquid crystal display on the back of the camera that the way in which photographic images were seen before capture changed, and yet this was nothing new. Early plate cameras and waist-level viewfinder cameras had allowed the photographer to view and compose their images on a glass screen before capture, so in many ways these new digital cameras were transporting photographers back to the birth of the medium without the need for dark cloths, chemicals and film.

Digital camera sales flourished, driven by technological advances and as the mega pixels grew and the prices dropped the digital camera market segmented into multiple categories: Compact Digital Cameras, Bridge Cameras, Mirrorless Compacts, Digital Backs, Digital Medium Format and Digital SLRs. However, it was the technological advancements in the development of low-price complementary metal oxide semiconductor (CMOS) sensors, that drove digital camera development and enabled the evolution of high-quality photographic capture within smartphones and the subsequent widespread adoption of the device as the principal choice of camera.

Digital photography replaced analogue photography at a pace which caught out the established camera and film supply manufacturers. Those adopting digital technology who were not interested in high-quality images were seduced by the ease and low cost of using a digital camera. As a result, film sales and processing experienced a rapid drop in demand, catching out supply companies and leading to large-scale internal restructures and closures. Kodak, which had led the photographic revolution for over 100 years, found itself out of step with the times they had helped create and suffered the most. Photography had been released from the shackles of chemistry and was about to enter a new world of both capture and dissemination.

We are now in that new world, but it shows no signs of slowing or ceasing from its rapid evolution to a destination that can only be guessed at. The writer on photography Stephen Mayes commented in an article for *Time: Lightbox* in August 2015[6] that 'Digital capture quietly but definitively severed the optical connection with reality, that physical relationship between the object photographed and the image that differentiated lens-made imagery and defined our understanding of photography for 160 years. The digital sensor replaced the optical record of light with a computational process that substitutes a calculated reconstruction using only one third of the available photons.' Mayes continues in the article to quote veteran digital commentator Kevin Connor on the issue of digital capture: 'The definition of computational photography is still evolving, but I like to think of it as a shift from using a camera as a picture-making device to using it as a data-collecting device.'

This is all interesting stuff and highly relevant within the debate concerning digital image manipulation, but it is in Mayes's recognition of the importance of the smartphone in photography's evolution that I believe that an essence of what photography may become lies. He says that:

The twist is that new forces will be driving the process. The clue is in what already occurred with the smartphone. The revolutionary change in photography's cultural presence wasn't led by photographers, nor publishers or camera manufacturers but by telephone engineers, and this process will repeat as business grasps the opportunities offered by new technology to use visual imagery in extraordinary new ways, throwing us into new and wild territory. It's happening already, and we'll see the impact again and again as new apps, products and services hit the market.

This belief confirms my own thoughts concerning the future of the medium, that we are living through one of the most exciting periods of the history of photography and that we should not be confined by its history or a preconceived notion of what photography is or can be.

Technological developments are progressing at such a pace that I have little doubt that by the time you read this book you will already know of developments that I at the time of writing have no knowledge of. However, perhaps a signpost to the future may have been planted just as I finished this book. The Japanese camera manufacturer Canon has presented a concept for a mini modular camera[7] that may or not become a reality by the time this book has been published. According to Canon their modular camera will be only a couple of centimetres thick and will incorporate a non-removable wide-angle lens that will allow it to be dust and splash proof. The battery will only be 1 cm thick, allowing the whole package to remain quite compact, recording internally to MicroSD cards. What's interesting about this Canon modular camera is that its functionality will be expandable with additional parts, such as an additional SDI output module or a larger battery. This would make the system capable of fulfilling many roles, from a body camera to a studio and broadcast-capable tool. It takes little imagination or camera knowledge to see this as a direct reaction to smartphone camera technology and we can only wait and see if these and other developments from rival companies such as Sony come to fruition.

What does this all mean?

Since the earliest days of the digital revolution the democratization of the digital image and therefore photography has seen the place of the photographic image take on a new meaning within our everyday

communication and in our personal, regional, national and global interactions. It has been a democratization that has been led throughout the history of photography by technological developments and the adoption of those advancements by photographers and artists to fully utilize the tools at their disposal. The outcome of this is that photographers have adopted the medium in its purest form as a medium for documenting both the seen and felt, the personal and international, the political and the everyday. They have embraced its immediacy and its possibilities but, as the medium evolves, new ways of seeing are becoming evident as new tools and dissemination channels develop.

As I have outlined through a brief history of cameras, each technological development has forced and encouraged the photographer to reconsider the way they see and their relationship with the creation of the photographic image. It is hard to argue against this view of the history of photographic seeing and yet it is rarely presented as a history so closely linked to the mechanical reality of the capture of an image and the impact it has had on the resulting photographic image. That is how we got to where we are today. But where are we today?

The most commonly heard answer to this is that 'We are all photographers now!' That may be true, but I would expand upon that statement by saying that we are all image makers and publishers now. Every time we post, share and send an image we are engaging with the process of publishing our images. This instantly changes the role of the photographer as we are no longer reliant on others to share and publish our images That is a positive situation to be in but the negative aspect of this is that the added role of publisher brings with it additional responsibilities and required knowledge to ensure that the publishing of those images is both appropriate and effective. This in turn raises the issue of where the images should be published; the context they are going to be given through the publishing platform chosen; and the expectation the publisher has of what that platform will achieve for themselves and their images.

The transferable skills required by the photographer today are multifarious and yet rarely identified within photographic education. The reason for this is that there is a lack of diversity of experience amongst those charged with teaching photography today within academic institutions. Those with the skills and experience required to teach these elements come from multiple backgrounds connected to photography but not necessarily as photographers and have held roles such as art directors, art editors, journalists, writers, publishers, broadcasters and photo editors.

These are the people who have been working with the photographic image within the context of visual narrative communication and are therefore experienced in the idea of the photograph within publishing environments. They also understand the concept of creating online brands, personalities and consistent visual language. And yet it is rare to find people from these backgrounds either teaching or acting as visiting lecturers or speakers. The reason for this of course lies in the continued fractured relationship between the acceptance of photography as either a commercial practice and/or art medium. Unless specifically designed as a commercial photography – or professional as I believe to be a more accurate description – course, many photographic courses see themselves primarily as theory-based and informed. Focusing on personal development with a cynical eye on the realities of the working commissioned photographic industry. I believe that the new photographic environment requires more than this to ensure that the student can fully utilize the opportunities available to them as part of their photographic education.

This may be seen by some as being a confrontational statement, but as I have outlined previously we have got to where we are today as visual storytellers by embracing technological development. To stop doing this because it takes us away from the recognized area of expertise of the photographer which at its heart is mechanical makes no sense.

If we accept the basic premise that photography is the act of capturing light in a box, we should as photographers have no issue as to what that box looks like. The emphasis in the previous sentence lies on the word 'light' and not 'box', but that box is a valuable tool that enables all visual storytellers and image makers to communicate, including those who do not use the term 'photographer' to describe their main area of creative activity. It is in this context that I embrace all forms of camera including the smartphone, and all forms of image dissemination including those that have social media functionalities. It is how we choose to use the smartphone and digital platforms that determines our understanding of and ability to embrace the new creative opportunities being presented to us.

Computational photography

We are in the early days of computational photography and its implementation so far has been restricted to effects within existing camera formats, but its implementation within smartphones is currently being developed by phone

manufacturers and is in its early stages. It is therefore worth discussing as a potential indicator to the future of photographic capture. Despite all of the technological developments of the medium, a traditional camera – both analogue and digital – today is still based on the basic principle of the camera obscura and as such it produces linear perspective images. A computational camera, however, uses unconventional optics to capture a coded image and software to decode the captured image to produce new forms of visual information. Computational photography or computational imaging are terms that refer to the capture of a digital image and the subsequent processing techniques that use digital computation instead of optical processes. This is a technological development most relevant to cameras within smartphones as it can be used to reduce the cost and/or size of traditional camera elements.

In 'film-like' digital photography the captured image is a two-dimensional projection of a scene, which due to the limited capabilities of a camera is recorded as a partial representation of what you can see. Despite these limited capabilities, the captured image is considered acceptable as what you have seen is what you almost get in the finished photograph. In computational photography, the aim is to achieve a potentially richer representation of a scene during the camera's encoding process. In some cases, computational photography is reduced to the process of Epsilon photography, where a scene is recorded via a series of multiple images, each captured by the Epsilon variation of the camera parameters. For example, successive images (or neighbouring pixels) may have a different exposure, focus, aperture, view, illumination or moment of capture. Each setting allows the recording of partial information about the scene and the final image is reconstructed from these multiple observations.

The term 'Epsilon photography' was established by Professor Ramesh Raskar[8] and was developed as an alternative to light-field photography as it does not require specialized photographic equipment. You may not be aware of the term Epsilon, but you will most probably have either used it without knowing or be aware of a number of its functionalities that are already being implemented within digital cameras such as High Dynamic Range, multi-image panorama stitching and confocal stereo imaging. The common thread within all of these imaging techniques is that multiple images are captured in order to produce a composite image of perceived higher quality, such as richer colour information, wider field of view, a more accurate depth map, less image noise/blur and greater image resolution.

The area of computational photography also includes developments that do require specialized equipment such as the light-field camera, or 'plenoptic' camera. This captures information about the light-field emanating from a scene; that is, the intensity of light in a scene and the direction that the light rays are travelling in space, in contrast with a conventional camera that only records light intensity. This is a form of image creation we are most used to experiencing as a hologram. In other cases, computational photography techniques lead to 'Coded photography' where the recorded photos capture an encoded representation of the world. In some cases, the raw sensed photos may appear distorted or random to a human observer. But the corresponding decoding recovers valuable information about the captured scene.

The sense that photography is now in the hands of the coders who are directly focused on the photographic capabilities of the smartphone was further illustrated with the 2017 launch of Apple's iPhone 8 Plus. Apple promoted the phone with the premise that its camera was the best they had ever produced. Their continued quest for these cameras to be seen as a 'professional' piece of equipment was led with coding that promised a functionality that delivered a portrait lighting feature, allowing the user to create 'professional'-looking images. Amongst the professional photographic community such claims are viewed with scepticism and disdain, but the desire of phone manufacturers to deliver what they believe to be professional images gives an accurate indication of how these cameras will develop in the future.

A number of reviews of the iPhone 8 obsessed over the camera and the website *TechCrunch*, for example, chose to review the phone purely as a camera dismissing all of its other functionality.[9] The interesting developments that the iPhone 8 demonstrated rely on the fact that its functionalities are not merely reliant on filters; instead they are closer to computational photography in their ability to sense a scene, map it for depth, and then change the lighting contours over the subject, all of which is completed in real time. In many ways, it could be seen as the fullest realization of the democratization of high-quality imagery that the company has been working toward since their iPhone 4. To achieve this Apple reportedly studied the work of artists and photographers such as Richard Avedon and Annie Leibovitz to inform the mimicry their coded software was able to imitate. 'If you look at the Dutch Masters and compare them to the paintings that were being done in Asia, stylistically they're different', Johnnie Manzari, a designer on Apple's Human Interface Team, commented in an online article on the *Buzzfeed* website in

September 2017.[10] 'So, we asked why are they different? And what elements of those styles can we recreate with software?' Continuing to elaborate on their research process, he stated that: 'We spent a lot of time shining light on people and moving them around — a *lot* of time. We had some engineers trying to understand the contours of a face and how we could apply lighting to them through software, and we had other silicon engineers just working to make the process super-fast. We really did a lot of work.' This attention to detail when designing the camera functionality within a smartphone must point to not only how we will capture what we see in the future but also what we will use to document what we see and how we will view the medium of photography.

Philip W. Schiller, senior vice-president of worldwide marketing at Apple, spoke in the same September 2017 *Buzzfeed* article about the issues Apple were addressing with the development of the smartphone as an image-capturing device that further outlines the progression and implementation of computational photography. 'There's the Augmented Reality team, saying, "Hey, we need more from the camera because we want to make AR a better experience and the camera plays a role in that"', Schiller said.

> And the team that's creating Face ID, they need camera technology and hardware, software, sensors, and lenses to support on-device biometric identification. And so, there are many roles the camera plays, either as a primary thing – to take a picture – or as a support thing, to help unlock your phone or enable an AR experience. And so, there's a great deal of work between all the teams and all of these elements.'

Schiller has also spoken about the evolution of the iPhone's camera, acknowledging that the company has been deliberately and incrementally working towards a professional-calibre camera. But it is in his statement concerning Apple's relationship with the photographic medium that he perhaps gives the clearest picture as to the process of how we may engage with photography through their products. He says 'It's what camera can we create? What can we contribute to photography?

Apple are not a traditional camera manufacturer recognized by professional photographers like Nikon, Canon or Leica for example. They do not have the photographic history, and many believe that this form of computational implementation merely leads to a dumbing down

of the photographic medium. Manzari spoke out about this: 'This is not about dumbing things down', he observed, noting that as devices become more professional, they often become more intimidating. 'This is about accessibility. It's about helping people take advantage of their own creativity' and it is exactly this point that forms the foundation of my willingness to embrace smartphones as a valid and useful tool within the visual creatives toolbox. Apple have slowly been building toward this level of photography with the iPhone over past decade, but the blurring of the lines between professionalism and amateurism remains a contentious issue for many within the sometimes 'conservative' world of photography.

The tough compact camera manufacturer Go Pro that has done so much to change the world of capture amongst action and sports imagery both still and moving has also begun to explore computational functionality and Virtual reality with their 2017 launch of a 360-degree spherical camera. Their *Fusion* camera boasts 5.2K resolution, powerful image stabilization in camera, and spherical surround sound. It's also waterproof at up to 16 feet, has a voice command feature, and works with the GoPro app so you can preview your shots and stitch them together right on your phone. The *Fusion's* OverCapture feature allows you to capture spherical content and frame it within a traditional video format. Because the camera captures everything at once, the photographer/filmmaker is able to view the footage and select the angles they like best and want to use. The development of VR as a form of visual experience is of course an expansion of the traditional still image, but just as once a still camera only captured still images, it was then able to also capture moving images. It can only be a matter of time before VR becomes an expected functionality all within one image-capturing device.

Virtual reality is not the only buzz phrase in the evolution of computational photography at the moment. Augmented reality or AR is also changing the way in which we are engaging with the medium. Based primarily on the imposition of objects, characters and filters to adapt our photographic viewing, AR is the logical next step in a lineage of image enhancement that can be traced back to coloured lens filters, practical effects, polarizers, subtitling, digital CGI, and most recently, Snapchat filters. We engage with AR without realizing it every time we use our smartphones as cameras and each new functionality is a direct result of AR development, but it is in its ability to recognize an object without needing to record that object as a photograph that the opportunities for computational photography to impact on our daily lives becomes most exciting. If we see AR as a broad computational

platform, and not just as a collection of individual apps and software fixes to manipulate images, its possibilities are endless and life-changing as it adapts your phone into an all-seeing and connecting tool. What I mean by this is that you will be able to point your phone at an object, receive contextual suggestions about what you're pointing it at, and receive advice on what to do in that situation. By capturing an image and transferring that image AR will be able to use the digital image as an information artefact to instigate actions and implement a decision-making process. VR is changing the way in which we see but AR will be able to change the way in which we act.

During a panel discussion at the New York PhotoPlus Expo 2017,[11] recorded and posted on YouTube but since removed, several experts explored different scenarios for what computational photography could mean for professional creatives. Their conclusions were those that I have outlined previously with the further development of both smaller and lighter cameras and as computational photography suggests a more immersive virtual reality. It was accepted within the discussion that for many photographers, computational photography creates some cognitive dissonance. According to Allen Murabayashi, co-founder of the online platform *PhotoShelter*, 'You no longer have to get it right in camera because the camera is increasingly smart enough to get it right for you. But that doesn't mean that all of photography is on a glide-path toward a utopian future.' Despite this coming from someone who claims to understand the professional photographer, this type of comment can be incendiary within the professional photographic community and destructive in those photographers adopting the possibilities of computational photography. The idea of placing the control of an image into the hands of a software engineer is unacceptable to any creative and only goes to reinforce the belief that the resultant image will consist of a homogenized digital representation lacking creative input. Murabayashi continued by stating that the central question photographers face is whether they can 'transcend the novelty of these [technologies] to best leverage these features for storytelling'. On this point, I agree with him, but his previous comments do not help photographers overcome this sense of novelty. Whereas Murabayashi's comments were made from his perspective of being involved with an image-sharing platform, Jim Malcom, the general manager of HumanEyes, North America – makers of the 'Vuze' Camera – bought the non-traditional camera manufacturers' viewpoint to the discussion. Malcom stated that, 'People don't know what they want until they experience it', extolling the rapid growth of virtual reality adoption and indicating that VR will become

an additional platform for visual imagery to be experienced. There are 15 million headsets in circulation now, he added, and stated that the market for VR content is already valued in the billions of dollars and that he believes that it is the artist's responsibility to experiment with the format. The predicted sales of VR equipment confirm these beliefs, as according to a 2017 report from the International Data Corp sales of augmented and virtual reality headsets will rise 108.3 per cent by 2020. In 2016, 10.1 million VR headsets were sold and IDC reports that this number is expected to reach 61 million in 2020.

It was left for Rajiv Laroi, another representative of a non-traditional camera manufacturer and the co-founder of the company Light, to make the most sweeping prediction for the future of both photography and computational photography. Laroi stated that 'In the coming years, computational photography "will be the norm" and DSLRs will be like film cameras are today: a small audience will still use them, but most photographers will have moved on … It's like when flat panel TVs came out, there was no longer a reason to buy a CRT.' A bold statement but one that makes sense particularly coming from Light who have created a camera that is seen by many as the most obvious progression for computational photography, namely the L16. The L16 is Light's first product and combines sixteen cameras into a single, relatively compact body while still producing huge RAW files – up to 160MB at a pop – with light-field capabilities to alter focus points and depth of field after an image has been captured. It was however left to Steve Medina, from the augmented reality company Avegant, who identified exactly how we should see the development of computational photography at this point, commenting that 'Augmented reality doesn't replace photography, it adds context and information'.

What we are talking about here is a radical change in the moment of capture and a re-imaging of the basic process of what photography is. The world of computational photography is connected to that of the experimentation currently taking place with virtual reality visual experiences. Whereas photography offers an interpretation of a situation controlled by the photographer, computational photography places the control of what is interpreted into the hands of software that aims to create a heightened experience of what is seen to potentially exactly replicate the experience of being at the moment of capture. The reality of this heightened experience in turn alters our understanding of what we see and how we see. We have already seen this expectation of the heightened experience of photography with the saturated colour and extreme contrast of so much digital

photography. The digital images we see are rarely the world we experience thanks to the pre-programmed nature of our digital visual devices and their desire to present images that are bright, colourful and sharp. In that sense, we have already left the photographic world of accurate representation and entered the hyper-realism of computer-coded image making.

One of the most difficult aspects of writing such a book as this is that the very subject matter I am attempting to address is in a state of constant fluidity and evolvement. This is particularly the case when it comes to the development of technologies with which we create and experience the images we choose to make and the creativity these tools allow us to explore. As I have mentioned throughout this chapter, those technological developments introduce us to new tools, new tool creators and inevitably those who have failed to move with the times suffer economic hardships. Despite this state of constant evolution there are some key moments that I feel are worth noting as signposts to the medium's history. One of these was announced in the autumn of 2017 in the form of a press announcement from the camera manufacturer Nikon's board of directors[12] announcing plans to close Nikon Imaging, a subsidiary based in China where some 2,500 workers at a factory produced compact digital cameras and DSLR lenses. The closure, Nikon explained, was due to 'the rise of smartphones' and the 'rapidly shrinking' compact camera market. This was the released announcement: 'In recent years … due to the rise of smartphones, the compact digital camera market has been shrinking rapidly, leading to a significant decrease in operating rate at NIC and creating a difficult business environment. The Company has decided to discontinue operations of NIC.' At the time of writing Nikon controls 30 per cent of the digital camera market; it will be interesting to see when this book is published whether that control has decreased.

Only time will tell if the Rylo camera will be seen as a similar signpost to that of Nikon's manufacturing decision in the development of moving-image capture. Created by two former Instagram employees, Chris Cunningham and Alex Karpenko, who had previously built the Hyperlapse app, the Rylo utilizes software development to control image creation post capture. Constructed with two cameras within one small camera body, each camera captures a 195-degree field of view, which the Rylo stitches together into a single sphere from which single still images, panned, split and standard moving-image footage can be extracted. Interestingly the Rylo team discovered that software was not the complete answer to the creation of a new form of imaging device as they struggled with the traditional camera lens issues of distortion. Computational photography still has to

address issues that traditional camera manufacturers have mastered, but it is interesting how they are choosing to do this. For example, Google's Pixel 2 smartphone has achieved its depth-perception functionality by training an algorithm to recognize the human head. Apple have taken a similar approach with their portrait lighting feature. The Rylo is at the time of writing in its very early stages of development, but the fact that an imaging device is being developed by people from an image-sharing background further illustrates the convergence of image creation and sharing, not only in practice but also in the creation of the devices we will use in the future to document the world we see.

The future for how we capture what we see is constantly evolving but how those images are displayed and one of the reasons why we now live in such an image-saturated environment can be explained by Haitz's Law that acts as an observation and forecast on the technological and manufacturing development, over many years, of light-emitting diodes or, as they are most commonly known, LEDs. Haitz's Law states that every decade, the cost per lumen – a unit of useful light emitted – falls by a factor of 10, and that the amount of light generated per LED package increases by a factor of 20, for a given wavelength of light. To every action there is a reaction as we are taught at school and the counterpart to Haitz's Law is Moore's Law which states that the number of transistors in a given integrated circuit doubles every 18 to 24 months. Both laws rely on the process optimization of the production of semiconductor devices. At this point you may feel that this has little relevance to photography, but it is an intrinsic explanation for how we now engage with the back-lit photographic image in our daily lives. Haitz's Law is named after a scientist called Roland Haitz and was first presented at a conference titled Strategies in Light in 2000. In addition to the forecast of exponential development of cost per lumen and amount of light per package, the publication also forecast that the efficacy – a measure of how well a light source produces visible light – of LED-based lighting could reach 200 lm/W – lumen per Watt – in 2020, crossing 100 lm/W in 2010. The paper outlined that this would be the case if enough industrial and government resources were allocated for research on LED lighting. More than 50 per cent of the electricity consumption for lighting – 20 per cent of the totally consumed electrical energy – would therefore be saved. This prospect and the continued implementation of LEDs within areas such as digital devices and LCD backlighting has led to a massive investment in research as suggested at the conference and as a result LED efficacy crossed the 100 lm/W threshold in 2010. It is now believed that if this trend

continues, LEDs will become the most efficient light source we have by 2020. What this means is that the screens we view images on will become larger, brighter and cheaper and in turn the back-lit image will become the dominant photographic engagement experience as brands utilize these digital billboards to speak to us on a daily basis.

The Oxford English Dictionary definition of the word camera is 'A device for recording visual images in the form of photographs, film, or video signals'. There is no requirement that a camera must only perform one function, that it cannot also send messages, access websites, play music or allow you to speak with others. To believe that a smartphone is not a camera is to dismiss the evolution of the photographic medium throughout its history and the changing nature of the photographic image. This is not something that I am willing to do.

CHAPTER 2
SPEAKING IN A DIGITAL ENVIRONMENT

As I have previously outlined, throughout the history of the medium it has been technological advances that have forced us to adapt our ways of seeing. But what we see can only be dictated by our personal experiences up until the point at which we are in the moment of creating an image. Where we are born, our physical presence, our relationships, our environment, our beliefs, our interests, our intentions and our expectations all inform our creative decision making. An image is informed by all of these factors and a body of work develops as these factors evolve and develop, as a personal visual language begins to show itself in both approach and outcome.

An approach to creating images is often referred to as a 'style', but style is transitory and often based upon creative fashions of the moment, whereas a language allows you to creatively express yourself over a prolonged period of time navigating issues of transitory trend.

What is important is to understand that as your work evolves so will your language and, just as when a foreign language is learnt with time, fluency develops and sophistication of communication grows. It would be unreasonable to expect to engage in an in-depth conversation with someone whose national language you have been learning for only a few days, weeks or months. Your vocabulary would not be developed to a level that would allow you to do this, and yet it is not unusual for a young photographer to be either overly confident with their work or unrealistically harsh when viewing their work after a relatively short period of time studying the medium.

Whereas the principal platform for these discussions was traditional print-based media and the gallery wall, today we have multiple platforms which we can utilize to engage in various conversations at levels of engagement that we can define for ourselves. The platforms we choose will to a large extent be defined by our work and level of linguistic competence, but as there are no right or wrong platforms there is no issue

with making a right or wrong decision. Whichever you choose should be right for you and your work. Having said that, each platform has a different character and rules of engagement as well as defined audiences and communities. For image makers the most obvious choice to explore is Instagram.

Why study photography?

Before we begin to discuss digital platforms, let's ask a fundamental question – Why study photography? Is that a good question? A pointless question? An obvious question? A rhetorical question? Whatever you think, there can be little doubt that it is a question regularly asked, for which there is no one agreed answer. The answer you receive or decide upon, and the satisfaction you have with that answer, is based upon your expectation of what photography will give you and your personal experience of the process of learning, teaching and implementation of photography in your daily life.

Expectation is defined by several factors. Do you want to be a professional photographer who earns their living purely from photography? Do you want to further explore photography as part of a personal interest or hobby? Do you want to gain a qualification that will aid you in teaching photography? Do you want to progress your work and develop your practice under the tutelage of those you respect? These are realistic and common reasons to invest both time and money in attending an educational establishment offering photography as an academic option. However, I wonder how many of those looking to study photography see it as an opportunity to learn how to work a camera, set up lights and how to use Photoshop? How many see it as a new language and an opportunity to expand their visual vocabulary? And how many people who have expectations of a course based on prior learning have them met or surpassed? These are more questions than answers, I know, but please stay with me on this. Let's be honest – unless you are going to enter the world of teaching, any photographic qualification you receive will be of little or no relevance to your career as a photographer. The benefit of study comes from the opportunity to spend an extended period of time exploring, experimenting and learning about photography with and from others who are on a similar journey as yourself, as well as time with those experienced and engaged with the world you wish to enter.

What if you don't want to be a photographer, but still want to study photography? In the university sector, 'transferable skills' is a phrase commonly wheeled out as a reason for studying a subject that may have little obvious relevance to a potential career, yet it is actually hugely relevant to the study of photography. Decision making, digital understanding, communication, self-confidence, presentation, collaboration, self-analysis, research and marketing skills are all essential elements of a professional photographer's working practice and should therefore, in my opinion, be the foundation of any good photographic teaching.

My experience is that very few potential undergraduate (or, for that matter, post-graduate) students of photography have this depth of understanding of what working as a professional photographer involves. Once you do, the answer to why you should study photography should be both simple and exciting. Photography today provides the alphabet for an international language that informs all types of global interaction. By understanding that alphabet, you can create your own journey within the new media environment. That may or may not be as a photographer. It is with this understanding that perhaps the elephant in the room can be addressed. That elephant comes in the shape of a widely held belief that we do not need any more photographers as there is no work for them. It is a tough belief to argue against if we see the study of photography as only having one outcome. But if we see the study of the medium as a gateway to visual literacy, then the potential outcomes are multiple.

The course I lecture on has a reputation for producing students who graduate and begin to work as photographers, photographers' assistants, agents, location hunters, picture editors, shoot producers and within post-production. But it is now the case that they are also moving into the spheres of filmmaking, social media and digital publishing. This is as a direct response to the implementation of moving image and social media understanding as part of a photographic education and the reinterpretation of the oft-repeated phrase 'We are all photographers now' to 'We are all publishers now'. With this understanding, the creation of lens-based media can be seen as an intrinsic element of global communication, and that is a powerful and seductive reason to study the language that is at the heart of the most important form of storytelling we have today.

I have spoken in the previous chapter about the impact technology has had on the development of the photographic image and its implementation. From this point on I will not discuss any form of camera other than the image capture software found with smartphones and this will become the principal method

of capture throughout this book. There are many reasons for this which will become clear as we explore the realities of photography in the twenty-first century, but my principal argument for focusing on the smartphone as camera is most clearly outlined through a series of facts published in 2015 by a group of academics working within the area of psychology[1] that showed that young adults use their smartphones roughly twice as much as they estimate that they do. In fact, the small preliminary study found that these young adults used their phones an average of five hours a day – that's roughly one-third of their total waking hours. 'The fact that we use our phones *twice* as many times as we think we do indicates that a lot of smartphone use seems to be habitual, automatic behaviours that we have no awareness of', commented Dr Sally Andrews, a psychologist at Nottingham Trent University.[2] For the study, the researchers asked twenty-three young adults to estimate how much they were using their smartphones during a specific two-week period, including the total amount of usage time and number of times they were checking their phones. The participants also answered questions about how their smartphone use affected their daily lives. Meanwhile, the researchers installed an app on the participants' phones that recorded how much time they actually spent using the device during the two weeks of the survey. The results showed that there was no correlation between the estimated and actual smartphone use. The participants checked their phones an average of eighty-five times a day each, which was roughly double what they estimated. The researchers also found that more than half of the smartphone use – 55 per cent – consisted of short bursts of less than 30 seconds of activity, which, as Andrews suggests, may be a sort of habitual behaviour for many users.

Such engagement with a piece of technology indicates a reliance way beyond any other we have had in previous generations on a multi-functional device. The fact that one of those functions is to create photographic images brings the process of the relationship with a camera into a new dimension of creative availability within a digital space. The fact that our reliance on the smartphone has developed at such a pace compounds our inability to address this new relationship.

Instagram: a gateway to photography

I'm not an early adopter of any technology, so it took four years for me to open an Instagram account. I just didn't get why I needed it, despite hearing

tales of photographers being discovered by high-paying clients amongst its many supposed positive attributes. It seemed like a platform I could take or leave, so for a few years I left it alone. Finally, I dived into its image-saturated depths and, lo and behold, I was reborn – or at least my enjoyment of photography was. Once I got over the fact that many professional photographers were using it as a self-promoting digital portfolio by reposting their archives, I started to discover new work. There were new photographers creating and distributing work at a furious pace that gave great insight into their working methods and developing narratives. I started to follow these photographers alongside others I was already interested in and knew of outside the platform.

I got it, but I still wasn't sure how I would use it in my practice. Slowly but surely, I started to realize that I could use both my smartphone and the platform as a form of digital photo sketchbook. This realization soon developed into a process of seeing and documenting that I refer to as #photosketching. A process which I have shared with the university students I teach as part of their exploration and enjoyment of photography as a visual language. It is a process of image making that I will return to later, but it is the foundation of my understanding of how seeing and creating has developed within the new photographic environment. Many of the students – although by no means all – were using Instagram like a photography-only version of their Facebook pages, documenting and posting nights out, boyfriends, girlfriends and holidays, but with little understanding of how it could relate to their photographic studies. It has been three years since I began introducing the #photosketching concept to address this issue. In that time, things have changed, and this is how.

Recently, when interviewing students looking to join the programme I teach on, I started hearing the same answer repeatedly given to a range of different questions:

Me: Where do you look at photography?
Them: Instagram.
Me: Where do you find out about photographers?
Them: Instagram.
Me: Where do you show your photography?
Them: Instagram.
Me: Do you visit exhibitions?
Them: No, I look on Instagram.

Few students talk of a passion for looking at or reading books. Very few look at magazines or can name photographers that inspire them. Perhaps most surprisingly, almost none of them look at photographers' websites for inspiration. In fact, looking at work online is viewed as research based solely on teacher suggestions and seems to be rarely self-initiated. In contrast, Instagram is theirs, it's yours. It's free – unlike books and magazines – and the students feel ownership of the environment. It acts as their personal researcher and promoter of images. Instagram is their gateway to photography, feeding them the images they want to see based on what they have seen, but not necessarily the images they need to see. It is not in Instagram's interest to push their subscribers out of their comfort zone or to introduce them to images that challenge perceptions. The Instagram account holder is a customer and therefore someone to be kept happy with what Instagram knows about them.

The students I interviewed spoke positively of their experiences with photography through the app. They are happy customers. But if we are to understand and accept that Instagram is the gateway to photography and potentially photographic education, then those of us in positions of education need to understand how to create a journey for the young photographer once they have come through that gate. To do this requires a respect for the platform and the process of image creation through a smartphone. It also demands personal engagement with the concept of new pathways into photographic creation and study. I will discuss the negative issues which an over-reliance on single image observation can have, particularly in an understanding of developing narrative at a later point. However, by explaining how students can take control of their learning through the use of Instagram, I believe it is possible to not only maintain and develop their excitement with the medium but also to utilize a tool they are already engaged with to explore photography outside the app's contextual parameters.

What I mean by this is educators need to introduce students to the concept of photography as part of their lives outside the smartphone. There is a need to introduce the artistic and commercial contexts for photography, and to explain how work they see on Instagram relates to these areas. If you discovered photography through more conventional and traditional pathways, this may seem to be an irrelevant suggestion. But for those who have come to photography only through the app, it can be a difficult connection to make. This lack of context awareness can also lead to a lack of understanding concerning copyright and image ownership, and the act

of commissioning. Traditional communication formats such as books, magazines, newspapers, billboards, television and exhibitions have long been recognized as gateways to photography for those taking their first steps into the medium. But these are formats that young students are too often not engaging with, and it is therefore only natural that the platforms they are engaging with will become the new gateways. To deny this would be to deny that the world of global communication is constantly evolving, and that photography has an intrinsic role in that evolution.

I found myself recently on a Saturday evening sitting in front of the television watching a popular mainstream entertainment programme hosted by the comedian Michael McIntyre. An aspect of the programme is that somebody is 'set up' to become the 'unexpected' star of the show and sing a song at the close of the programme. The unexpected star on the episode I watched was a seventeen-year-old girl, who from the moment she appeared on our screen documented every comedy event with her smartphone. In the five minutes she was on screen she created at least five photographs as she created a visual record of everything she saw that was either unexpected or humorous. She even found time to create a selfie with a reality television celebrity who was part of the 'set up'.

The reason for this burst of photographic activity was not missed by McIntyre who commented that, in the excitement of the sting being revealed, she had walked away from her phone – surely a traumatic situation for someone of her age!

The previous week I had watched the Netflix documentary film *American Meme,* a film that follows the journeys of four social media disruptors, Paris Hilton (@parishilton), Josh Ostrovsky (@thefatjewish), Brittany Furlan (@brittanyfurlan) and Kirill Bichutsky (@slutwhisperer), as they hustle to create empires out of their online footprints. Footprints created and left through the creation of photographs and short videos that document every aspect of their lives. It's an interesting film and one worth checking out to gain an entry level insight into the business side of such social media engagement and the dark emotional impact it can have on those who find themselves absorbed by such digital immersion.

Only one of the people featured in the film came from a photographic background or with a photographic intention, and yet all of them relied completely on the photographic image as their central form of communication. The one photographer who is featured, Kirill Bichutsky, a nightlife photographer known for posting vulgar 'Girls Gone Wild'-style pictures on his Instagram account @slutwhisperer, fell into photography

by mistake thanks to some informal portraits of the artist Drake. His documentation of half-naked girls in clubs being covered in champagne and imbibing countless shots are created as part of his club-night tour of the States promoted through his Instagram account. In that sense his work has a self-perpetuating sense of hardcore marketing of soft-core image making. Images created to promote the next event with no pure photographic intention.

All of the characters featured in the film, just like the unexpected guest on the Macintyre show, have an umbilical cord attachment to their smartphones, constantly documenting where they are, what they are doing and who they are with. In addition, they also employ photographers and filmmakers to create images of themselves to quench the thirst of their armies of fans hooked on their image-laden digital feeds. But the centre of all of these feeds is the self-creation of visual imagery by those who do not see themselves as photographers. Not once is the term 'photographer' used to describe the act of making photographs in the film by those creating the images.

Surely, this is where photography is today. An expected functionality of a device to be used by those with little or no training or interest in the history or context of photography as a form of documentation. A shorthand language of global communication to be used by influencers to promote, market and sell product even if that product is the 'self'. The mental health, and wellbeing of such activity is starting to become widely investigated and reported on, and the effects such activity has on those included in *American Meme* is clear to see.

As someone fully engaged with photography and filmmaking from a more traditional route, I find the appropriation and reinterpretation of visual storytelling by those who see it as intrinsic to their lives outside a traditional understanding both positive and informative. It challenges my understanding of the medium and how it is evolving, how others see it and how photography is viewed by those who have no interest in photography outside its use as a communicative tool. This is not in my opinion the death of photography or of the professional photographer, it is the transformation of photography, the democratization of photography. It is not an intentional dumbing down but an inevitable result of technological developments in image creation and dissemination. The challenge for those involved with photography as photographers is not to dismiss the evolution of the medium but to respond to these developments both creatively and professionally.

For a photographer to ignore the impact of Instagram on lens-based image creation could be an act of informed decision making. For a teacher involved in photographic education to ignore Instagram's impact on the next generation of photographers would be an act of denial and negligence.

The digital community

I was engaged in conversation with someone on Twitter concerning the reason for my posting of images on Instagram. His suggestion was that I posted images to be seen and that my intention was to seek positive feedback and praise. He noticed that few if any of the images I posted had received comments and he believed that this indicated a failure in the platform and a weakness in the work that I was posting. He could not have been further from the truth or exhibited a more obvious lack of understanding of how the platform can be used.

There is no doubt that many people see the platform in the same way that this photographer does, but it is not how I see it or how many of the photographers I know on Instagram use it. They do not see it as a visual popularity contest or free feedback session. It is not a community in that sense. Of course, we have grown used to the idea of digital platforms encouraging us to build our own communities through our friends, family and colleagues encouraging a sense of positive self-belief when our images or comments are liked or shared. We all like to receive some praise for our endeavours but although these may be outcomes from our engagement with a platform such as Instagram, I would like to suggest that they should not be a driver to your engagement or a barometer of your success.

I use Instagram as a tool to build my vocabulary; it is my digital sketchbook where I post a documentation of my visual experiments. A place which I can easily return to for inspiration, to jog my memory concerning light, composition, colours, the keystones to my photographic practice. I am not the only photographer or artist who uses Instagram in this way. The sculptor Anish Kapoor under the moniker of @dirty_corner documents not only his work but also the observations that inform his work. The artist Martin Creed (@martin_creed) does the same as does the politically driven Ai Weiwei (@aiww), pop artist Keeny Scharf (@kennyscharf), street artists Shepard Fairley (@obeygiant) and Banksy (@Banksy), light and space artist James Turrell (@rodencrater) and many

more, in fact too many to list here. The art community is well represented on Instagram and they are using the platform to share their work but also to give an insight into their own working practices. They are showing us what inspires them, and in doing so they are giving us access to their digital sketchbooks.

I have deliberately chosen to discuss artists and art first when talking about the digital community on Instagram as it is so commonly seen as a place for photographers and photography and I wanted to show how it is in fact a visually creative depository for all creatives, not only those who choose to use a camera as their principal form of visual communication. However, it is worth noting that even the most prestigious and well-known photographers use Instagram in a similar way. Photographers whose work is often seen on gallery walls such as Martin Parr (@martinparrstudio), Stephen Shore (@stephen.shore), Joel Sternfeld (@#joelsternfeld) and Wolfgang Tilmans (@#wolfgangtilmans) all use Instagram as a visual document. There can be no doubt that it is a serious tool for people serious about their art to engage with.

However, it is not just a platform for artists, professional photographers working across all areas of the medium from fashion to still life, from sports to food, from documentary to music and from interiors to travel use Instagram as a platform to both document and market their work. The differentiation between professional photographers and professional Instagrammers is an interesting one to explore.

When I speak with students who are using Instagram as a research tool, I always ask them who the photographers they are citing work for. What I mean by this is who are the clients the photographers are working for; in short, does the work exist outside Instagram? This is an important distinction to make if you are hoping to build a professional practice as a photographer. Defining a client's needs based on the images they commission is the foundation of understanding how the commissioned photographic industry works and one of the simplest ways to do this is to see who commissions the work that you like. Professional Instagrammers may well have large followings but that does not necessarily translate into a professional career as a commissioned or syndicated photographer. The easiest way to gain this information is by reading the Instagrammers' description of themselves as most professional photographers will include a link to their website or to their agent's website in their headline description, that will allow you to see the work they show within a professional context and who has commissioned the work.

There are many reasons why someone decides to engage with a digital platform and by association its myriad communities. The fashion photographer Ellen Von Unwerth (@ellenvonunwerth) was quoted in the *Observer* newspaper in 2017[3] as saying 'It's not special, any more to be a photographer … Even when I take a picture, everybody stands next to me and takes the same picture. Five minutes later it's on everyone else's Instagram and I'm old news – so I'm forced to take pictures on my iPhone too.' The fact that such an established photographer feels a pressure to engage with a platform based on the practice of amateurs indicates the power that some platforms can have, but that sense of competition misunderstands how a photographer can manipulate a platform to their own ends.

In contrast to Unwerth, Magnum photographer Christopher Anderson saw Instagram as an inevitable development of his practice:[4] 'In my case it was important to be on Instagram because it has become such a fulfilling and fun creative outlet. I am able to look at, think about and take pictures with a freedom and immediacy that is more difficult with my "work".' Fellow Magnum photographer Matt Stuart echoes my feelings in the same article as Anderson, on how Instagram can be utilized most effectively: 'I use Instagram as a sketchbook/scrapbook of my life, so maybe it has loosened me up a bit and made me share more than I would usually with my serious work. I think it is the most social of social media apps as pictures communicate so instantly.'[5]

The life of a creative can be a solitary one that can lead to a sense of insecurity and the community's online platforms can often provide essential support during moments of indecision. Initially you will need to find communities appropriate to you but when you do this form of digital networking can be important in building your practice as a sense of informal mentoring occurs within the digital space.

We easily forget that ten years ago there were no smartphones, and as recently as 2011 only a third of Americans owned one. Now nearly two-thirds do. That figure reaches 85 per cent when you're only counting young adults. According to Statista,[6] the statistics portal, in a recent survey they conducted 81 per cent of respondents in the UK owned or had ready access to a smartphone and in 2017 96 per cent of respondents aged between sixteen and twenty-four reported owning a smartphone. Of course, we could just as easily replace the word smartphone in these statistics and use the word camera instead. By doing so it would not only give us a true reflection of how many people have regular and easy access to a camera but also an approximate number of people who could be engaged with photography and therefore be part of the broader photographic community.

Let's now consider this from a global perspective. It is predicted that there will be 7.5 billion people in the world in 2017, and approximately 5 billion of them will own a mobile phone. If 80 per cent of those phones have a built-in camera that leaves us with approximately 4 billion people as potential photographers. If these photographers create ten images per day that will amount to 3,650 photographs per year, per person, which in turn equates to more than 14 trillion photographs being created on an annual basis. InfoTrends'[7] most recent worldwide image capture forecast takes a more conservative viewpoint, estimating smartphone camera users will create 1.1 trillion photographs worldwide in 2016, a number they believe will increase to 1.2 trillion photos in 2017. These are staggering figures, but they only deal with image creation not image dissemination and it is when these figures are explored that the pace of image sharing is exposed.

According to the technology, media and telecommunications practice at the business advisory firm Deloitte,[8] more than 3.5 million photos would be shared every minute in 2016 and almost 60,000 photos would be shared every second in the same year. They also estimated that 2.5 trillion photos would be shared or stored online globally in 2016, which would indicate a 15 per cent increase from 2015. Of these, more than 1.875 trillion photos would be shared through social media and messaging services. They also claimed that more than 90 per cent of the photographs created in 2016 would be taken using a smartphone. They went on to estimate the impact this photo sharing would have on the global digital network and online storage as being approximately 3.5 exabytes (the equivalent of 3.5 billion gigabytes), a 20 per cent increase from their figures from 2015.

These are numbers that have little to do with the day-to-day experience of the average photographer, but they do indicate the scale and speed by which the use of photography as a means of communication has grown. It also puts into perspective the concept of judging your popularity and creative success through the numbers of followers you have. I recently read an article with the headline *How I Reached 10,000 Followers on Instagram*[9] written by a photographer for an enthusiast photographer online magazine filled with 'tips' on how to build a following. The photographer admitted that it had taken him a number of years to reach this point and that during this time he had become obsessed with chasing followers. In so doing he had lost sense of his photography and had allowed Instagram to take control of the images he created and posted. Despite the misleading title the article contained some good advice on avoiding the pitfalls of engaging with a platform such as Instagram, which could just as easily be applied to Facebook, Twitter

or Flickr. However, it also included advice on the importance of the use of hashtags, which leads back to the underlying desire to create a large following based on subject matter rather than creativity.

There is no doubt that the effective use of hashtags – a form of content-signalled metadata – can help build community and market your work. But with all areas of community building you have to be aware of your personal expectation of what that community will give you and where your marketing will take you. If you are in search of numbers that's fine, but I would question what those numbers will give you and where it will take you creatively.

There is, however, a difference between an exhaustive list of hashtags and a well-written caption that allows you to provide context for your images which your community can use to further understand your practice and intentions. The Social Photo Editor of *The New York Times* has spoken of the need to pay particular attention to the writing of these captions:[10] 'our goal is to tell a *New York Times* story in each caption. We're writing to the photographs. If we use a picture of a person, we include that person's voice. When possible, we tell the story behind the photo – we try to be conversational.' It's simple common-sense advice but it is rarely followed.

I am all for this simplification of engagement. There is no need to over-complicate the understanding of the digital space and how we can best use its positive attributes. Magnum photographer David Alan Harvey uses the metaphor of the campfire to simplify the concept of the online community in the same Magnum article addressing Instagram in which both Anderson and Stuart outline their beliefs. He believes that beyond the new avenues for feedback and conversation social media brings, there is something incredibly elemental about the sharing of stories to a collective audience.

> It's something very primal, even more than we ever thought. It's about community, it's the campfire. This is the new campfire, and campfires are where you tell stories to a public. The public could be ten people when we were sitting round the campfire as kids, camping. It's a larger community now. We're consuming photography this way – and guess what, we want more, and more and more – we can't get enough of it. It's the need to be in touch with each other, and it's still somehow a private experience, even though the pictures that I made for my grandmother are now going out to millions of people, they are still, in my view, a private experience, and you're sharing it with a few more people that you used to.

If you were to extend the campfire metaphor to developing your own community you would only want to invite those you admire, respect, like and want to learn from to your own campfire. The success of that primal interaction of storytelling would not be based on how many people you can seat.

Harvey's view of his community and how it relates to his broader professional practice identifies a mentality that enforces the importance of creating an engaged audience:

> I monetize my audience by selling workshops, books and prints. The beauty of it is you are monetizing the audience in a nice way, you don't have to pay any rent, but you've got a store. You just put your product in the window and see if people like it. And if they don't there isn't any investment up front. Social media is just a way to get to more books, more prints, more personal experiences. I don't use it as an end in itself.

This idea of community as potential employers is again not based on a size of audience but of the quality of audience. The Feature Shoot website identified the reality of this when they spoke with six commissioners of photography in 2017 on their engagement with Instagram[11] when looking for new photographers and important stories. Oliver Laurent, then at *Time* and now at *The Washington Post*, commented that 'One can learn a lot about a photographer's vision, identity and commitment through her or his Instagram feed. Depending on the situation and my editorial needs, I will either seek a particular photographer or let the app guide me through serendipitous connections to discover people I never knew about, especially outside of my regular circles of acquaintances.' Jane Yeomans, photo editor at *Bloomberg Businessweek*, developed this understanding of the potential use of the app from a commissioner's perspective by stating that 'Instagram is one of the many photo tools I use when both assigning and sourcing photos on a daily basis. I often look at Instagram to see where photographers are in the world, as most weeks I am looking to assign a story worldwide. In addition, I look at Instagram for existing photos to license.' These commissioners are looking at Instagram as a professional tool to help them expand their knowledge of photographers and photography, but they are also engaged with it as users outside their professional environments. Engagement for pleasure and from a professional context are not mutually exclusive as Jenna Garrett, photo editor at *WIRED* (US) illustrates in the same article: 'Instagram is my primary and favourite form of social media so I'm always poking around on it. I really like Instagram's explore feed and

checking out who photographers I admire are following (you can discover some great stuff by doing that!).'

Whether you see the people you engage with within the digital space as followers, an audience or a community will depend greatly on the decisions you make prior to your initial engagement with a digital platform and that engagement should be informed by the expectations you have of that platform. A negative experience too often directly relates to an unrealistic expectation or lack of understanding of how the platform integrates into your broader creative practice.

Digital visual literacy

Whenever I am asked what I do for a living, I always reply by saying that I make a living from photography. I am a photographer, I write on photography, and I teach photography. People usually respond well to the first two endeavours in that list, but it is the third that most often causes a short intake of breath or the raising of an arched eyebrow. If I am talking to a photographer, the comment that I most often receive next concerns the dishonesty in teaching photography when, according to some, 'there is no future as a photographer'. It's a good point to raise, but to do so is to misunderstand the possibilities that the study of photography can present for a student interested in the photographic image and its role outside the 'photographic community'.

As long ago as 1971, the then photographic critic for *The New York Times*, A.D. Coleman, called for photo education to adopt what he called a 'new manifesto for photographic education',[12] one that embraces not only non-photographers within its teaching number but also collaborations with areas such as history, psychology, geography, music, the sciences – in fact, all areas of learning that in some way have a connection with the photographic image. Sadly, his call for such a manifesto has largely fallen on deaf ears, as education has become increasingly compartmentalized in its delivery, funding and research. As I have previously mentioned, today's buzz phrase within student recruitment and education is 'transferable skills', a term used to describe learning that may be received within the study of one subject but has relevance to other areas of practice and life outside the confines of the specific subject studied. When A.D. Coleman put forward his manifesto within an analogue world, his hope was for these skills to be developed via cross-fertilization through teaching. Today, within a digital environment,

that cross-fertilization is already established within our everyday lives, but does photographic education understand and teach this to their students or does it persist in seeing photography as a subject to be taught to create photographers? In short, is visual literacy, an asset that allows students to construct meaning out of visual information, being taught and explained within a context of employability?

My belief is that most photographic education revels in the process of creation without providing the required context to further utilize whatever visual skills have been developed. The harsh reality is that on any course only a few students will progress into photography as a profession on graduating. However, if an understanding of photography as a visual language is developed, those students who choose not to describe themselves as photographers can be highly employable in other fields. They can leave education having learned a new language, one without international borders: the language of graphicacy, the understanding of the use of images to communicate.

The visual literacy I speak of is the ability not only to create images and develop a personal visual language but also to see the relevance of learning graphicacy to the wider world outside 'straight photography'. The most obvious starting point for the application of this skills base is within the online environment and social media platforms, but it is at this starting point that photo education often falters. A lack of serious engagement with these platforms by those charged with teaching photography within institutions instantly presents an issue with the teaching of the importance of the online environment as a professional context for photography. These online environments also call upon a more traditional literacy in the form of the written word and, here again, many photography courses fail to understand the importance of non-academic writing as an essential post-graduation ability, but there is no point in having that literacy if it cannot be implemented.

Narrative needs to be placed within a context appropriate to the story it is telling to succeed in its intention, but the ability to create narrative is also highly relevant to non-traditional photographer-related employment. Failing to understand this need for context immediately defeats the intentions of the storyteller and severely limits the non-photographic opportunities for students who study photography. Visual literacy is the foundation to all effective digital communication in the twenty-first century, and its power cannot and should not be underestimated.

The reality of photography now is that it is available to all, but not understood by all. The development of visual literacy allows young photographers to explain photography to those who recognize its existence

but look no further than the image itself. The young photographer then becomes a conduit outside the photographic community for a reinterpretation of photography as a language. In adopting this 'role', photography students creates a new role for themselves. That role is a self-created role, but one which has relevance to multiple career choices and positions of employment. As a result, studying photography not only becomes something more than creating photographs, it becomes an essential learning process in understanding global communication.

Developed visual literacy is an essential outcome for any student currently studying photography. My recent graduating students are leaving a photographic course with a skillset that enables them to look for career paths that are not defined by photography but are informed by it. They have been able to identify their assets as visual communicators and the type of roles looking for those abilities. These include positions within both traditional and online publishing: as social media editors, as filmmakers, digital marketers, curators, within post-production, production coordination, as stylists, writers, researchers and – yes – also as commissioned photographers! The skills they are being asked to demonstrate? Coherent and accurate writing ability, professional social media interaction, a willingness to collaborate and work in a team and communicate clearly, confidence on the telephone and good interview technique – all skills that any photographer will recognize as being essential to a career within the medium.

These are transferable skills and they are in demand. The addition of visual literacy to these abilities makes someone both employable and desirable. It also explains why someone who has spent three years studying photography could decide not to be a photographer. It is not because they have failed, but because they can see that what they have learned is more than just mastering lighting setups, f-stops and Photoshop techniques. Photography in the twenty-first century is a primary form of communication and we owe it to young photographers that they leave education fluent in the language of images.

Why is narrative such a difficult concept for young photographers to master?

Writers believe that reading is the foundation of good writing. That's all reading – the good, the mediocre, the bad and the truly awful, with no boundaries placed on where the written word appears, or how or why it was created. I've drawn an analogy with this and the teaching of photography as

a visual language and I'd now like to extend that analogy to the logical outlet for connective elements of language – the narrative. The love of reading is something which those of us who enjoy reading can take as a given. But in a formal education environment in which reading is often seen as an enforced chore; the early childhood joy of reading can easily and quickly be extinguished. The result of this is a rejection of all forms of reading and, as a result, of the narrative.

When I've asked students hoping to commence their photography studies at university what they read I have invariably been met with a sense of confusion. Why would I ask about books when they want to study photography? This confusion continues as I question them about films they have recently seen and film directors they admire. Of course, the connecting element in both of these creative forms is narrative, and it is an enjoyment and awareness of storytelling that I am searching for in their popular cultural influences. Sadly, it is rarely evident.

This linking of creative practices and the willingness to question and enquire seems to be rare amongst a generation for whom the ability to discover has never been so easy or so available. In addition to the rejection of reading there is also the obsession with the single image. I believe that in many ways the reason for both of these negative situations can be attributed to the digital platforms that have done so much good in connecting the global photographic community.

The limited character count of the tweet and the preoccupation with the single image on Instagram can reduce both attention span and the opportunity to develop complex and nuanced storytelling. Both platforms can be extremely positive elements within a photographer's professional practice, but they can also dominate both the presentation of the images and their creation. These are platforms where both long- and short-form narratives can be effectively showcased, but for this to happen the photographer needs to understand the construction of narrative not only through creation but also through editing.

The art of editing is a skill that can often take years to master based on shooting experience and developed visual knowledge, so it would be unrealistic to expect the novice photographer to immediately possess the ability to know which images lead, drive and deliver a narrative. Many student photographers have only known their own images as back-lit screen-based outcomes, viewed at a size and number dictated by the size of the screen. I believe it is essential to encourage students to step away from the digital screen as a primary editing environment. They should print their work

cheaply and quickly at a size that allows it to be viewed clearly. They should lay out their images on a floor, so they can begin to see them as a developing body of work. This is nothing new to the experienced photographer, but this is often a revelation in thinking and seeing for many young photographers.

Digital platforms, and the way in which students engage with them, must bear some responsibility for the lack of awareness of the importance of narrative in visual storytelling. As a result, the understanding of the storytelling power of photography is where I think the most work needs to be done by the lecturer or teacher. Encouraging students to see photography as something more than the creation of a 'successful' single image requires them to see the importance of narrative in storytelling in related creative practices, from song lyrics to news articles, from a short story to a feature film. These areas have a creative synergy to photography, but this is not always obvious to the student photographer. Without engaging with an understanding of narrative beyond photographic practice – combined with an enjoyment of storytelling – it is impossible to develop narrative as a photographer. It is also extremely difficult to teach narrative to people who have never considered narrative as an essential aspect of photography.

When using the word narrative in relation to photography, I am not restricting the area of discussion to documentary work. The creation of narrative is an essential ability, whatever area of specialization the photographer works within or across, from fashion to food, from interiors to still life, from sports to portraiture, from news to cars. It is the creation of the narrative that not only fulfils a personal desire but also a client brief. For the past few years when discussing with photographers the connection between moving image creation and stills photography, I often use the analogy between the traditional analogue contact sheet and the importance of a storyboard to a filmmaker. The sense of a narrative developing through a series of consecutive images is easy to explain from this perspective, but with digital frames the images are rarely seen and studied in this context of narrative progression.

Why is narrative such a difficult concept for young photographers to master? Because it is a concept that they are unaware of. It is something that they take for granted and do not question, something that visual digital sharing platforms do not encourage. Because it is something that is pushed to the back of the educational queue in favour of technical skills, post-production proficiency and other photographic aspects that fulfil an easily implemented marking matrix. And yet – just as with writing – the establishment of a clearly defined, developed narrative is the foundation of all successful storytelling.

Finding a narrative

There are times as a photographer when we deliberately set out to find a story and times when a story evolves from our interests and practice but there are also those moments when a story is forced upon us. That situation occurred with Associated Press photographer Burhan Ozbilici as he explained:[13]

> The event was routine enough – the opening of an exhibit of photographs of Russia – and when a man on stage pulled out a gun, I thought it was a theatrical flourish. It was anything but. Moments later the Russian ambassador was sprawled on the floor and the attacker was waving his gun at the rest of us, shouting slogans. Guests ran for cover, hiding behind columns and under tables. I composed myself enough to shoot pictures.

The resulting image tells that story, it's hyper-digital clarity creating a cinematic news image for our times. The narrative is clear, shocking and deeply affecting in its emotional coldness.

I first saw it on Twitter as so many people did, an environment that showcases the single image with an immediacy that forces interaction. I clicked off. I couldn't take in the reality of what I was seeing. I took a moment and chose to see both the image and the story on the BBC News app. I needed to understand if what I had seen was real, I needed an explanation for what I had seen, I needed context. Over the following days 'that' image became lodged within my photographic mind library. Part *Reservoir Dogs* (the suit, the stance), part *Dog Day Afternoon* (the attitude, the anger, the cry to the media), it has none of the visceral horror of the images of the shooting of John F. Kennedy and subsequently Lee Harvey Oswald or Bill Eppridge's images of the murder of Robert Kennedy. What it does have is the cold reality of a situation, of a narrative unfolding, a movie still appropriate for mass media consumption. We can see what has happened and what is happening but there is also space within the image for us to write our own narrative.

I was immediately reminded of *Falling Man*, an image created by another Associated Press photographer Richard Drew of a man falling from the North Tower of the World Trade Centre during the September 11 attacks in New York City in 2001. I still have trouble looking at that image. Actually, that's not true, I cannot look at that image. I cannot help myself from writing the narrative for that image within my head. Who he is, what his thoughts were before he jumped and whilst falling and the inevitable conclusion

to his fall. It is a narrative that I do not want to write but it exists within that image, it's there if you want to read it. Before I saw Ozbilici's image I was intending to base my writing on single image narrative on the ability of a successful photograph to invite you into its world and encourage you to travel through it. I love images and photographers that are able to do that. It is the ability to see a situation, identify the central element of an image and create a subliminal structure created from shape, form, colour and juxtaposition that takes the viewer on a journey through the image to that central element, all within the split second of image capture. This to me is the foundation of single image narrative created in the moment, but the long-form constructed narrative image has its place within photography also and the work of Jeff Wall, Gregory Crewdson, Helen van Meene and Philip-Lorca diCorcia immediately comes to mind (I'm sure that you can suggest many more), but as viewers we know that what we are being presented in this work are constructed narratives, fiction rather than fact.

I began to understand the difference between these two forms of visual narrative the first time I saw William Eggleston's images in the solo exhibition of his work *Ancient and Modern* at the Barbican Art Gallery, London back in 1992. My understanding of photography at the time was limited and divorced from my understanding of other art forms. However, a tour of the exhibition with its curator soon had me understanding both the intention and reality of Eggleston's work and of course his sense of narrative. Stills from a film yet to be made. Some images feel like that and others seem to contain a complete screenplay within one frame like the work of Henri Cartier-Bresson or Joel Sternfeld, Lee Friedlander or Sally Mann for example. But this week my attention was drawn to an image that demonstrated a filmic sense, a dark narrative. As the art critic Jerry Saltz commented in his excellent analysis of the Ankara images: 'It's a new surrealism of modern life, made all the more harrowing because it could not be more truly real.'

When speaking becomes addiction

I have until this point focused on the positive aspects of the smartphone and the associated digital platforms related to the photographic medium and engaged creativity, but as has been widely documented all of these elements have addictive qualities that can lead to negative outcomes. I feel that it is therefore appropriate at this point to address some of these issues and look at the facts concerning our interaction with the smartphone.

In the spring of 2016, the cartoonist and educator Lynda Barry, prior to giving a lecture and writing class at NASA's Goddard Space Flight Centre,[14] demanded that all participating staff members surrender their phones and other such personal devices. The phones were reluctantly surrendered, and all agreed to take notes by hand, as Barry also requested. Just like Barry I find myself regularly having to lecture to students feverishly tapping away on their laptops and phones as they take notes. And just like Barry I believe in the pencil as a more appropriate tool for note-taking within a lecture structure. She has also made an interesting observation concerning the possibility of smartphone obsession impacting negatively on creative practice: 'Once, we were keener students of minor changes to familiar environments, the books strangers were reading in the subway, and those strangers themselves. Our subsequent observations were known to spark conversation and sometimes ideas that led to creative projects.' I agree with Barry on this, but I believe that what is called for in this regard is balance; however, others feel that total abstinence is required. The Georgetown University Computer Science Professor Calvin Newport commented in his 2017 book *Deep Work*[15] that 'shallow phone time is creating stress, anxiety, and lost creative opportunities, while also doing a number on our personal and professional lives'. Newport goes on to say that, 'these companies offer you shiny treats in exchange for minutes of your attention and bytes of your personal data, which can then be packaged up and sold'. But like the slot machine, the social media network is a 'somewhat unsavoury source of entertainment' given the express intent of its engineers to make their product 'as addictive as possible', comparable to what dietitians now call '"ultra-processed foods" – all sugar and fat, no nutrients'.

In a 2017 online article CBC[16] – the Canadian Broadcasting Company – spoke with the co-founder of a Californian start-up company called Dopamine Labs, Ramsay Brown. Dopamine Labs is a company that uses computer coding to influence behaviour, primarily in compelling people to repeatedly engage with a specific app. Brown commented in the article that: 'We're really living in this new era that we're not just designing software anymore, we're designing minds.' He goes on to say that: 'One of the most popular techniques is called variable reinforcement or variable rewards.' This form of technological manipulation raises all kinds of issues surrounding the negative implications of smartphone addiction, all of which are important to understand when navigating the digital space and also when working with millennial digital native students. The process of variable reinforcement involves three distinct steps: a trigger, an action

and a reward. A push notification, such as a message that someone has commented on a Facebook photo, is a trigger; opening the app is the action; and the reward could be a 'like' or a 'share' of a message or image that has been posted. Brown states that 'These rewards trigger the release of dopamine in the brain, making the user feel happy, possibly even euphoric … just by controlling when and how you give people that little burst of dopamine, you can get them to go from using the app a couple times a week to using it dozens of times a week, the rewards aren't predictable. We don't always get a like, a retweet or a share every time we check our phones. And that's what makes it compulsive.'

The rise of social anxiety, lack of resilience and a loss of social confidence amongst millennial students has been widely reported and attributed to extended social media usage. The agenda of this book is not to review these aspects in detail, but I do feel that it is important to register these issues, as they are issues that many teachers and lecturers face on a daily basis. A lack of education in how to use these platforms and devices in the early years of the education journey has resulted in a misunderstanding of their potential role by the students in their learning and an inconsistent adoption of digital tools by teachers has created a mixed message from an academic perspective. By teachers universally engaging with all aspects of the digital space they give themselves a new set of tools with which to teach and the possibility of reinterpreting these tools for their student cohorts to use and explore their creative potential. This does not mean that traditional methods should be jettisoned but it does require an incorporation of the established and the new.

Research was published in the journal *Psychology of Popular Media Culture* in 2018 by Danielle Leigh Wagstaff, psychology professor at Federation University of Australia, that revealed details of how Instagram can affect a person's mental health and wellbeing. In an article titled *The Psychological Toll of Becoming an Instagram Influencer* by Jenni Gritters,[17] Gritters quotes Leigh as saying that: 'With Instagram, we have immediate access to all of these idealized images, which aren't always an accurate representation of the world. People tend to post only their best images on Instagram, using filters that make them look beautiful. We have a false sense of what the average is, which makes us feel worse about ourselves.'

There can be no doubt that Instagram and in fact all social media platforms can encourage an unrealistic view of the world and life that in turn can become triggers for mental wellbeing issues and at worst negative addictions. But to dismiss or ignore the principal communication tool

New Ways of Seeing

of our times and the impact such software development can have on our lives ensures that you are both not part of the digital conversational environment, but also the conversation that the students we lecturers are engaging with are part of. An awareness of the issues the digital space can raise is intrinsic to the teaching of photography in the twenty-first century and being part of the conversation is essential for both those teaching and those learning.

CHAPTER 3
THE BASIC VOCABULARY OF A VISUAL LANGUAGE

To learn a language, we need to know and understand which elements we need to learn and how to structure those elements into a form that enables communication. We accept that when we are writing we first have to understand how to use nouns, verbs and adjectives before exploring metaphors, similes and multiple forms of grammar and syntax before we start structuring sentences, paragraphs, chapters and narratives. The development of a visual language is no different from this but instead of words we have images, and our grammar and syntax is defined by light, colour, texture, shape, form, composition and juxtaposition. These are elements common to the foundation of all of the visual arts but whereas with painting, drawing or sculpture they can be played with, explored, developed and manipulated as part of the process of creation, the photographer has to bring all of these together successfully in the fraction of a second it takes to press a button or shutter.

The reality of this is that the photographer has little space in which to explore these elements in the moment other than by taking another image, moving and therefore redefining the composition or waiting and then reconsidering the new situation in front of them from a visual perspective. This process of instant decision making and snap, or perhaps 'snapshot' judgements, was explored by the American educational philosopher John Dewey in his book *How We Think*[1] (1910) in which he examines what separates thinking, a basic human faculty we take for granted, from thinking well, what it takes to train ourselves into mastering the art of thinking, and how we can channel our natural curiosity in a productive way when confronted with an overflow of information. Dewey states that:

> Reflection involves not simply a sequence of ideas, but a consequence – a consecutive ordering in such a way that each determines the next as its proper outcome, while each in turn leans back on its predecessors. The

successive portions of the reflective thought grow out of one another and support one another; they do not come and go in a medley. Each phase is a step from something to something – technically speaking, it is a term of thought. Each term leaves a deposit which is utilized in the next term. The stream or flow becomes a train, chain, or thread.

This understanding of decision making as a series of questions answered, leading on to a final outcome, is the basis of creating a visual language by mastering the elements previously outlined leading to a successful image and/or series of images. An accurate metaphor for this would be that of an image-led crossword in which each answer helps you to resolve the following question until all questions are answered. This is how I see the learning of photography and any visual language.

The writer is able to engage with this process through a series of drafts, constantly adapting and editing the work until its completion. The artist through sketchbooks and preliminary drawings, the sculptor through the creation of a maquette, but the photographer has had none of these options available to them to aid in their creative development. However, the digital space now presents the photographer with their own environment to learn a visual language with the tools available to them as I have previously mentioned, through the use of digital platforms such as Instagram.

This understanding has been identified by the photographer Robert Ketchum writing in *World Literature Today* in 2013,[2] when he states that

> as the world grows more digital and thinking travels at new speeds through social networks, a lot of information will be transferred across language boundaries through visual images without any 'wordcraft'. Social network users feed on visual imagery, and demand for it will be ever greater. Those that use this technology in the most visually captivating ways are speaking a kind of pixel poetry that is feeding inspiration and revolution worldwide, delivering iconic images of people and events.

The idea of pixel poetry is an ambitious one for many but as the furniture designer George Nelson stated in his 1977 book *How To See:*[3] 'The good news is that seeing is not a unique god given talent, but a discipline. Visual literacy can be learned', and it is this reality that I would like to address within this chapter. As Nelson also states: 'We can learn to read images

the same way we learn to read words: through experience, exposure and practice.'

What makes a photograph good?

I have to admit that I am unable to answer that question, at least without knowing the context in which the image is being seen and, even then, I find the use of the word to be too subjective as a form of comment of use to the photographer. For this reason, I never use the terms 'good' or 'bad' in relation to photography; instead I use the words 'successful' or 'unsuccessful' determined by the context the image has been placed in and its intention within that context. Just as a word can neither be good or bad independent of a sentence, so an image cannot be viewed objectively without understanding the intention of the photographer for the image. There is no uniform standard by which a photograph can be judged and therefore be defined as 'good'. However, there are certain qualities that consistently lead to an image being successful whatever its context. These are immediacy, emotional impact, engagement and graphic quality.

Immediacy could just as easily be described as 'stopping power', the ability to arrest the viewer and to draw them to and into the image. In its most basic sense this could be achieved by photographing unusual subjects, treating the subject in an unusual way or by combining both approaches. In an increasingly chaotic visual landscape online immediacy is one of the hardest aspects of successful photography to achieve. It can also lead a photographer into the trap of trying too hard to shout the loudest in a noisy environment. Immediacy is important but not at all costs to your personal aesthetic. A visual language is not defined or evolved through the heavy use of post-production filters or Internet viral-friendly content.

Emotional impact and engagement are difficult qualities to define but their absence is always obvious to perceive. In order to create images with emotional impact the photographer has to make some form of emotional connection with their subject, they need to empathize with their subject and be truly interested in their lives and situation. Without this empathy, the resulting image can only appear cold and observational.

The term 'graphic quality' refers to the combination of all of the aesthetic qualities and decisions made by the photographer concerning lines, forms, colours and all other elements of consideration in creating

the final image. All of these qualities remain outside the technical understanding and teaching of photography and, in an environment where technological advancements have democratized the ability to create a technically proficient image, the importance of a personal visual language cannot be over-emphasized. It is a difficult pill for many experienced and traditionally trained photographers to accept but the fact is that today a photographer is not initially judged on technical ability. As a result, the student photographer has to prioritize the purpose, meaning and emotional impact of their work, never forgetting that the camera is merely a tool that allows you to accomplish an end.

The notion of the 'good' photograph as an end can provide an extremely negative force on a student photographer's creative progress. The search for the 'good' photograph is in itself a futile journey to commence for the young photographer unaware of what constitutes a successful image outside their limited learning based upon marks being placed on work defined by procedural conformity. Unrealistic expectation of what is achievable in the early days of experimenting with the medium can often lead to students falling out of love with photography, and a lack of enjoyment in the work quickly shows itself in the images being created and the general disposition of the student. This inevitably leads to students fearing to show work that they believe to be of sub-standard quality and yet at their stage of learning they are in no position to make this judgement. I therefore have no time for the 'good' photograph and instead encourage students to create images and share images without concerning themselves with the perceived quality of the image. This is the process of 'photo sketching' that I have previously mentioned. A process of freeing the student from a pre-conceived understanding of photography and an introduction into the sense of photography as documentation of their immediate environment.

The eye, when guided by the brain, engages a selective, subjective process of seeing, and editing what is seen to deliver an image the mind is interested in seeing. In contrast, the camera is indiscriminate in its viewpoint, it sees what it wants to see within its field of view, determined by its user. It is therefore the photographer's responsibility to edit the lens's view through knowledge, questioning and interest, to create an image that shows the subject out of its immediate context, so that the viewer's attention is drawn to the picture and to the photographer's intention in creating the image. In attempting to do this a successful image can be created but it cannot be expected to occur every time an image is made or without considerable practice.

Looking at a flat screen

It is at this point that I would like to address perhaps the most important change in photographic engagement and its impact not only on the way in which we see and record what we see but also in the way in which we create photographs, that of the LCD – Liquid Crystal Display – screen. The history of the evolution of the LCD screen is much longer than you would perhaps imagine and stretches back to the end of the nineteenth century. But the screen we know and use today began to come to fruition in the early 2000s. There is no need to enter into the technological complexities of how an LCD is constructed but it is important to understand the basics. LCD panels produce no light of their own and therefore require external light to produce a visible image. In a transmissive or active matrix type of LCD, this light is provided at the back of the glass stack (or screen) and is called the backlight – it is this type of screen that is used in cameras and smartphones. This is an important fact to understand as it has a direct effect on every image you create, giving it an almost 'stained-glass window effect'. What I mean by this is that a piece of stained glass held in the hand will appear flat and colourless; however, held up to the light the colours and form come to life just as the digital image appears when back lit.

The eye adjusts to changes in brightness, its pupils contracting and expanding as it scans from light to dark areas within our vision. As a result, the contrast range of our vision is wide, enabling us to see detail in both the brightest and darkest situations. In the past the 'pupil' of a camera – the diaphragm – although variable and adjustable, could and can only be set at one specific aperture for each exposure or frame. Today sophisticated software within our smartphones removes that decision-making option and delivers an algorithm that resolves these issues by making judgements that we have little if any control of. The resulting image is then back lit on our screens to ensure maximum if unrealistic impact and a representation of the scene that has been controlled by the device. For many photographers this lack of control in the creation of an image is a major issue and I have to agree with them when speaking about photography in its purest sense; however, I also see the benefit of this form of image making in which the technical considerations are removed for the student photographer, as part of their visual learning.

It is important to understand this hyper-real quality created by the smartphone when looking at images. The eye does not normally notice

minor changes in the colour of light; however, the smartphone sensor does and intensifies the experience of seeing. Seeing reality in photographic terms means realizing potentialities, the potentialities of light, colour, contrast, perspective and focus. It means not only seeing what is in front of you but also analysing what you see in terms of light, shadow, colour relationships, space and depth. The smartphone can take control of many of these elements for you, but it is in taking control of the tool which you choose to use as a camera that your mind's eye supersedes the device's software, allowing the photographer to anticipate possibilities of positioning, composition, illumination and scale.

This decision-making process has and remains for many photographers an act engaged with utilizing just one eye. Despite DSLRs being fitted with LCD screens, for many years the majority of professional photographers continue to view the image through the camera's viewfinder, but as photographer David Eustace once told me: 'Photography is the most selfish act, we don't even share the image with both of our eyes.' This sense of exclusion allows the photographer to literally focus on only those elements they consider to be important to the final frame, but in doing so the process immediately places a regimentation on the image to be created. The camera has to be placed on or at least very close to the eye, immediately taking the photographer into a world defined by the rectangular shape the camera implements on the photographer. This immediately removes the photographer from the world they are in and places them into the world they are creating. This is not a criticism, merely an observation; I have myself when working with a DSLR completely lost contact with my environment as I became increasingly connected with the image I am trying to create; it is a natural outcome of the process and the level of intensity required when creating images. In fact, many photographers speak positively of that moment when the photographer, camera and subject become as one entity, and this is something that I both recognize and agree with. In this context, I agree with photographer Henri Cartier-Bresson who commented that: 'It is an illusion that photos are made with the camera … they are made with the eye, heart and head.'[4]

However, this way of seeing has now been supplemented and for many replaced with a new way of seeing, not with one eye and with the camera pressed to the face, but with both eyes and at arm's length. The smartphone screen has completely changed the way in which we see, compose and create an image. As a result, the images that are being created today differ from those of the past in that they are created with the photographer fully in

the environment the image is being created in. They are aware of what is happening around them and around the defined area of the image they are attempting to capture.

In order for a photographer to make the right choice when creating a photographic image, they must be aware of three things: what to do, how to do it and why it should be done. This in turn presupposes that they know how to see 'photographically' and this is made harder when the photographer remains conscious of their immediate environment whilst attempting to 'make' – or as I prefer to say 'find' – a photograph. Every photograph is a translation of a reality into a picture and it is by editing that reality that a photograph exists. This editing requires confidence and is something that comes with experience; however, that does not have to be experience purely in terms of age; it can also be in terms of images created and questioned. The development of a visual language through 'photo sketching' is the basis of creating a visual language that will provide you with the building blocks for your creative confidence.

The use of a screen to create an image is not a new concept to any young photographer. However, how they experiment with the process may well have not occurred to them. The concept of what constitutes a photograph is engrained within students – often through narrowly defined school education – to such an extent that many are unable to see images captured on their smartphones as being 'photography'. The belief that photography can only be created with a DSLR is one that I constantly have to address. Once this issue is addressed and the stigma associated with images created on a smartphone is removed, students feel free to experiment not only with the content of their images but also where, when and how they create images. This freedom to explore the medium with a device they feel comfortable with handling and using can be a valuable key to unlocking a student's creativity and addressing many students' apparent lack of willingness to fail as part of the creative process.

How can something as simple as a screen achieve this? If we see the screen on a phone as what it is – a smaller version of a television, computer or cinema screen – it is easy to see how a student would find it easier to develop a relationship with a smartphone screen than a traditional camera viewfinder. It is something that they have grown up with throughout their lives and are used to viewing images on. The immediacy of capture and viewing also provides an experience they are used to having. The challenge is then in taking a familiar experience and developing it into an unfamiliar approach to visual creativity.

It is at this point that I turn towards the photographic approach of Garry Winogrand, well known for his photographic approach of not looking through the viewfinder and instead using a dynamic arm outstretched posture to capture images that he described as being 'On the edge of failure'. This approach fits perfectly with that of the flat screen, which is often obscured due to poor lighting conditions, finger smudges or cracked screens. Winogrand explained his approach in a talk in Austin, Texas in 1974:[5]

A work of art is that thing whose form and content are organic to the tools and materials that made it. A still photograph is the illusion of a literal description of how a camera saw a piece of time and space. Understanding this, one can postulate the following theorem: Anything and all things are photographable. A photograph can only look like how the camera saw what was photographed. Or, how the camera saw the piece of time and space is responsible for how the photograph looks. Therefore, a photograph can look any way. Or, there's no way a photograph has to look (beyond being an illusion of a literal description). Or, there are no external or abstract or preconceived rules of design that can apply to still photographs. I like to think of photographing as a two-way act of respect. Respect for the medium, by letting it do what it does best, describe. And respect for the subject, by describing as it is. A photograph must be responsible to both.

Images as symbols, photography as language

The issue for young photographers consumed by visual information is in deconstructing those images to understand their context and intent. Young photographers are so used to being assaulted with pictorial symbolism that they are no longer aware of its power as a language. Again, to explore this issue further I must return to the analogy between photography and language. Letters for example could be seen as symbols, which we understand as representing sounds and combinations of sounds and words stand for concepts, objects, actions, events and situations. Just as professional writers and speakers are aware of the importance of using the appropriate words to convey expression and intonation, professional photographers understand that they have a substantial number of symbols at their disposal, which

appear in a number of different forms. Light in conjunction with shadow as a symbol for depth for example. This idea of symbols within photography is not new and was outlined in some detail by the photographer and writer Andreas Feininger who in his book *The Complete Colour Photographer* (1969) stated that:[6]

> Whether or not he likes it – or is aware of it – a photographer cannot avoid working with symbols. He should think of the camera as a means of exploring the world and extending his horizon, as an instrument for making life richer and more meaningful by acquiring insight into many of its aspects which otherwise would remain unknown, as a powerful tool of research. To be able to do this he must be in command of his symbols and know how to exert control.

Whatever understanding you feel comfortable with concerning its communicative nature, photography as a language directly connects with the 'non-photographer's' engagement with and use of the medium today. We do not need to write captions for the images we take before sharing them with friends and colleagues to explain where we are, how we feel, who we are with and what we are doing. In fact, this idea of the visual image as a form of principal communication can be seen to have been taken to its most defined and immediate conclusion through the use of the emoji, meme and emoticon.

In January 2017, in what is believed to be the first large-scale study of emoji usage, researchers at the University of Michigan analysed over 427 million messages that had been input via the Kika Emoji Keyboard[7] and reported that the 'Face with Tears of Joy' was the most popular emoji. The Heart and the Heart Eyes emoji stood second and third respectively. The study also found that the French used the emoji associated with love the most. People in countries with high levels of individualism, such as Australia, France and the Czech Republic, used more happy emoji, while this was also the case for people in Mexico, Colombia, Chile and Argentina, whereas people used more negative emoji in cultural hubs known for restraint and self-discipline, such as Turkey, France and Russia. Emoji are now universally considered by many to form their own language and there has been discussion amongst legal experts on whether or not emoji such as the gun and face could be admissible in court. Furthermore, as emoji continue to develop and grow as a 'language' of symbols, there might also be the potential for the formation of emoji 'dialects'.

A meme is best understood by seeing it as an idea, behaviour or style that spreads from one person to another within a culture, acting as a unit for carrying cultural ideas, symbols or practices through writing, speech, gestures or other imitable phenomena with a mimicked theme. An Internet meme is developed from this and is widely recognized as an activity, concept, catchphrase or piece of media which spreads, often as mimicry or for humorous purposes through the Internet, most often as or incorporating a still or moving image. The word meme was first used by writer Richard Dawkins in his 1976 book *The Selfish Gene*,[8] as an attempt to explain the way cultural information spreads and Internet memes are a subset of this general meme concept specific to the culture and environment of the Internet. The concept of the Internet meme was first proposed by Mike Godwin in a 1994 issue of *Wired* magazine,[9] but Dawkins has since explained his belief that Internet memes are a 'hijacking of the original idea. The reality for photography is that a meme provides yet another context for the visual image to be transmitted and transmuted as a form of communication in addition to its original context and purpose for creation.'[10]

The emoticon developed as people started to use punctuation marks to create figures and faces to express a person's mood. A process that I can remember in its most basic form was on early calculator digital displays. As social media platforms have developed the use of the emoticon became more widespread. It was therefore only natural that these crude statements would evolve into a range of more sophisticated visual symbols that allowed more subtlety in their communicative usage. The emoji originated on Japanese-made mobile phones in the late 1990s and directly relate in style and form to the historical Japanese culture of symbolism through figures. They have since become increasingly popular worldwide with their inclusion into the Apple iPhone's operating system, which was followed by a similar adoption by Android and other mobile operating systems.

Now I know that this book is primarily focused on the changing nature and understanding of photography but if we are discussing visual language it is essential that we identify the environment in which photographs now exist. The use of emojis and emoticons as a universally understood shorthand piece of communication links directly to how many people use photography today. However, despite the universal nature of the emoji symbol, interpretation of a particular symbol can differ from one culture or nationality to another, hence the discussion concerning emoji dialects which I previously alluded to. Photography has no such dialects and therefore transcends the issues that

other symbol-based visual languages can be restricted by. And yet it has its own forms of symbols that need to be learnt.

In his book *Photography Changes Everything* Marvin Heiferman[11] spoke with experts in 3D graphics, neurobiology, online dating and global terrorism amongst others to better understand how photography affects our everyday lives. Over the past forty-odd years, Heiferman has curated global photography shows concerning genetics, celebrity, street photography and humanitarian crises and edited *The Ballad of Sexual Dependency* by Nan Goldin,[12] widely considered to be one of the most important photo books of the twentieth century. Heiferman is currently a Contributing Editor for Art in America and is part of the faculty for International Contemporary Photography, at Bard College and the School of Visual Arts, New York. In an interview with *Wired* magazine in 2013[13] Heiferman expands on the idea of photography as a language outside the traditional photographic community when he says that: 'People have wildly different contexts in which they use photographs – different criteria for assessing them, reasons for taking them, priorities when looking at and evaluating them. It creates incredible possibilities for dialogue when you realize the medium is so flexible and so useful.' He goes on to say,

> In the past, it was more conventional; we had to have a reason to "make-a-picture" and it was usually to document something specific. Whereas now people take pictures because the camera is there (in their hand). It has got to the point where sometimes if you ask people why they take pictures they can't even say. I think people are using images in a completely different way and as a communicative tool.

Photography is no longer solely restricted to the process of creating 'good' photographs and it is no longer restricted to the photographer to create photographs. Photography is now a democratic global language without national or regional barriers. It is created for many different reasons and exists within many different environments. With this knowledge I believe that it is possible to reimagine the process of learning the photographic symbols required to use it as a visual communication tool in the twenty-first century.

Kick over the statues and rebuild them with new tools

I hope that by now I have made a convincing enough case for a re-evaluation of the role of photography and the photographer and for the necessity for

those already engaged with the medium to reassess their own practice. The digital democratization of the medium cannot be argued with. Whether or not this is a good thing raises issues for many but from my perspective the freedom and possibilities it presents can only be seen as positive. If like me you see these developments as being positive, the question has to be how to explain and teach these understandings to a student cohort.

The photography course I teach on embraces the smartphone as a tool of visual documentation and incorporates Twitter and Instagram into its teaching pathway for students and submissions of work for marking. Yes, we mark the students' Twitter and Instagram usage! Why wouldn't we and why wouldn't you, since they are essential parts of visual and written communication within the digital space which we all exist within? This does not mean that we do not also teach the basics of photographic technique and skills; of course we do, but we incorporate complementary skills appropriate to the digital space within the students' learning journey. Initially when students first join us, they are often shocked, confused and perhaps worried by this. It is surprising how many students are not engaged with digital platforms of any kind outside Facebook at the age when they join us – this is most often at eighteen years of age directly from school or college education – and some have been prevented in doing so by their parents, whereas others have seen little relevance of the platforms to their lives and almost all have little or no understanding of the platforms as professional tools of communication or creativity.

This may come as a surprise to those who see all young people as social media experts and anyone over fifty as digitally incapable, but this is the reality and one I deal with each time I meet a new cohort of students. It is in fact an interesting aside to comment on how many of those students are keen to get into the darkroom and start working with analogue processes; that is, until they realize the financial costs that are connected with that work. And it is at this point that the digital native explores the photographic world in which they have evolved, a world in which creating images has no cost.

Through accepting the smartphone as a camera and online sharing platforms as forms of publication, I then return to the history of photography to illustrate the wealth of inspiration that lies in the work of photographers whom many of today's students have no knowledge of. My starting point for this are the careers of two photographers whose work seems to greatly influence the work most commonly seen on Instagram. The first is Irving Penn and the second is Aaron Siskind.

The American photographer and educator Aaron Siskind holds a pre-eminent place in the history of American photography. Beginning his photographic career in the 1930s as a social documentarian with the New York Photo League, he ultimately radicalized the medium by emphasizing the photograph as an abstract form of expression and an aesthetic end in itself. Siskind taught in New York City's public schools for twenty-five years before becoming recognized as a photographer and then a gifted pioneer of photographic education, but it is in his abstract expressionist-informed photographs that his influence remains so dominant in today's Instagram aesthetic. I often show his work to students without revealing the year in which it was created and ask them to guess when these pictures were created. Of course, they are always amazed that such photography existed during a time which they consider to be past and of little use or interest to them. Interestingly Siskind spoke of the need to reconsider our beliefs of what photography is many years before the advent of digital capture, when he commented that: 'We look at the world and see what we have learned to believe is there. We have been conditioned to expect ... but, as photographers, we must learn to relax our beliefs.'

Irving Penn's work existed within a more commercial environment than Siskind's but it is in his personal work – which also influenced his commissioned work – where a visual experimentation relevant to the digital space can be found. While training for a career as an art director, Penn worked for *Harper's Bazaar* magazine as an office boy and apprentice artist. At the age of twenty-five he quit his job and used his small savings to go to Mexico, where he painted a full year before he convinced himself he would never be more than a mediocre painter. Returning to New York, Alexander Liberman, art director of *Vogue* magazine, hired Penn as his assistant, specifically to suggest photographic covers for *Vogue*. The staff photographers didn't think much of his ideas, but Liberman did and asked Penn to take the pictures himself. Penn soon demonstrated his extraordinary capacity for work, versatility, inventiveness and imagination in a number of fields including editorial illustration, advertising, photojournalism, portraits, still life, travel and television.

These are two of my starting points, but I am sure that you could and would find your own, but they are just starting points to kickstart a student's imagination as to what can be achieved and what has been achieved within the medium. From this point, I quickly introduce the work of photographers such as William Eggleston, Stephen Shore, Lee Friedlander, William Klein and Juergen Teller amongst many others. Again, I am sure

that you will have your own photographic touch points but to me the relevance of the medium's history to today's forms of digital capture cannot be underestimated and yet it is too often dismissed and taught as theory disconnected from practice.

When talking to students about photography, I often use the metaphor of music to question their level of engagement with the subject they are studying. I ask whether they would consider it reasonable to be studying music and to have never heard of Bach, Beethoven, The Beatles, The Rolling Stones, Nirvana, David Bowie, The Sex Pistols, The Clash, Madonna, Michael Jackson, Kanye West, Beck, Beyoncé, etc. Of course, that list could go on forever and the students are always keen to add names of people I have not mentioned, but the answer is always the same – a resounding no! I follow this question by asking how many photographers they can name, or which photographers have work they're familiar with. The response to this question is always more muted and often little more than an embarrassed silence. My point has been made and an awkward realization falls upon the room. They have not discovered the benefit of having heroes.

I grew up in an age of heroes – the 1960s, 1970s and 1980s were rife with popular cultural heroes: writers, singers, actors, broadcasters, artists, designers and thinkers who all challenged my perceptions and offered new places to go creatively and intellectually. I learned photography by looking at the work of the photographers whom I admired, my photographic heroes. Karsh for his studio portrait classicism; Eugene Smith for his empathy and narrative constructions; William Klein for his graphic immediacy; Diane Arbus for her unsettling subject matter; David Bailey and Richard Avedon for their sense of unimpeachable confidence; Don McCullin for his unflinching eye; Robert Frank for his spontaneity; Ernst Haas for his sense of experimentation; and Walker Evans for everything! All were and remain heroes to me. They informed my eye as cultural heroes just as Bob Dylan, Robert Hughes, John Berger and Ernest Hemingway fed my mind and, in so doing, informed my photography. They were and remain the building blocks for the way I see and create photographs, and perhaps most importantly what, who and where I choose to make my photographs.

I understand that the words 'hero' and 'icon' can often be misunderstood in this context. I do not use them as terms of deification. I am not placing them on pedestals, but I do recognize their importance culturally in both a personal and wider context. Of course, each generation should have its own heroes, but in so doing we should not forget those icons of the past that laid the path for the photographers of today.

We should also not forget that the work we now see in blockbuster museum exhibitions and weighty coffee table monographs was at one time the work that was shown in small gallery shows, magazines and sometimes not at all! Icons and heroes rarely appear fully formed. They earn their positions of respect through hard work and dedication. So, it would be reasonable to assume that we can learn not only from their work but also from their journeys. The rebels that kick over the statues often become the icons placed on the same pedestals in future years as the importance of their actions are recognized by subsequent generations inspired by their thoughts and actions. Even the most rebellious minds of their time can become the establishment of the future.

To deny photography's history and those who helped create it is to deny the importance of the work they created, both historically and aesthetically. It is also to deny the learning that is available from looking at and understanding that work. To return to the metaphor of studying music: would it be reasonable to expect someone to write a song or a series of songs without ever having listened to at least one? Therefore, would it not be reasonable to expect that the more you listened to different forms of song, the better your understanding would be of how to write one?

Why is it then that so many young photographers are unaware of the history of their medium? Some blame social media and the lack of accurate image accreditation for explaining the lack of awareness of photographers amongst today's digital natives (those born since the digital revolution). They may have a point. Images are too often seen today out of context of a photographer's wider body of work and therefore images are remembered, but who created them is not and neither is when, how and why that image was created. Others blame poor teaching of the history of photography where theory-based dogma too often kills the excitement that students should have in studying the past as having a relevance to their practice. Personally, I think that both reasons have an impact to a greater or lesser extent on the apparent apathy towards the importance of engaging with the icons of photography. However, I believe that there is a more relevant issue that is causing this situation and I think that it is something that those who teach photography need to address.

It is the importance of personality, the personality of the photographer. We need our photographic heroes and icons and we should not feel embarrassed to see them as we see heroes and icons from any other area of creative expression. We should be interested in their lives, their motivations and their personal histories and we should share this interest with the students we teach. We need to make them real to our students. We need to make

them as important as the images they create. We need to understand our heroes' strengths and their frailties, their motivations and their outcomes. We don't need to put them on pedestals and treat them as relics of the past to be revered. We need to make them relevant to today and to anyone starting their photographic studies.

In an age where young photographers are swamped by images, we need our photographic icons and heroes more than ever to provide context and inspiration. We need our students to connect with photography through the personalities that have given so much to the development of the medium and to feel as part of its history. A young musician will reach back to music from the past to inform what they create today. There is no reason why a young photographer should not do the same. Continuing this metaphor of music and musicians, it would be ridiculous to restrict students to acoustic instruments, wax cylinders and 4-track recording studios and deny the possibilities of electronic instruments, downloads and Garage Band. These are the instruments of today, and combined with the instruments and knowledge of the past allow creatives to create art appropriate to the times we live in.

Entering and engaging with the digital space

There is an argument to say that many of those reading this book are already engaged with the platforms I have mentioned and the understandings of photography that I have already discussed. I hope that if you are not that you are now considering taking the first steps to developing an engagement with the digital space but, either way, I am sure that it is now clear that it is impossible to teach to those already within a space that you have no knowledge or experience of.

I am not saying that such engagement is compulsory, but I have yet to hear a cohesive objective argument against some form of involvement with these platforms by any lecturer or teacher I have spoken with or read. On that basis, I would like to illustrate how such engagement could benefit the learning of photography based on my own experiences within the learning space as an educator and photographer.

As I have previously mentioned the majority of the cohort I teach are aged eighteen years of age and as is a recurring factor within creative education today the majority are female. My classes range from approximately twenty-five to forty students and all of the students I teach have to complete the same compulsory modules. The course I teach on is titled Editorial and

Advertising Photography and students leave the course with a BA (Hons) if they successfully complete all of their modules over a minimum three-year period. Students are encouraged to bring smartphones into class to record and document lectures and to tweet from class if they feel the need to. Some students work with traditional work books in lecture, but the choice remains with the student. In summary then the course is no different from many others that are currently being delivered. However, from the moment the students join the course they are encouraged to begin a reassessment of their understanding of photography and their relationship with the medium in relation to a potential career outcome.

Students are introduced to the importance of social media to their learning in the first few weeks of their course and at the end of their first year they are introduced to the concept of that interaction being marked as part of a compulsory module. This is not only a new way for them to see social media but also education embracing elements of their life that they had previously seen as separate from their formal learning journey. The focus of the course is to introduce students to the concept of photography as a means to document their passions outside their interest in photography and it is in the process of unlocking these passions that the use of a smartphone can be such a useful tool.

Those of us with long memories will remember that moment as a child when we were faced with a blank piece of paper and the decision as to what should be drawn. It can be an intimidating moment and one that can easily destroy a young child's creative confidence. The very young child makes marks and is happy with the process, unconcerned by the result. But as we grow, so do our concerns about how the finished product will be judged. This anxiety leads to either a rejection of image making or a reliance on perceived successful clichés. Neither of which are the basis for the creation of a defined personal visual language or personal and professional creative fulfilment.

To avoid this outcome, my suggestion to anyone starting out on a learning journey with photography is to reject all their preconceived ideas about the medium. I believe that it is important to start at the very beginning and see photography as nothing more than capturing light in a box. I encourage students to place no importance on the size, shape or cost of that box. With this understanding, I then stress the importance and power of that box if they identify what they want to use it for, but it is at this point that it is all too easy to return to the creative dilemma of the blank page. To avoid this dilemma requires an understanding of photography that is often seen as a

revelatory experience by many students. The answer is to see photography as a documentation of your life and your passions, a documentation that your light-capturing box is going to facilitate.

Just as the young child attempts to draw the subjects they are interested in, so the young photographer must identify the passions they have and wish to document. These passions should have no connection with photography and should not be defined by areas of practice such as portrait, still life, landscape, etc. They should, however, be personal and based in both life experience and a sense of inquiry. That's the theory, but the reality can be more difficult to implement. Finding your passion and identifying the stories you want to tell can be challenging for many young photographers, as too often they have dismissed the obvious for being 'too' obvious.

This idea that the answer should be complicated is at the heart of the confusion that can surround the decision concerning what and whom to photograph. When faced by a blank page as a child, my art teacher – no fan of figurative work – gave a sweet to the first child to make a mark on their page, whatever that mark may be. It was invigorating and freeing as a method to release the anxiety and tension that surrounds making that first creative move. I don't hand out sweets, but I do encourage students to make simple and obvious moves in identifying their passions. What hobbies do they have? What do their parents do? Where do they live? What do they read? And on and on until a picture starts to form, and a sense of realization comes over the student that it is okay to focus on elements of their life which, up until that point, they have not considered relevant to their photography or of interest to anyone except themselves.

This is rarely a ten-minute conversation. I have worked with students over many years helping them to discover the passions that they are able to document with insight and enthusiasm. Once they do, it is as if a great weight has been removed from their shoulders, the weight of a non-existent expectancy that has developed within them due to a misunderstanding of what the true purpose of photography is. The student is then able to create work that makes sense to them and explore where the work sits within a professional photographic context. Where they progress to is then based on a simple equation:

= passion + understanding images + context = area of specialization

It would be impossible to be a soccer photographer without an interest in soccer, a food photographer without an interest in food, or a fashion

photographer without an interest in fashion. Similarly, it is unrealistic to expect that a student will be able to find and tell stories with their images that they themselves do not have an insight or knowledge of. Only a skateboarder knows when that trick is right, and when to press the shutter. Only someone involved with cosplay knows the names of the characters and the accuracy of a created costume. These are just two examples of discussions I have personally had with students when helping them to define their personal passions. I could give many more, but I hope these give a flavour of how open these conversations need to be from the perspective of both parties. Everything is on the table in these discussions and nothing is dismissed. However, there are times when they can become emotional and too challenging for a student that has never had their interests (or lack of interests) questioned. It is at this point that several solutions can be suggested to help the student find a passion for a subject they have not perhaps previously considered.

Researching the work of photographers whose work they admire is always a good place to start and creating a scrapbook of images by these photographers can aid in identifying recurring themes of subject matter. Using a smartphone as a principal image-creating device also seems to break down the fear of photography and the pressure to find a 'style' that so many students have ingrained into them by the perceived need to 'fit' into the photographic industry. When the passion (or passions) has been identified, the documentation of that passion can begin and a passion for that documentation soon develops and evolves into a passion for photography. Without the first, the last is unachievable.

This idea of specialization often concerns arts educators who see university education as a period for experimentation and exploration without the confines and doctrines of potential career destination and requirements. My experience is that focusing on a student's passions achieves this goal whilst my role is to provide a professional context for the student's conclusions from their creativity. This comes to fruition through the implementation of an Instagram diary element integrated into a module I devised titled The Personal Portfolio. This module allows the student complete freedom in whatever area of photography they wish to explore and comes at the end of the student's first year with us. The requirement of the student is that they create at least one image per day with their smartphones for approximately thirty days based upon their everyday environment. The images themselves are not judged as to their perceived quality, the importance is in the process not the final result. However, the images should demonstrate a willingness

to engage with a spirit of experimentation and evidence an awareness of the basics of photographic seeing; this is the beginning of photo sketching and students are required to use the hashtag #photosketching with every image they post. I do not review the work through the module, but I will speak independently to any student not engaging with the process to explore any issues they may have with the module's requirements.

The student response to photo sketching has been universally positive as a search for the hashtag on Instagram will reveal as students have continued to work with the process years after the module has finished. Exploring the hashtag will also demonstrate the breadth of subject matter documented and level of personal approaches bought to the practice by the students. The students themselves have seen it as a key to understanding the medium of photography on their own terms with tools they have grown up with and use every day of their lives, and a pathway to discovering the passions they wish to document. From my perspective, it is a process by which they begin to learn a new language.

CHAPTER 4
#PHOTOSKETCHING

This book is titled *New Ways of Seeing* but it could just as easily be called new ways of recording, or new ways of sharing or perhaps new ways of storing images. This is because the new ways of seeing to which I am referring are directly related to these complementary practices connected to the creation of the photographic image. However, it is these functionalities that support a new way of seeing photographically and the practice of photo sketching. Many students will have had to complete workbooks or sketchbooks as part of their learning within the arts prior to attending university but too often these are seen only as tools to aiding marking rather than individual learning. They are treated as finished artefacts in themselves and not as part of a creative process of research and experimentation. I have too often been presented with a black paper book bound in ribbon filled with neatly written text transcribed from Wikipedia in silver pen that has achieved high marks and praise from teachers, but which has acted as no more than an exercise in completing a task rather than acting as a tool of enlightenment. I believe fervently in the workbook as an essential tool of discovery and creative problem solving and encourage students to keep them as a physical entity that reflects their internal questioning and creative conflicts. As such I expect them to be messy, energetic and filled with questions, answers and dead ends, all of which have as much value as each other at the time of creation as in the future and after a period of reflection has taken place. My belief in the practice of photo sketching is therefore as an addition to these traditional practices not as a replacement for them.

During a recent conversation with a young photographer and his parents, they asked me to give feedback on his work as he was being taught photography at school by an art teacher who had no photographic experience. This to them was an issue and so I happily agreed to view the work on his Flickr account. All of the images were technically proficient and included 'painting with light', post-produced landscapes/empty buildings and 'flash-lit' action skateboard images. The images were all

very good of their type but said little of the young man's life other than that he was excited about the process of creating 'good photographs'. However, there was one image that suggested something more. It was of a young boy performing a basic skateboard trick on an ordinary suburban street. It had not been post-produced in any way, the composition was well considered and the whole image was believable. The kind of image that in ten years' time would stand as an historical document of a time and place, a feeling of what it was like to be that boy, doing that thing in that place. I explained all of this to the boy and his parents and commended him on the image.

My comments were met with disbelief and some anger. They did not agree with me concerning the image; other images had much more technical skill, they suggested, and others took more time to create! I explained that their opinions were valid but subjective and as such difficult to defend when placing the work into the context of a professional photography environment where work will be judged from a multitude of different perspectives, where technical ability will rarely be the dominant factor. Objective analysis is where they should try and get to, I explained.

Within photography 2 + 2 rarely if ever equals 4 and therefore to progress as a photographer technical knowledge and ability cannot be replied upon to be the arbiters of creative success. They should be seen as tools to create the work you wish to create, not as the end product in itself. I encouraged him to be open-minded and to view photography as a process by which he could document his life and passions, informed by all areas of popular, social, political and historical culture. Use your phone to do this I suggested, have fun and fall in love with photography unencumbered by the need to create the 'perfect photograph'.

'That's just snaps!' I was told. 'That's not photography!'

Our conversation continued for nearly an hour. I gave him names of photographers he should check out, suggested exhibitions and galleries to visit. I did my best to open his and his parents' eyes to what photography is and can be. I'm not sure that I succeeded. I may have. In retrospect, I realize that despite asking for my opinion of the work, what they really wanted were their beliefs to be confirmed, not questioned. They wanted me to confirm that photography was a science and that they were getting the experiments right. That photography could be reduced to a series of right answers and rules you can put a tick next to. Both parents have careers in areas where this is the case and were struggling to understand how this could not be the case for their son and his prospective career.

This idea of 'snaps' and the importance of the process of creation of images as process lies at the heart of photo sketching. The first element of photographic seeing I suggest to students to consider is the most important and fundamental, that of the seeing and capturing of light and the four main qualities that concern photographers: brightness, direction, colour and contrast. In addition to these the photographer must master direct light, reflected light and filtered light as well as understanding the properties of natural and all forms of artificial light.

It is far easier to show images to explain the process of photo sketching than to try and describe it through the use of words. However, there are a number of basic premises that need to be addressed to fully utilize the practice as a form of learning and teaching the medium of photography as a visual language.

Light in digital form

A smartphone computes light through its sensor and pre-programmed firmware but the basics of light retain their four main functions for a photographer. These are to illuminate the subject, to symbolize volume and depth – aspects that create the atmosphere of the image – and to define the overall design of the photograph through areas of dark and light. Now this is not a 'how to' book, I would like to think of it more as being a 'why to' series of thoughts but it is important to recognize the importance of the traditional basics of photography whatever type of camera is being used to create photographic images. The experienced photographer understands light, recognizes how light works, its qualities and most importantly how to manipulate it their own creative ends.

It always amazes me how many of the students I speak with when they first begin studying photography at university have never considered light as an important aspect of photography or for that matter in how they see. It is an omnipresent factor in their lives and in that way no different to air, and therefore taken for granted in much the same way as our breathing is taken for granted. They have never questioned the art of seeing or for that matter seen it as an art. This is where the use of the smartphone comes into its own as both a teaching and learning tool.

There can be very few occasions when a photographer has not wished that their eye was in fact a camera to ensure they never missed capturing the image they have seen. The eye as camera has been with us

as an unachievable concept since the early days of photography. This is a reasonable desire as there are many similarities between the human eye and a camera, including a diaphragm to control the amount of light that passes through to the lens. This is the shutter in a camera, and the pupil, at the centre of the iris, in the human eye is in effect a lens to focus the light and create an image. Light rays enter the eye through the cornea, the clear front 'window' of the eye and the cornea's refractive power bends the light rays in such a way that they pass freely through the pupil, opening in the centre of the iris through which light enters the eye. In its simplest sense the iris works like a shutter in a camera. The lens is composed of transparent, flexible tissue and is located directly behind the iris and the pupil and is the second part of your eye, after the cornea, that helps to focus light and images on your retina.

A smartphone camera works just as a DSLR or in fact any digital camera would. The user focuses the lens, light enters the lens, the aperture determines the amount of light that reaches the sensor, the shutter determines how long the sensor is exposed to light, the sensor captures the image and finally the camera's firmware processes and records the image. The issues that smartphones have with this process is in the light entering the lens and with the shutter determining the light. This is because in a smartphone the lens, aperture and sensor are very small – and therefore less able to receive the light they need. This has traditionally resulted in smartphone cameras having difficulty in capturing accurate images in low light conditions. This situation is improving all of the time; however, particularly with the wider adoption of OIS – optical image stabilization – and with every new phone comes functionality developments addressing issues of image capture quality.

However, the process of photo sketching is about exactly these issues, discovering what makes 'good' light and 'bad' light and how both can be mastered and utilized within the creative process. I encourage students to experiment with light by deliberately taking images in lighting situations that are difficult and by breaking the 'rules' of how to work with light. These experiments are the most effective methods of demonstrating the power that light has in impacting on a photographic image. Many smartphone cameras have the option to adapt their exposure compensation tools to correctly work with a particular light situation and/or revert to manual adaption of the ISO and shutter speed, but it is by making mistakes that we learn, and I always encourage students to make mistakes before addressing the

issues that resulted in their images. I also encourage students to turn their flash option off on their smartphones when they begin photo sketching to encourage them to be aware of the environmental light that surrounds them before adding supplementary lighting sources.

There is no shortage of lighting tips and techniques to adapt and follow for the young photographer online but the idea of photo sketching is to learn through mistakes and experimentation, not to replicate a tried and trusted formula. Nearly all photographers at some stage of their career will follow a tried and tested path even if they are not aware that they are doing so. They find themselves taking this journey by unconsciously or consciously in the case of students imitating what other photographers are doing and in doing so find a feeling of security and a sense of direction. However, this is a path that can too easily lead to images that have no personal connection with the photographer creating them. Playing with light with a smartphone can lead to a personal understanding and interpretation of light that is loose and free in its creation, which in turn leads to a personal language being developed outside traditional photographic technique constraints.

Of course, this is possible with any form of camera but the physicality of using a smartphone camera immediately breaks the conventions of camera use as I have previously outlined and therefore the process of image capturing is completely different to that of a DSLR or analogue camera. The lack of perceived value attached to a smartphone image aids in the experimentation process as the student does not feel a pressure to create an image that will be judged as 'serious' photography. When it comes to exploring light you cannot take enough photographs or make enough mistakes so this idea of the 'throwaway' image is the perfect vehicle for a student to feel comfortable with the process and the concept of failure in learning.

The photographer whose work I most often use to introduce students to how light can be used within a photographic language is Australian Trent Parke. Parke works primarily as a street photographer but he moves seamlessly from high-grain black and white portraiture to rich, graphic colour street-based images, but it is in his use of extreme light and shadow that I find that his work connects most effectively with a student cohort. In an interview with the Israeli newspaper *Haaretz* photography blog *Hasifa* – Exposure – in 2013,[1] Parke outlined his intention with his work that explains his process of image making and echoes the central concept behind photo sketching:

The camera is just a black box. I never deliberately try to get too technical. It happens, but only as a result of a particular emotion that is forcing me to shoot in a particular way. Emotion and imagination are the keys. I take documentary photographs and turn them into something else. They are what they are, but when they come into my world, I place them in different contexts. Nothing is ever what it seems to be.

Parke primarily creates his images on film, but he doesn't dismiss digital technology as he explains in the same interview: 'I am not a film purist though. Digital is great for the right jobs. It just comes down to what suits your methods best.' This comment is of relevance to the adoption of the smartphone for photo sketching and echoes the feelings of all professional photographers that their choice of camera is based on the situation they find themselves in and the right tool to fulfil their creative expectations.

Looking for juxtapositions

Many students find the idea of juxtapositions to be the easiest aspect of photo sketching to master as it relates directly to many of the projects that have previously been set within their art education at school or college. Projects that have required them to look at textures, colours, shapes and forms are common amongst this level of art teaching, but is rarely used as part of an in-depth exploration into photographic seeing. An attention to detail is essential in the development of creating a visual language, photographic seeing is based upon the ability to see and identify images of aspects of an environment that many would dismiss as of being of no interest. In a sense, this could lead the photographer towards describing this work as still life, landscape or architectural photography but I prefer to use the word environmental to remove preconceived ideas as to what these descriptions imply aesthetically. The word environmental also opens up the student's immediate surroundings to photographic documentation and therefore removing concerns that they need to travel to find subject matter for them to explore. Again, this is where the smartphone is such a useful tool with which to encourage the idea of exploring a student's immediate environment. It is always with them, always to hand and perhaps most importantly perfect for experimenting with angles at which images can be created.

The photographer selects their point of view for any image they are creating, and it is the photographer's ability to observe that defines the success of the final photograph. The use of a screen on a camera changes this process of observation and aids in the ability to create abstract juxtapositions to focus on how details within an image can contrive to bring interest and meaning to a photograph. The idea of a photographer exploring such abstractions with the intention of creating an image that is pleasing to the creator, leaving the interpretation of the image to the viewer, can often be a key of understanding the broader world of contemporary art for many students who have been unable to understand abstracted and conceptually based art forms.

To this end I introduce students to the work of the artist Sean Scully, an Irish-born American-based painter and printmaker who uses photography as a documentary source for his architectural-based abstract paintings in oil. This connection of abstraction, painting and photography always resonates with students struggling with the idea of photography as a form of personal introspection. To further illustrate this, I show Scully's photography alongside his paintings to demonstrate how the abstraction of the built environment can then be further abstracted through the art of painting. Of course, what Scully is doing with his photography is photo sketching, although he is not using the term to describe his process. The idea that a photograph can be part of a process and that it does not have to be a finished artefact in of itself is something that I have discussed in previous chapters, but it is through the exploration of juxtapositions that this starts to become real for the student.

This sense of abstraction and juxtaposition is the foundation for much contemporary art and particularly of contemporary art photography but what do we mean by abstract photography? Abstract photography is sometimes referred to as non-objective, experimental, conceptual or concrete photography, and is a means of depicting a visual image that does not have an immediate association with the objective world. It may also be seen as an isolated fragment of a natural scene in order to remove or reinterpret its inherent context, it may also be purposely staged to create a seemingly unreal appearance from real objects, or it may involve the use of colour, light, shadow, texture, shape and/or form to convey a feeling, sensation or a message. As such it is a means to an end for many photographic artists, but I also see it as a first step in the creation of a visual language.

What is interesting in my experience is how many students see juxtapositions only in the term of opposites and contrasts. Of course,

these can be effective and should be explored but I also encourage the documentation of complimentary juxtapositions. It is easy to see contrasts but less easy to understand complementary elements, so this presents another area of learning for students who have yet to be challenged to question what they see and how they see within education. The process of photo sketching allows the young photographer to explore all forms of juxtaposition but the creation of the image is only the first step in the questioning and learning process. Reflection on those images is essential just as it is in all forms of arts education, but the speed and ease with which images can be created with a smartphone ensures that there is a multitude of images to ignite conversation and debate based upon the student's personal exploration of the medium. Through this conversation and looking comes gradual understanding of what is seen, how it is seen and the potential to develop both of these into a personal visual language.

Seeing in colour

There are few more contentious issues based on analogue photography thinking than the debate over colour and black and white photography. The acceptance of colour photography as being acceptable for more than just a family snapshot was hard fought, but it is a battle than has been won thanks to photographers such as Ernst Haas, William Eggleston, Saul Leiter and Stephen Shore amongst others. Colour photography now fills gallery walls as well as magazine pages and billboards and yet black and white photography is still seen by some as the only 'true' photography. There are echoes of the lack of willingness to accept the smartphone as a serious camera in the issues colour photography faces in being accepted as serious photography. Today we have a choice and it is one that needs to be made as all choices need to be informed with understanding and knowledge.

We take seeing in colour for granted but the colour we see in a photograph and in real life can be vastly different, so it is perhaps worth looking at how we see in colour. Colour is a psycho-physical phenomenon created by light and its effect in terms of colour sensation depends upon three main factors: the spectral composition of the incident of light; the molecular structure of the light reflecting or transmitting substance; and the colour receptors in the eye and the brain. Basically, colour is light and what we perceive as white light is a combination of many different wave lengths that can be separated from each other and made visible with the

aid of a prism or spectroscope. This is the basis of colour theory and it used to be a fundamental aspect of learning photography, though today it is not. We take for granted what we see and how we see it and leave the science of that to the scientists.

To be scientifically correct, we must attribute colour not to an object itself, but only to the light reflected from that object; however we rarely do this and instead we speak of the 'surface colour' of an object. In this case it is usually understood that an object's colours are described as they appear in white light, the standard of which is set by what we understand to be daylight. Otherwise colour cannot be described in definite terms as any change in colour of the light by which the colour of the object is described would be inaccurate as it will have been determined by the colour of the light. This understanding of artificial light having a colour is a basic understanding required to control resultant photographic images. The coldness of neon light and tungsten and the yellow hue of the standard lightbulb will have an obvious impact on the colouration of any photograph and therefore the understanding of the properties these light sources contain is essential for any photographer. The best way to learn is, as with all areas of photographic education, to experiment and take pictures in all light environments, taking note of the type of light dominant when an image is created.

To describe a specific colour, three different qualities must be considered and the universally recognized terms for these are hue, saturation and brightness, and it is in the adaption of these three elements that the digital image has taken photography into a new era for the viewer. As such, it is worth spending some time looking at these in more detail. Hue is the scientific term for colour that has now become a word commonly used within digital cameras and photography. Red, yellow, green and blue are the major hues with orange, blue-green and violet being seen as secondary hues. But what does 'hue' mean? Well, it is the factor that makes it possible to describe colour in terms of wavelengths of light and as such the human eye can distinguish approximately 200 different hues.

Saturation is the measure of the purity of the colour and indicates the amount of hue a colour contains. The more highly saturated a colour is, the stronger and more vivid it appears, conversely the lower the colour saturation the closer a 'colour' approaches neutral grey. Brightness is the measure of the lightness or darkness of a colour and it corresponds to the grey scale with black and white photography where light colours rate as high and dark colours as low.

These are the correct definitions of these terms as I understand them and their relationship to the photographic image making and seeing. But with these controls now available to manipulate with ease on digital cameras and smartphones, as well as in easy-to-access post-production software, the temptation to create images that have little or no relation to real life can be a hard one to resist. It would be naive and foolish to ignore the importance of post-production techniques to many photographers as a crucial tool in creating their final images in the digital age. It would also be naive to not accept the seductive nature of post-production; when it gets you in its grips it can be very hard to escape from or deny the possibilities it offers you. Photoshop can appear like a dealer with a well-stocked pharmaceutical cabinet.

I am not naive! I have been involved with professional photography long enough to see far too many badly cross-processed images from the analogue days and hyper-colour HDR panoramic images from the early days of digital, alongside all manner of over-produced images. In short, when it comes to looking at 'over done' post-production I am no virgin. Even so it still amazes me how often images are completely destroyed by an over enthusiastic adoption of every tool a Photoshop plug-in and palette can offer.

I recently saw a conversation on Facebook focused on the fact that many 'photographers' are now using post-production as an area in which to 'focus' their images. This seems to me to sit comfortably with my belief that some (perhaps too many) photographers are seeing the initial digital capture as nothing more than that. A process of capturing digital information which they will then manipulate to create the image they wish the image to be, with no reference to the person that they met and photographed.

I may be considered by some as being 'old-fashioned' in believing that it is important to get things right 'in camera' in the moment, but that to me seems to be the true essence of photography. I have no issue with post-production as a process, but I do when that process leads, dictates and dominates the process of photography. This seems to be a mistake that too many portrait photographers are making. It is an even bigger mistake to base a career on that post-production technique to create a 'style' upon which clients may commission you. I have been involved with photography long enough to see 'styles' come and 'styles' go. Approaches to photography also change, as the years pass but the desire to honestly document is intrinsic to the true photographer's practice and it is that desire that never dates.

I have previously spoken about the unreality of the digital image due to its back-lit nature, but it is in the manipulation of hue, saturation and brightness that the digital image can too easily be transformed into a hyper-real representation of the scene captured. This sense of the hyper-real has rapidly become what is perceived as the normal amongst digitally created and viewed images in which strong colours and over-emphasized contrast are used to create more dramatic and impressive images. This understanding of what constitutes a successful image fails to understand the role of photography as a documenter of what is rather than what could be. In essence, this is a desire to control the aspects of space and depth without an understanding of how these can and should be used with a sense of understanding and balance.

Photo sketching and photographic seeing

The photographer Henri Cartier-Bresson spoke of the Decisive Moment in relation to the moment of photographic capture, but the most decisive step could be seen as the moment when the decision to press the shutter and the decisive decision could be seen as the moment when the subject matter for the image is decided upon. These three stages of photographic capture are the basis in learning how to see photographically but it is the first stage of decision making that many students find the most difficult to engage with. To see photographically requires the photographer to not only focus on situations they find interesting and therefore wish to document but also to isolate a situation as a photograph. The picture exists in conceptual form in the photographer's mind before it is made but it is not until the shutter is pressed that the concept becomes a photograph. We can take this idea of the conceptual photographer back one further stage and consider the idea of wanting to create a chosen type of image as a conceptual idea until the photographer actually moves to engage with their subject through the medium. The process of making the concept real can be supported by the practice of photo sketching, learning to observe and capture photographically.

The photographer in tune with their practice is able to constantly see photographically, observing, concentrating and anticipating what could be a 'photograph' and the best way of developing this photographic state is to take a large number of images. The point of this is not to create lots of photographs with the hope that one might be okay. The creation of many

images should not be done indiscriminately. Each shot should be considered with consideration but with the spirit of experimentation, as part of a process not of making or taking an image but of finding an image. It is a process that professional photographers working on commission adopt as they cannot leave a location without having the image they need and have been assigned to capture. It therefore makes complete sense for any student to adopt as part of their learning. The use of the smartphone as part of this process means that the young photographer always has a camera at their disposal to aid their observational skills.

The idea that a successful image can be captured by a young photographer touching a shutter button just the once is both naive and illogical. Many see a subject, location or object that appeals to them, grab a picture and move on with little consideration for the technical or aesthetic considerations of photography. This is rarely due to a lack of time or opportunity but more often due to a lack of confidence. This lack of confidence hampers the photographer's ability to physically engage with their subject and in turn explore the subject with a photographic eye. The addition of a camera which they have to place to their face as a physical barrier between them and their subject adds to this sense of disconnection from the environment. The smartphone is their constant companion and one they use with little thought as to how and why they are engaging with its functionality. It therefore fulfils the role of a camera that many experienced photographers attribute to their relationship with their regularly used cameras, that of an extension of their arm/hand. The smartphone is this for the digital age.

There is an argument to say that all aspects of photography can be learnt but even when they have been learnt, the process of becoming a photographer is a lifelong journey. It is an argument I would agree with but perhaps the most difficult, intriguing and mysterious aspect to learn is that of composition. In essence composition should be seen as the process of bringing elements together and dismissing others. These elements are not purely the seen elements but also aesthetic and technical decisions such as focus, perspective, subject, position, proportions and colour. As such composition cannot be left to the moment of image capture, it needs to be considered prior to the shutter being pressed.

I often ask photographers studying the medium at school what they think being a professional photographer means and the answer is most commonly this: 'You get paid to take the pictures you want, to express your creativity.' Of course, this is an idealized expectation, but the creation of an image does

fulfil at least the second part of this belief. There are rules of composition and my teaching has always been that it is important to know that there are rules –the rule of two-thirds and the golden triangle for example – but that they can too often 'constrict' creativity if they are too strictly observed and followed. There is a saying that the most important part of any camera is the twelve inches behind it – your head and therefore your mind – and it is the honesty that the photographer brings to the image that dictates the success of the resultant image. The photographer Edward Weston said that 'good composition is only the strongest way of seeing the subject'[2] and the simplicity of this statement gets to the core of how to explore a personal approach to successful composition.

Photographic seeing is based on the premise of bringing order out of chaos wherein everything acts upon, against and interferes with everything else. Where form, colour and shape blend and overlap to compete against each other. Composition is the graphic reordering of these elements and it is an art born of experimentation and repetition. When looking at students' work the most common piece of advice I find myself giving is the need for clarification. By this I mean simplification of the image and the clarification of intention in creating the image that leads to the simplification and resultant clearly defined message or story that emanates from the image. It is interesting to consider that the DSLR camera seems to lead young photographers into initially creating a landscape image, as this is a way of holding a camera that comes most naturally to many, whereas the smartphone leads the same person to first create an image in portrait format. Once again, an example not only of a change in the way of seeing but also in how the camera takes the lead in these developments.

The artist David Hockney recalled a conversation he had with Henri Cartier-Bresson to the art critic and author Martin Gayford.[3] Hockney said:

> We first met at my drawing show in Paris in 1975. He immediately wanted to talk about drawing, as he did whenever we met after that, and I always wanted to talk about photography. He said to me that what made the photographs good was geometry. I said to him, "Yes, well, it's a matter of being able to translate three dimensions into two dimensions, which means making a pattern, how you arrange it. It's also a question of looking at the edges". The edges counted particularly for Cartier-Bresson because he deliberately didn't crop anything. He made sure that the photograph worked as he took it.

115

I like Hockney and I like what he says, it makes sense to me, but I only recently realized just how relevant his comments are to me personally and my photography. That may seem a strange admission for someone who trained in graphic design and who has worked with photography for as long as I have but let me explain. For years I have created images on gut instinct; some worked, some less so, but when it came to portraiture my hit rate was okay but never as good as I wanted it to be. The hits won awards and kept clients happy, but I struggled to build a consistency of vision in my work that I was happy with. I don't think this is unusual amongst photographers (in fact I know it is not) so I hope that what I intend to discuss here is of use to those of you like me. I have written before about finding, not making or creating a photograph, and it is my renewed awareness of the importance of geometry in the creation of that image that has allowed me to take control of the portraits I create.

In many basic drawing classes, students learn that there are three basic elements of a composition: the frame, the positive and the negative space. The positive space is easiest to understand. Generally, it is the space occupied by your subject. Conversely, negative space is the space that is not your subject. The negative space is defined by the edges of the positive space and the frame or border (the third element). So, part of the negative space is contained by the frame and another part is contained by the positive space. Sometimes the negative space is completely contained by the positive space. What is important to understand about this is that the negative space also defines the subject. As I have said this is basic teaching on an art course, but I wonder how often it is taught to photographers of any age? I was aware of it as a designer, but it has taken me some time to apply that awareness to my photography.

Here's a simple exercise you might want to try. Take a sheet of tracing paper and a black marker pen. Lay the paper over a print of one of your images and see if you can identify the positive and negative space by drawing over the images the lines that define the different areas of the image (in effect what you are creating here is the subliminal structure of the image but maybe I'll talk about that another time). Take the paper away from the print and what you should have is an abstract image of juxtaposing shapes. This should give you an insight into the geometry (the properties and relations of points, lines, surfaces) of the image and the strength of that geometry in the construction of the imagery.

It was by deconstructing my own images in this way that I started to understand them better and with that understanding I was not only able

to bring the longed-for consistency to my work I had strived for but also to understand other photographers' work from a new compositional perspective. A 'win, win' situation. I never want to stop questioning my work and learning from others so in that respect my work is a work in progress, with no definite answers but with some ideas and questions. As David Hockney said in the same conversation with Martin Gayford I previously mentioned: 'I question photography. A lot of people don't accept that the world looks like a photograph. I think it does, but it doesn't entirely, I think it's actually a lot more exciting than that.' I couldn't agree more.

The idea of photographic seeing carries with it a sense of responsibility, a responsibility to document with accuracy and truth. The act of composing an image can often play with these elements and distort the reality of a situation. By editing out people or important aspects of a scene, the truth can be altered in camera. There is much conversation today concerning the ease by which digital images can be altered through post-production software, but it is important to realize that manipulation of an image can also occur at the point of capture. The idea of photo sketching as a process of image capture can allow a photographer to quickly create a series of images that reveals a fuller version of a situation than one image can do. Of course, the final edit and choice remains with the photographer when they decide which images to share, but a process of multiple documentation may lead the photographer to share the images as a narrative series which may tell a visual story with more accuracy. When working as a professional photographer this requirement for honesty and truth can present additional issues when working on commission.

I was recently commissioned by a magazine to create a portrait of a well-established television personality, well known for his erudite banter, quick-witted ripostes and sartorial elegance. Those are the attributes that we as viewers would associate with him but as we are aware many television personalities – particularly experienced, established ones – choose to develop an 'onscreen' persona separate from their 'off-screen' one, whilst others are who they are whatever the environment. I have to be ready to be met by both types of situation and respond creatively and positively to the people I meet to photograph. I have no issue with this and in fact it is an aspect of my work that I find the most challenging and rewarding. My intention on every shoot is to try and capture a sense of the 'real', an insight into who a person is, not just what they look like. I try to 'find' that image. Prior to the day of the shoot, I undertook my usual online research of the person's career and personal life. I like to arrive at a shoot informed and armed with information

that will either ignite, promote or sustain conversation and demonstrate the fact that I am interested in them as a person, not just an object to capture in front of my lens for money.

On this occasion, I completed my usual research and discovered a tragic event that had recently occurred in the person's personal life that I was not previously aware of. Armed with this information I arrived at his house on the day of the shoot to be met by a slightly nervous and melancholic version of the personality I had seen on television. This sense of sadness and melancholy extended to the house and as we drank tea in his kitchen the conversation was also tinged with regret concerning the past. Casually dressed when we met, he said that he would go upstairs to change and smarten up. We would use the lounge for the portrait, he said; the location had been decided for me, which is never the perfect situation.

After a short time, he returned smartly dressed. I preferred the casual outfit he had been previously wearing but no problem. We went into the lounge and thankfully there was some beautiful soft light coming through some large windows and French doors, but the rest of the room felt cold, unloved and impersonal. Melancholy filled the room and it was at this point that I knew that I had to capture that sense of melancholy in the portrait. I had to illustrate the essence of the person and his environment without manipulating either him or the image to achieve a final goal, whilst retaining his sense of pride and dignity.

I started to work with my camera, searching for the image, talking all of the time as our conversation continued going off at unexpected tangents as we discovered more about each other. At one point, he asked when we would start the photographs, he thought I was just 'practising', based upon previous experiences when he had been stage managed. I assured him that we had already started and that all was going well.

The moment I realized that I had 'found' the picture I told him that I was finished. He was surprised that it had been so quick and described the whole process as being therapeutic. He felt our conversation had been helpful. I said my goodbyes and left wishing him well. On editing the images in my studio, I noticed that his mouth had never changed, it was the same in every frame from every angle; fixed, determined. His eyes were consistently sad but also fixed and determined. His melancholy evident but not dominant. I chose the image to send to the client. The image was a surprise to the client, but they understood why the chosen photograph was as it was. I could of course have tried to change his mood on the day, told him jokes, made him laugh, used a backdrop or utilized any number of tricks to create a 'happy'

portrait but that is not why I am a photographer. I do not want to create a falsity, I want to find and document the reality. I had used the idea of photo sketching to create the portrait and through the process I had found an image that was both honest and true.

Self-criticism and personal analysis are vital elements in learning to be a photographer and remaining a photographer. They allow the photographer to work with a perspective, to draw conclusions and to ask the right questions of themselves and others. The basis of all of this is personal honesty and the ability to accept the honest feedback of others. The basis of this is enthusiasm for the medium, a desire to question and to share the answers to those questions in visual form. In that sense, the photographer is in perfect alignment with any artist working in any other medium but as with all areas of creativity a lack of self-confidence is becoming an increasing issue to developing both creativity and practice. The way to overcome this anxiety is through continued creation, a process that maintains a sense of progress and engagement that in turn aids in building both personal and creative confidence. Formative feedback from others can then be viewed as part of this process of learning rather than as a critical assault on a very few images that have taken on an unrealistic importance due to their scarcity. The idea of shooting and sharing as part of a process rather than as an end in itself is the basis of photo sketching and its subsequent importance in the creation of a visual language. The young photographer must develop their own way of seeing photographically in harmony with their own personality and personal life experiences. They must develop their own interests and passions, forming opinions on photography based on their own experimentation with the medium. This is not just based on strengths and successes, but more importantly on embracing weaknesses and limitations. The willingness to fail is essential as part of the process of learning, therefore in the early stages of photo sketching I recommend not only that students think little about the images they create but also that they spend little time in analysing them. It is only after a large number of images have been created that analysis of those images should take place.

When that analysis takes place, it must be both informed and aware of the photographic medium outside the world of online images and images captured in the very recent past. A knowledge of the history of the photographic medium is essential in providing the context to understanding an image and is not something that should be dismissed as irrelevant within the digital space. I am currently in the process of researching and speaking with photographers whose period of mass recognition for their work was the

1960, 1970s and 1980s for a film project I am working on. The work of these photographers once filled photo magazines and galleries across the world. They were asked to speak at conferences and many of them taught some of the most forward-thinking, recognized and regarded photography courses in the UK and USA. Now in their seventies and eighties, that same work resides under beds, deserted darkrooms and within dusty cupboards unseen and forgotten. Meanwhile, the photographers themselves continue to work on projects and pursue the medium with all of the passion and determination that they once did, even though they believe that they have been largely forgotten. Their emails to publications go unanswered. Their attempts to be exhibited often flounder as they hope for deserved retrospectives and recognition. Through my research I have discovered photographers I had no knowledge of and work that I was unaware of. I have had discussions which have made me rethink my understanding of photography and its history. And by listening to these wise, experienced souls, I have been able to understand and challenge my own practice.

I am passionate about history, not only the history of photography, but all history (social, political, economic) and all of these come together in the work featured in the photographic magazines of the past. Not only those often-cited professional titles but also in the enthusiast and amateur market, who were just as likely to interview or feature a 'named' photographer from the period as titles such as *Creative Camera, Camera, Blind Spot* or *Aperture*. It is in reading past issues of these magazines and others that we can rediscover the work of photographers still available to us to make contact and engage with.

Why is this important? Because the history of the medium is essential to our understanding of its present and future, and by reaching out to these photographers we can experience living history outside that written in books. The stories they have to tell are rich in detail and provide insight into realities that are too often handled with a broad brush stroke of historical summary. As any journalist knows, if you want the facts, go to the source!

A photographic life can often be cyclical with times when even the most recognized photographer's work is no longer in fashion or demand. I well remember working with William Klein and Jean Loup Sieff in the mid-1990s when neither of them was receiving commissions. Of course, this period was short-lived for both, but it is a fact that tastes in photography do go in and out of fashion. Certainly, much of the work I have seen recently during my research is solidly rooted in the documentary and contemporary art aesthetic of the late 1960s and 1970s. Prints with deep, rich blacks and

no fear of using grain to emphasize atmosphere and mood. These images are historical documents, not only of time and place but also of photography, where the medium was, its possibilities and limitations, and its potential power when placed in the hands of those who mastered its eccentricities.

However, it is rarely seen in exhibitions today. Too recent to be seen as truly historical and too distant to be seen as contemporary, this work – and the photographers who made it – seems to have been placed into a photographic limbo by the tastemakers and gatekeepers of today. Thankfully, I think this situation may be changing. I have previously written about the publisher Café Royal Books, based in the UK and run by Craig Aitkinson, concerning his independent approach to publishing books of photography. The imprint's personality is based upon a desire to create a multiple publication documentation of British life, and in so doing Craig has been responsible for important bodies of work by photographers such as Homer Sykes, John Claridge, Daniel Meadows, Patrick Ward and Paddy Summerfield, amongst many others. This work and these photographers fill the pages of the photographic magazines of the 1970s alongside the more obvious names. Their work was important then just as it is important now.

I have spoken to all of these photographers over the past few months, about their work and about photography then and now. Those conversations have been entertaining, informative and enriching and they all began by me emailing them out of the blue and just saying hello. It's something I recommend. However many books I look at, articles I read, talks I attend and exhibitions I visit, there is nothing better than sitting down with a cup of coffee and a photographer whom I admire and letting time drift as we talk. Those conversations are based on a shared passion for the medium and a lifetime of creativity and experience, which makes them invaluable and something to treasure.

The sad fact is that if I did not have these conversations now, there is a time in the not-too-distant future when it will not be possible to do so. Many of the photographers I have spoken with recently are in their sixties, seventies and eighties and, despite not losing their passion for the medium of photography, they are (as we all are) getting older. Their memories do not exist in books and their stories need to be remembered to be passed on to future generations. I believe that it is our responsibility to do so. Every town and city has photographers and work of the recent past waiting for you to rediscover. They have stories to tell and work to show you, so why not go out and find them, listen to them, talk with them, collaborate with them and – most important of all – learn from them.

An understanding of the history of the medium is essential to developing a visual language just as it is essential that anyone looking to progress their image making needs to immerse themselves in the image-rich digital space. This includes all of the online platforms so reliant on images uploaded and shared by both amateur and professional photographers. We expect musicians to develop their understanding of the medium by listening to music, writers by reading, filmmakers by watching films and artists by looking at work, so why do so many photographers feel that they do not need to look at photography to inform their own practice? It's a question I am not yet fully able to answer despite continual questioning of the students who seem to see little need for informed awareness of those practising the medium they profess to love. My belief is that the process of photosketching helps young photographers to see photography more as a process of seeing rather than as a series of individual unrelated single images. In so doing it causes them to see a reason for finding both historical and contemporary context and relevance for their own photographic experimentations and removes the creative anxiety associated with the pressure of 'getting it right' every time they press the shutter button.

CHAPTER 5
BUILDING THE NARRATIVE

All art has a narrative and poetic or aesthetic aspect and photography is no different from any other creative endeavour in its need for a sense of developed storytelling. However, whereas camera manufacturers continually promise to deliver the ultimate and easy 'professional' photograph, none of them attempt or promise to provide a professional narrative of images, and it is the creation of a visual narrative that divides the amateur from the professional photographer. When asked how I define the role of a professional photographer I always use just two identifying factors, both of which are developed through the process of intense photographic seeing. The first is the ability to create visual narratives and the second is the consistency in doing so. I have no issue with accepting the fact that anyone can create a photograph that from an aesthetic and technical perspective they believe to be 'professional'. What the term 'professional' actually means is of course open to multiple interpretations but if we accept that the creator is happy with the image and, in their eyes, it contains professional attributes, I do not believe that we will be far from reaching a generally understood use of the word in this context. However, to be able to create such an image on the demand of a client repeatedly and to be able to evolve narratives either on commission or as part of a broader artistic journey, requires a level of understanding and commitment that few amateurs are willing to explore and devote themselves to.

I often explain the role of the photographer to students as being that of a visual problem solver and storyteller – an explanation that is often met with confused looks, as many young photographers see the medium as little more than a process of the creation of an image. Any context that process may then have outside an artefact to receive a grade/mark or qualification has yet to be considered and it is therefore essential that the understanding of potential image context is addressed at the beginning of any photographic education. I will discuss context at a later point within this chapter because I would first like to address the issues that surround even a basic grasp of what a visual narrative is and how to begin creating one.

You can't tell stories if you don't have a story to tell

Narrative can be chosen, and it can be thrust upon us, it can be long form and it can be over within a few minutes. Just as a novel can unfold over hundreds of pages, as a short story can exist over just a few and how a poem or song lyric can condense a narrative into a series of well-chosen words and phrases. The form is fluid, as is the method of delivery, but the constant is the need to communicate. This need to communicate is central to the adoption of all of the social media platforms within the digital space; however, none of them lend themselves easily to the creation of a narrative. This in turn has led to a vast consumption of images without context or with a deliberate or non-deliberate distortion of context, a fact that is perhaps best illustrated by the Pinterest platform. This is a platform that many students see as a relevant and useful research tool due to its wealth of imagery. But of course, they are images placed within a false context, untrue to their original context of creation and usage. To demonstrate this let's imagine someone who is interested in fashion who has created a Pinterest account based on that passion. Let's say that they choose to create a series of pages devoted to white shirts and they will do this by Google searching the term 'white shirt' under the images tab. They click and drag images that fulfil their 'white shirt' criteria onto their desktops and subsequently upload them to the Pinterest platform. In so doing they create their own new narrative and place the found images into a new context, but they are also discarding the history attached to each image in favour of a narrative based purely on image collaging. In a sense, this is similar to writing a song constructed purely of lines from other people's songs.

The creation of exhibitions, books and bodies of work through appropriation of images is an accepted form of creative curatorial practice but the artists engaged in this work are incorporating in-depth research and image analysis into their practice to provide both context and narrative to the resultant works. This work is a result of both the ease of accessing imagery through the digital space and old-fashioned curatorial work within historical archives and as such benefits from both the recognition of photography as an accepted and important art form and the research potential of digital tools. This is not the case with the work that appears on platforms such as Pinterest. I have no issue with this, even though the stripping of an image's context does have a negative impact on the young photographer's understanding and engagement with the medium.

This negative impact is most clearly seen in the lack of knowledge of photographers. When images are sourced from a Google word search the relevance of the image to the search becomes more important to the student than who created that image and why. The name of the photographer becomes an irrelevance and the narrative context in which it was created has been destroyed. In turn, the ability to understand how to create a narrative based on a personal unique vision becomes impaired. How can an extended narrative based upon a series of images be created if the photographer sees only the single image form? Of course, this is not possible, and it is this deficiency combined with a lack of knowledge of other photographers working successfully in the medium that leads to the young photographer's loss of confidence in defining their own creative journey as a visual storyteller.

The majority of photographers who have been accepted into the Magnum photographic agency utilize the power of narrative in all of their work, as is seen in the iconic images of New York created by Bruce Davidson from the late 1960s to the present day. Davidson felt the broad, urgent political climate of those decades cried out for documentation and its impact on his immediate environment provided the stories he needed to show the plight of impoverished inner-city residents within the context of this global turmoil. Davidson explained how he found these stories on the Magnum website:[1]

In 1966, I began to document the neighbourhood in Spanish Harlem known as 'El Barrio'. At first, I met with the local citizens' committee, Metro North, to obtain their permission to produce a document that would serve as a calling card to be presented to local politicians, prospective business investors and the mayor. The community workers took me around to meet and observe people living in abysmal housing. I witnessed people working together to improve lives and create a place of peace, power and pride. At that point in American history, we were sending rockets to the moon and waging a futile war in Vietnam. I felt the need to explore the space of our inner cities and document both the problems and the potential there. I photographed the people of East 100th Street and their environment in an open 'eye to eye' relationship, using a large bellows camera with its dark focusing cloth. I carried a heavy tripod and a powerful strobe light along with a portfolio of pictures taken in the community. As I stood before the subjects, the physical presence of the classic camera lent a certain respect to the act of photography, placing me in the picture itself.

This decision to document the known and the immediate environment can be traced back to the earliest days of the medium and is at the core of the photographer's desire to tell stories that impact upon them on a personal and local level. Davidson is not alone in using these local stories as a mirror to larger issues of a national and/or international importance. Photographers such as Jim Mortram in the UK document the lives of those living within his immediate vicinity dealing with the impact of governmental austerity. The work titled *Small Town Inertia* has gained national recognition and respect for the integrity Mortram brings to his long-form storytelling. I'm sure that you will be able to provide your own examples of photographers working in this way in addition to the two I have mentioned. It is an often-heard maxim that you do not have to travel further than the end of your road to find stories to tell and narratives to explore however; their narratives can also come from stories others have told.

Another Magnum photographer, Patrick Zachmann, was inspired to document the Italian city of Naples by a small news story that had at the time received little international news coverage. The resultant immersive documentation of the Naples mafia and police bought the stories he uncovered to a much larger audience as he explained again on the Magnum website:[2]

> The first real story I did was on the Naples mafia. I was reading the newspaper in France at that time, which said that there was a gang war between two main families in Naples, with 400 dead in a year. At that time, it was the Lebanon war and all the reporters were going there. I didn't want to follow the same route, but I did want to confront the violence I had read about. I was young and as a photojournalist I wanted to experiment and push my limits.

The young Belgian photographer Bieke Depoorter has stated that she struggled to find her niche within photography, initially experimenting with street photography, which she never felt truly comfortable with: 'I was always trying to be a street photographer, but I felt like I was stealing people's pictures, in a way.'[3] It was in 2009 when she decided to travel through Russia, photographing people in whose homes she had spent a single night, creating a project titled 'Ou Menya' – which in Russian can mean 'with me', 'at my place', 'it's mine', or 'Come and sleep at my place' – that she found her personal visual language and stories that she wanted to tell. The work was recognized internationally through winning several

awards, including the Magnum Expression Award, which in turn led to the project being published in book form in 2011.[4] Speaking at the Magnum Photos Now event, Depoorter said:

I wanted to travel on the trans-Siberian train and stop in small villages and photograph there. I didn't have money for hotels and in the places that I wanted to visit there were often no hotels, so I asked the first girl that I met in Moscow who spoke English to write me a letter that said, 'I'm looking for a place to sleep' so that I could find a place at night. The first night, I ended up in small village and it was getting dark, so I showed the letter to people to find a place and some people took me in. It was an eye-opener because I took pictures and finally, I felt comfortable with photography … When I was staying the night people really opened up for a few hours and I could take pictures of very intimate moments. I thought that maybe I should do it every night and focus on the intimacy of families and see what happens during my trips.

The work that these photographers are discussing is personal work, images that are self-initiated, narratives that are self-discovered and funded, work that prior to the digital revolution within photography was expensive to complete and very difficult to promote and share. It was therefore confined to those photographers willing to make the sacrifices needed to see such projects through to completion. That is no longer the case and as I have outlined through the previous chapter the fact that the smartphone is now our constant companion and that it allows us to create photographic images without any additional cost, allows anyone and everyone to document their lives and tell stories that they can publish within minutes of having created them. Many photographers feel that this is not a good thing, that a period of contemplation and consideration should be bought to any images before they are shown to others and I agree, but only to a point.

The London-based photographer Brian David Stevens began a self-initiated body of work in early 2017 documenting the tragedy of the Grenfell Tower tower block fire. Each day he would visit the scene of the tragedy and create images that he felt reflected the emotional power of the resultant structure. As he created these images, he shared them through various social media platforms and his own website. The response to the images was universally positive both within and without the photographic community, which both encouraged Stevens to continue with the work and created

possibilities for the work to be exhibited. This visual openness with a body of work requires a level of confidence and belief in the work's qualities which in Stevens's case had been developed over a number of previous personal projects.

The photographer Niall McDiarmid demonstrated a similar openness with sharing a visual narrative as it developed. McDiarmid is a portrait photographer who discovered the narrative that has dominated his visual output for the last decade by chance as he explained to Phil Coombes for BBC News in 2012:[5]

> I had the simple idea of going for a walk in the streets near where I live in south London to see what interesting characters I could meet – see who I crossed paths with. I was pleased with the images I was getting so I decided to expand the series to cover the whole of London. I took to the streets in my spare time, going to different areas and stopping off at places I hadn't visited for years, meeting engaging people and taking their portraits. Within a couple of months, I had branched out to cover towns across South East England and then, in the summer 2011, I had the crazy idea that I could go to every major town in the UK. Since then I have visited more than 75 towns, covered thousands of miles and photographed more than 500 people. Although many of those who agree to be photographed tell me a bit about their lives, I really just want this to be a visual project – a record of that person on that street at that time.

McDiarmid has now published two books of the work and staged a number of exhibitions, but none of these appeared until he had spent a number of years sharing the images online and building a following for the work within the digital space.

This idea of utilizing and manipulating the digital space to help form and support the development of a long-form narrative is at the heart of these photographers' success in developing audiences for their work and in turn getting their work seen. They are storytellers who want their stories to be experienced and shared and therefore are adopting the appropriate tools to do this in the twenty-first century.

Nothing I am saying should come as a revelation to any photographer fully engaged with the changing landscape of lens-based media practice. The digitally engaged photographer will already be exploiting the creative possibilities new technology affords them. They will be actively exploring

both the still and moving image, they will be promoting and sharing their work across multiple online platforms and creating bodies of work previously beyond their economic capabilities free from the incurred analogue costs of processing and printing. However, I question how many are analysing those practices and placing them within a broader understanding of artistic practice to bring a depth and rigour to the work they are creating and in turn avoid the real threat of professional photographic practice becoming a self-reverential, internalized tsunami of repetitive imagery. Many photographers have eagerly embraced the concept of marketing through Instagram, promoting work completed using more traditionally accepted professional cameras, but to do this is to misunderstand the creative possibilities that the smartphone and Instagram offer. Those that have adopted these possibilities have been at the vanguard of creating a new photographic language, although it is one which heavily references the work of past photographers. Just as the multitude of filters promise aesthetic outcomes from the history of photographic presentation, so the images themselves are echoing work created under very different technological parameters. Photographers are also manipulating Instagram and using it as a narrative tool thanks to its slider functionality and viewer grids that allow images to be seen as a form of digital contact sheet.

The square format of Instagram lends itself to a form of compositional abstraction at the touch of a button as new ways of seeing are instantly suggested by its algorithmic functionality. The experienced photographer will instantly recognize this as being akin to the square format created by both analogue Hasselblad and Twin Lens Reflex cameras, a format that was swiftly superseded by the emergence of DSLRs. This abstraction has led to an interesting intentional or non-intentional adoption of an abstract expressionist approach to photographic image making pioneered by photographers such as Aaron Siskind (1903–91), in which the process of creation is more important than the end result. This is the essence of photo sketching as I have previously discussed.

Images heavily influenced by Siskind's deceptively simple black and white work documenting observed graphic marks and tarmac juxtapositions, created from the 1950s until his death in 1991, are to be seen all over the Instagram platform. As are images echoing the pioneering abstract expressionist colour work of photographer of Saul Leiter (1923–2013). Leiter adopted a similar approach to his image making to Siskind, walking, observing and capturing his images with a similar fascination with the process of image making within self-imposed

aesthetic and geographical parameters. An interesting aspect of both of these photographers' work is their relationship with painting as both an influence and secondary form of creative expression. However, despite the proliferation of images on Instagram referencing their work, I do not believe that the majority of these images have been or are being created with knowledge of these photographers' work or their processes; it is the smartphone as a tool for image capture that is leading the process and form of documentation.

The photographer Ernst Haas was an early pioneer in the experimental use of colour film that bridged the divide between commissioned photojournalism and more experimental self-expressive work. Hass is a photographer rarely discussed or cited as an influence these days, and yet he was the first photographer to be the sole subject of an exhibition of colour photography at New York's Museum of Modern Art in 1962. A reassessment of his large body of work instantly reveals his influence on today's Instagram photographers. Vivid, saturated colour, controlled blur, graphic abstract composition and the documentation of urban daily life all feature in Hass's images. Created on film but just as dynamic and relevant to today's photographic visual culture as they were when they were created over fifty years ago. However, where Hass was experimenting with chemical boundaries and the limitations of analogue reproduction, today the effects he mastered are easily achievable with the swipe of a finger to the left or right of an inbuilt post-production filter. It is this ease of achievement that I feel has seen the work of these photographers become so relevant and yet unrecognized.

Where the photographers I have discussed so far have been experimental in their image making and influence, from a contextual and technical perspective it is within the informal storytelling approach of photographers such as Robert Frank, Stephen Shore, William Eggleston and Lee Friedlander that we can find the visual narrative foundation for the Instagram photographer.

The ability to record the everyday, the domestic and the urbane with an aesthetic looseness and creative awareness is central to the work created and still being created by these photographers. Their approach has always been that of the observer, voyeur, documentarian and in the case of Friedlander specifically the self-chronicler. The smartphone is of course the perfect tool for creating work based on these fundamental aspects of visual storytelling. However, where once this work relied upon grants, bursaries, commissions or independent financial security to be made, today the financial concerns behind creating such work have been removed. Just as the technical and compositional aspects of experimentation have been simplified through

the smartphone's algorithms, the democratic ability to create digital files without an attached expense has given the photographer freedom to tell whatever stories they wish within a single image, in short-form or long-form narrative. This democratization of photography has seen a proliferation of personal projects and bodies of work being created, bringing stories big and small, intimate and expansive to a wider audience than could ever have been achieved previously with analogue technology.

The personal project

The concept of the personal project may well seem alien to anyone who sees photography purely as a form of hobby but to any photographer fully engaged with the medium it is the most important aspect of any form of photographic medium. The sheer number of people experimenting with photographic language is taking photography into new and unchartered areas of understanding, leaving the professional photographer in an interesting and challenging position as to how to define themselves as a photographer. My answer to this dilemma is to focus on the two specific requirements a photographer must have to develop, evolve and succeed both creatively and professionally; these are the abilities to be consistent in image making and to be able to craft and deliver visual narratives. These are not abilities that can be easily learnt and just as an artist sees their work as an explorative progression, so the photographer has to understand the importance of a similar process of visual exploration that feeds into a final image or body of work.

During a discussion concerning the moving image functionality now incorporated into most still cameras, a New York-based photographer said to me: 'Why wouldn't I use it? It's another way in which I can be creative.' The logic of this statement is of course obvious and yet his openness to new technology being a key to his own creativity is I find surprisingly rare amongst photographers. This is not surprising to me if you view photography within an historic context. The success of a photographer as a photographer has too often been based upon the perceived success of a single image or selection of single images, rarely as a body of work in which we consider the photographer's creation processes, contact sheets, workbooks, research, influences and perhaps most importantly his visual experimentation outside his or her recognized area of practice. If we change the way in which photographic images are created, then we must also change the way in

which they are seen and read. The process by which the images have been created now provides the context for their creation and the 'back story' to the aesthetic and narrative decisions made in their completion.

However, it is important to keep in mind that the creation of a personal visual language is led by process but not controlled by it and that a digital visual language is enabled by technology but should never be dictated by it. Life experience and passion are the driving forces behind the creation of narrative and as photography enters into a new landscape of understanding and intention, it is essential for photographers not to become seduced by the surface possibilities available to them whilst ignoring the fundamental truths of powerful storytelling and image making. It is often stated that everyone is a photographer today and that this is a negative situation for photography and photographers to find themselves in, but would we describe all those who can write as authors? Authors are masters of language as artists are masters of their process. Professional photographers can and should learn from both of these practices.

The filmmaker and photographer Wim Wenders has made his feelings clear concerning this transition that photography is going through:[6] 'I really don't know why we stick to the word photography any more. There should be a different term, but nobody cared about finding it.' It is an interesting point to make, particularly when discussing the opportunities the personal project can present to the visual storytellers. So far, I have primarily focused on the creation of the still image and the appropriateness of the smartphone to capture images and then share those images within the digital space, but it would be ignorant of me to ignore the smartphone's ability to also capture both moving image and audio files. Functionalities which allow creatives to develop narrative-based personal projects into formats previously restricted due to financial constraints and technical skills. This creative and technological convergence is now well established, but its development has occurred at lightening pace and as a result many have been left behind.

I often refer to the button on cameras and phones that needs to be pushed to create moving images as the 'Don't Touch' button, since it is the one that many photographers seem to have a fear of pressing. The fact that one small button can induce such fear in a photographer is of course based upon the fear of the unknown and as such is a fear of experimentation and learning.

I recently took a journey into the darker corners of eBay, in search of magazines focused on filmmaking. A few clicks in and I discovered exactly what I had been looking for: the self-proclaimed 'Britain's best-selling home cine magazine' titled *8mm*. I immediately clicked to buy four copies at the

knockdown price of £2.99 each, based purely on the covers. Sadly, on arrival they proved not to offer as much as expected, or promised. What they did do, however, was get me thinking. The magazines were low in pages, quality of writing and images, but they were filled with advice as to how the enthusiast could make, edit, present and archive films; and make a wooden box to keep them in. They had a wonderful 'build it yourself' quality to creative problem solving and a 'make do and mend' approach to what would today be called a 'workflow process'. But the two elements within *8mm Magazine*, which began the thought process that I want to explore with you, were the advertisements and the classified advertisements.

The advertisements, as you would expect, were primarily for cine cameras manufactured by some recognizable and some not-so-recognizable names: Canon, Kodak, Hanimex, Eumig, Agfa, Bolex and Fujica all featured repeatedly. Obviously, these advertisements extolled the virtues of each camera they were promoting, but they also included the prices of the cameras they were promoting, and the prices were high; as were the prices of the projectors, screens and everything else involved with being an enthusiast filmmaker in 1969. A good-quality family camera, such as a Super 8 Bauer, for example, was retailing at a considerable £96 10s 0d, which would be equivalent to approximately £1,150 today.

If you wanted to raise your game and invest in one of the top-of-the-range Canons of the time, then you would have had to find £399 16s 3d; a staggering £5,010 in today's money. And remember, these cameras were not for professionals, they were for enthusiasts. In short, you had to be extremely committed to even consider entering the filmmaking world. And yet a quick flick to the classified advertisement section at the back of the magazine reveals three pages of information on local filmmaking clubs nationwide.

Filmmaking was a thriving hobby. From Croydon to Edinburgh, from Gosport to Leeds, people were making films, sharing knowledge and putting on club film shows; despite the costs involved and the technical difficulties of working with the technology of the day. Looking at these club pages reminded me of a BBC children's television programme that I used to watch once a week, every week, on returning home from school. It was called *Screen Test* and comprised a general film quiz aimed at eleven-year-olds, a film clip made by the Children's Film Foundation and a regular segment where films were shown which had been made by its young viewers. The show rapidly grew in popularity and spawned a young filmmakers' competition, which in turn produced a number of professional filmmakers and one Oscar winner. *Screen Test* ran on BBC1 from 1970 to 1984.

Not to be outdone, ITV had its own film show for the young, *Clapperboard*, which was presented by the laconic Chris Kelly. *Clapperboard* was more of a film review programme with an educational element to it, with episodes covering such adult film information as the film music of Ron Goodwin and the set design of Ken Adam (the set designer of the Bond films). It also profiled the cinematographer Freddie Young and looked at the work of Jacques Tati. It was an intelligent film series which ran from 1972 to 1982. Both of these TV series promoted the history of film and the excitement of filmmaking to the young, and both died with the advent of video film technology. Today we have YouTube and the cult of the YouTuber whose platforms for sharing are now free, digital and international, and the local film club has been replaced by social media and online forums. What has not changed, however, is the desire to tell stories.

Young filmmakers today are being visually educated by the moving image as the dominant factor. The still image is a secondary creative option to them. This reality means that we will all have to reassess how, where and why we exist within this new landscape of image makers and how we present our stories. Those of us with long careers within the professional world as both filmmakers and photographers have to accept that things have changed and embrace what is now possible. My discovery of the forgotten world of *8mm Magazine* and my remembrance of both *Screen Test* and *Clapperboard* only go to show that the passion for filmmaking which was once so prevalent has remained dormant for too long, and that thanks to technological advancements it is now rising like a phoenix from the flames.

The personal project does not need to be confined to the still image; it can incorporate moving image and audio. It can exist on multiple digital platforms and be disseminated across multiple broadcast environments. We should not fear the 'film' button, but we should embrace it and the possibilities it gives us as creatives and in our understanding of the power of the narrative form. The spirit of the auteur is fundamental to the filmmaker's DNA and the personal project is the starting point for many films that have reached fruition. Perhaps this is something that the photographer can absorb into their own creative DNA and the ease of access of the tools to start experimenting with narrative in the form of moving image should make this absorption both an easy and productive process.

However, the very term personal project brings with it an implied reaction against work that has been commissioned as if one has more validity than the other, just as I have previously discussed the perceived importance of

an image based on the camera it has been created with. This perception is deeply rooted within the photographic community and is based on the belief that commissioned – or, as it is so often referred to, 'commercial' – photography is of a lesser standing than that which is self-initiated. This debate has become even more relevant since the digital revolution, with the commissioned market becoming increasingly competitive and the creation of personal work easier and cheaper than it has ever been before.

Working with the personal

I recently received a tweet that contained this comment: 'Just because everyone has a camera these days, it doesn't mean anyone can make a great image.' I was tempted to respond immediately but restrained myself as the limited Twitter character count would never have allowed me to respond to the comment with the required accuracy of language and understanding that the comment required and to my mind demanded. I am constantly being questioned by friends working as professional photographers and creatives concerning one central aspect of my own professional practice, namely that of working as a university lecturer teaching photography to young photographers. These comments from friends and the 'tweet comment' bring into sharp focus the most relevant and important question facing professional photographers in the twenty-first century: where is professional photography now?

I read many articles concerning the detail and interpretation of a particular image, exhibition, book and/or a photographer's body of work, comments on competition decisions, the technological merits of a new camera and the theoretical interpretation of work based upon sociological, political and economic mantra. These articles, posts and blogs inform, entertain and more often infuriate me due to their obstructive use of language but rarely deal with the bigger issue; the bigger discussion of photography's global evolution outside the recognized genres of professional photographic practice.

Let's swallow the bitterest pill first and accept that the Twitter comment I have mentioned is both incorrect and inaccurate. Anyone today can take a great picture; the creation of a successful single image is beyond very few. However, the ability to consistently do so and construct a visual narrative are much harder skills to achieve. The vast quantity of images currently being created across a broad range of image-capturing devices is often commented upon as a series of statistics. Those that create these images rarely see or describe themselves as photographers and yet they are the very people who are taking

photography into its future life. They are documenting their lives without concern for peer review, comment or adoration from 'the photographic elite'.

This elite is portrayed as a powerful cabal of 'practitioners' teaching photography, whilst attempting to protect it as something 'special', something intellectually beyond the uninformed. Whilst those creating images with their smartphones by the thousands on a minute-by-minute basis have no interest in this exclusive group and approach. Why should they? As the multitude uses images as a newly democratic everyday visual language created for posting and sharing, those trying to deliberately mystify that language are stuck in a repetitive state of visual procrastination.

A recent meeting with someone deeply embroiled in this practice and academia left me both saddened and frustrated. The work I was shown was repetitive and insular, non-communicative and non-involving. The logic behind the work was weak and tired. There are many reasons for this approach to photography. In this case (as so often) the reasons appeared to be intellectual snobbery and an archaic and inflexible understanding of photographic practice to gain university research funding. The more complex the context, the intellectual investigation, the language used to describe it, the better and more important the work, right? Wrong!

A graduate came to see me recently. He had graduated in 2014 from a leading university photographic course in the UK. He had been a star on the course, made connections, been published and taught by leading names within the elite I have previously alluded to. And yet his view of photography was tainted and unrealistic. He had been told that photography had no future, that there were no jobs for him so there was no point in the course teaching him skills that the lecturers felt worthless. He commented on how the lecturers' input was based on the need for him to follow their aesthetic and approach. He was dismissive of the course and explained that many of his fellow students felt the same.

One year out of university and he was lost. Photography had been presented to him as a world led and determined by a self-appointed group of taste and king/queen makers. Not as an exciting and powerful global visual language. His education was not based on what was best for him, but what was best for the lecturers, based on their self-interested approach to what photography now is and could become. I have no problem with selfies, I have no problem with pictures of burgers created to sell burgers, advertising images, editorial images, self-initiated projects, family snaps, Instagram, Flickr, Facebook posts, smartphone images and tablet-created images. It is all photography and I love photography. I love all forms of communication.

That is what I teach! Photography based on passion with no boundaries and no frontiers. You want to shoot weddings? No problem. You want to have your work in galleries and exhibitions? No problem. You want to shoot food, fashion or dogs? No problem. This is because the personal project should be exactly that, it must be personal to you.

A passion for the medium of photography should be based upon a passion to communicate and create images. Therefore, the creation of personal projects should be a primary concern and occupation for any young photographer and yet the idea of personal documentation presents many issues for those who enter higher education having seen photography and the arts as a learning journey dependent on a marking formula. This situation highlights many problems with the teaching of the arts prior to the university experience and its potential for presenting students with a formulaic series of projects framed by markable outcomes that have little space for student self-introspection. The placing of a self-initiated practice into a spoon-fed structure leaves many students confused by photography when its true potential is revealed to them.

It is interesting to take a moment at this stage to also consider education's relationship with technology and particularly with the smartphone. Institutions are keen to embrace and invest in the concept of desktop computers and tablets as potential learning tools, and yet the one personal computer that the majority of their students have in the developed Western world and are most confident in using is dismissed as a disrupter to the formal learning process. Students are either banned from bringing them to school or from using them within school hours as if the smartphone has only negative connotations as a communication device. This is despite the fact that the teachers leading these classes are themselves users of the same device within their lives. As I sit and write this book, I am unaware of any school embracing the possibilities that the smartphone offers as both an educational tool and device upon which to develop transferable communicative skills. I am aware however of many schools highlighting the negative influence it can undoubtedly have if used without an awareness of its potential to manipulate and develop anxiety issues within the developing young mind. Yet, by treating a device as the central reason for these issues is to misunderstand the importance of education moving with the development of the digital space. If educational establishments were to begin recognizing the relationship their students have with their smartphones and incorporate the device into teaching that personal relationship, they could harness this to develop creativity and the smartphone and its associated platforms and apps could be placed within a professional context alongside its existing social use.

New Ways of Seeing

In effect, many students are already creating personal projects without the realization that the images they are creating to post on social media platforms could be incorporated into their studies and their creative development. This personal relationship with the documentation of their lives is possible thanks to the ubiquity of the smartphone and the ease with which images can be created and shared. The ability to develop these images and experiences into narratives could be taught within a multiple of subjects, not only within the creative arts. Students are using smartphones to read from, as note-taking devices and research tools practices previously undertaken with a series of different tools. The fact that one device is the primary tool demonstrates how the smartphone is not only changing the way we see and experience images but also how students engage with narrative comment.

The small screen issue

This reliance on a small screen to engage with both written and visual narratives by young people is having a detrimental effect on how we see. A UK-based optician brand conducted a survey in 2016 across 2,000 parents in the UK with children aged between two and sixteen, to see which digital devices young people use and how regularly they use them. According to the survey, young people are spending an average of one hour per day on each of the following devices: a personal computer, a digital tablet (such as an iPad), games consoles and a smartphone. They are also estimated to spend just over half an hour each on an e-reader such as a Kindle, their MP3 player and on electronic learning devices at school or college. This is in addition to watching almost two hours of television each day. The same survey reported that most UK households no longer share a computer or have only one television in their living room, but it might be surprising to learn that as many as 39 per cent of parents taking part in the survey said that their children owned a tablet, whilst 38 per cent acknowledged their children owned a smartphone.

With greater access to digital devices than any other generation before, it's only natural that young people are turning to these devices for both work and play wherever they can. In turn, this means that they are spending more time than ever before engaging with content via digital screens. When we look at an object at close range, our eyes work harder to focus than they would if we were looking at something at a longer distance. Looking at electronic screens for lengthy periods of time means that our eyes are constantly working hard to bring the images or text on screen into focus. This is a reality I discussed

148

with my own optician who stated that the majority of the prescriptions for glasses he now gives are dictated by the distance at which most people view a computer, tablet or smartphone screen.

The most common side-effect of using digital devices for a prolonged amount of time is known as Digital Eye Strain. This can be caused by young people holding devices incorrectly, in most cases too close to their eyes as a result of small text or pixelated images on a screen. Another potential cause of eye strain is the high-energy visible light or HEV commonly emitted by digital devices. Frequent exposure to this HEV light, especially at night, can be damaging to a person's eyesight, leading to vision deterioration over time.

There is no doubt that an over-reliance on a smartphone to view images over an extended period can be detrimental to someone's eyesight, but it is also detrimental to a photographer's ability to develop narrative. Even the use of a larger computer screen to edit a body of work has its limitations and it is for this reason that even though I am a great believer in the smartphone to capture images and develop narratives, I also recognize the importance of removing those images from the digital space to edit those images into a finished narrative.

It was the UK-based photographer Chris Floyd who first bought to my attention the notion of rejection as an intrinsic part of the editing process. Chris had just shot a series of portraits of one of my daughters and as I stood by his laptop to begin my edit, he declared that he could not stand next to me and experience the rejection. The use of that word in this context hit home and bought clarity to a process I have been involved in for nearly thirty years.

The most common mistake made by photographers when editing their images is to begin by selecting those images they 'like' and use this selection as the basis of a final edit, an issue that is multiplied if the issues chosen are based upon social media 'likes'. This subjective decision is too often based on surface emotions and aesthetics which provides a weak foundation for an informed and vigorous edit of the work. That foundation must be built on objective decisions based upon the success of the image within the context it was created within or for. That objectivity comes from rejection.

Few photographers that I have met either enjoy or are good at editing their own work. They have too much invested in the images either emotionally, intellectually or even financially to be as hard on their work as a third party might be. This investment prevents a truly objective decision-making process. The rejection of images is based on the concept of 'successful' or 'unsuccessful' images, not that of 'good' or 'bad'. The commission, the narrative and our own visual language are all aspects of the context by which we can judge an image as being successful or not. With a clear understanding

of the intended context and proposed outcome of a shoot it is easy to reject images that are unsuccessful in meeting these criteria.

When editing work, I therefore recommend that you begin by rejecting the unsuccessful to be left with the successful. This process should take place over a number of different stages (I always suggest two to three) with each stage becoming more and more rigorous in its attention to detail, not only of context but also composition, repetition of image, narrative progression, technical requirements and personal aesthetic. The rejection of unsuccessful images will leave you with the most successful of images. The images you 'like' may be in this final edit but if they are they will be there on merit, not purely on subjective taste. Of course, some edits are easier than others and the more experienced you are at both creating and looking at images will increase the speed by which you edit your work. However, by following the process I have outlined you will not only ensure a strong edit, you will also ensure that you understand the edit, a vital factor when talking about the work or if challenged about individual images or the edit as a whole.

As photographers, we all fear rejection and yet have it as an everyday reality of our photographic practices, so to bring it into the intimate practice of editing our work may be a hard pill to swallow or accept. However, I do believe that by doing so the editing of work not only becomes logical and cohesive, it becomes an extension of an informed photographic practice. It also remains the fundamental skill required in building a narrative; a writer has an editor, a photographer may have an editor but with the personal project the reality is that the photographer will have to be their own editor. I always say that a photographer is judged on the work they show, not on the work they have created. It is therefore that what you do show is the work that needs to be seen.

There is a photograph of the great *Harper's Bazaar* magazine art director Alexey Brodovitch working with the photographer Richard Avedon on an edit of an Avedon shoot. Images are printed on paper and are placed on the floor. I have a similar image of the photographer Minor White editing a body of his own work in the same way and a photograph of the photographer Weegee editing hundreds of prints for a forthcoming book with his apartment floor covered in prints. Despite these images documenting edits that were undertaken over forty years ago, the process being undertaken in all of these images remains the basis of how I edit images today and how I teach the art of image editing.

The incorporation of traditional methods and contemporary forms of digital capture is in my opinion a vital coming together of practice that recognizes how a knowledge of the medium's history combined with an

open approach to its future can retain the creative vibrancy and relevance it has had throughout its long gestation as a contemporary art form. There is no secret to developing an editing eye: it can only be nurtured through the continued and repeated viewing of images, both good and bad supported by rigorous analysis of those images. Questioning their relative qualities with an understanding of the context within which they are used. To learn to see, we have to see and question what we are seeing.

Point of view

I have spoken previously concerning the role photography is having outside the recognized photographic community and the possibilities that the moving image has in developing narrative and this is an area that I would like to explore in further depth. Anybody who has watched on television reality programmes based on police activity and/or debt collectors will be aware of the implementation of the point of view (POV) camera to document the situations these professions can find themselves in. Similarly, referees at sporting events are increasingly wearing either chest- or head-fitted cameras to take the viewer into the heart of the sporting action.

This implementation of small image-capturing devices to provide a POV experience has been common among the extreme sports communities such as skateboarders, surfers, skiers, mountain bike riders since, for example, the launch of the GoPro series of cameras. These POV films rapidly populated YouTube and in so doing established not only a new form of visual experience narrative but an expectation of how such experiences can be seen. In essence, these films and their enthusiast creators raised the bar for all filmmakers in the realm of believability, whether that is in creating documentary or fictional narratives. Just as the hyper-realism of the digital image has changed the aesthetic expectation of what looks 'real', so these POV films changed the visual understanding of what is believable and in that sense what 'is real'. The same can be said of the POV films created by head and body cams worn by police and law enforcers to document a situation that may be questioned in a court of law at a later date. These visual narratives can hold a visceral fascination for those whose lives do not regularly engage with situations of potential violence and criminality. In that sense, they provide a vicarious experience for the viewer whose life may be more mundane than that which they are being shown. They also provide a believability that it is hard to argue with due to their immediacy and unedited reality. The narratives they document are unwritten and unfold

before our eyes, placing us in the position of participant, judge and jury. They allow us to be in the moment even if that moment has long passed.

The images that are created as POVs inform the way in which we see, experience narrative and engage with the image as truth. There is much debate on the reality of photography as truth and its role as a medium that allows an edited interpretation of what is true from one person's perspective, but those discussions are for another time and place in this context. The acceptance of these POVs providing the truth is based in many cases upon multiple recorded perspectives of the same scene, from more than one body or head cam, from fixed CCTV positions and fixed dashboard cameras in cars. The visual recording of an unfolding narrative is in that sense little different to a multiple camera setup for a television advertisement or blockbuster movie, with the only difference being that the script is being written in real time.

The use of the smartphone to photographically document events is not, however, confined to the fixed corporate or governmental eye. It is commonplace today for those involved in accidents from which an insurance claim could be made to reach for their phones in the heat of the moment, to document a situation that may in the future be doubted or questioned. This brings the idea of the citizen journalist to the personal and the level of activity being recorded to the everyday. We have become used to the concept of citizen journalism documenting areas of conflict and turmoil such as the Arab Spring, the street battles of Syria, the atrocities committed by Isis and in Myanmar, environments where those living amongst the violence are best able to show the reality of a situation developing. But the idea that we are adopting a similar form of documentation to provide proof of a car accident, parking infringement or environmental issue is seldom considered.

The moving image as a form of news documentation is nothing new but the technology which is being used to gather that news is, and it is the scaled-down size of the tools being used and the ease in which they can be used that is changing our expectation of news just as it has changed our relationship with the photographic image. The still image grabbed from a piece of moving image is of course a photograph and the removal of one frame from its original context is not new. However, the fact that the same device can now create both forms of documentation and that the quality of the image taken as a still is so high has resulted in a blurring of the boundaries between these two different yet closely connected mediums.

Perhaps the most powerful and disturbing example of the different forms of narrative created by the two mediums occurred in 1968 during the Vietnam War. A news cameraman for the National Broadcasting Company of America

(NBC) and an Associated Press photographer, Eddie Adams, both found themselves in a situation where they individually witnessed and documented the shooting of a Viet Cong prisoner named Nguyen Van Lem by the South Vietnamese Chief of Police Nguyen Ngoc Loan. The resultant film footage and photograph became two of the most famous examples of American photojournalism of the period and both took on a political context in the United States which may have eventually led to a change in public opinion and the subsequent end of the war. What is interesting with the benefit of hindsight is how the film footage remains extremely shocking to watch, but it is the still image that retains the power to truly shock with its capturing of the exact moment that the bullet hits Lem's head and the impact it has on his face. The film footage shocks but it does not allow that time to explore what is happening in the way in which a photograph does. This is an important quality that a photograph possesses that must not be forgotten in the digital space, where the moving image and multitude of images can too easily prevent the important image from being given its due time to be considered and understood.

This connection between the still and moving image as complementary forms of visual narrative is most clearly seen if we use the metaphor of the filmmaker's storyboard. Quite simply, the storyboard is a series of images in sequence that indicates the progression of the narrative. It is no surprise therefore that these images are bought to life within a filmmaking environment by a creative described as the Director of Photography, and it is also of no surprise that many of these creatives have come from a background of photographic education. If we consider the analogue photography contact sheet as a similar series of images that illustrate a photographer's search for and documentation of a narrative, it is clear that the process of building a narrative through a series of images is common to both mediums. Filmmakers have always learnt from photography, but I question as to how many photographers are utilizing filmmaking as a tool in their construction of stills-based narratives.

Returning to another shocking and memorable image created during the Vietnam War, we can clearly see this sense of connection between the still and moving image. On 8 June, 1972, the Associated Press Vietnamese photographer Nick Ut was approximately 25 miles northwest of Saigon, when the South Vietnamese air force mistakenly dropped napalm – an inflammable explosive – on the village of Tra Bang. Acting on instinct and adrenaline Ut immediately began to document the resulting carnage, but as he carried out his role as a documentary photographer, he noticed a group of children and soldiers alongside a screaming naked girl, her clothes blown from her body by the explosion. Ut commented later that: 'I took a lot of

water and poured it on her body. She was screaming, "Too hot! Too hot!"' Ut took Kim Phuc to a hospital, and with the help of colleagues ensured that she was transferred to an American hospital for treatment that saved her life.[7] Ut's image makes an immediate emotional contact with the viewer and brought the brute reality of war to the living rooms, diners and bars of the American populace, personalizing that brutality through the naked child. The most basic and emotive of figures that all nationalities and religions can connect with contributed to the changing tide of support for the war. The photograph soon became a totemic image illustrating the atrocities of the Vietnam War alongside the equally disturbing Burning Man photograph, an image documenting the self-immolation of a young Buddhist created by photographer Malcolm Browne. When the sitting President Richard Nixon questioned the image's validity, Ut stated that: 'The horror of the Vietnam War recorded by me did not have to be fixed.' In 1973 Ut was awarded a Pulitzer Prize as a recognition of his image's photographic and political importance.

By viewing Ut's contact sheets documenting this horrific act of bombing, it is clear to see how the chosen image comes from a series of images of the villages and the girl running from the bombing along the road towards him. Images that could just as easily acted as a storyboard of a film to be made. Just as Ut recorded the scene as a series of still images, alongside him news cameramen recorded the scene, but it is Ut's defining image that remains as the most powerful evidence of the narrative of that terrible day.

I have chosen just two images and two instances that come to my mind to help illustrate the connections between the still and moving image. I am sure that you can think of many more. The chosen examples are not in themselves important; they act merely as a starting point for thinking outside the traditional understanding and teaching of photography. A bringing together of multiple forms of narrative to inform the process of visual storytelling in the digital space. A form of visual storytelling that is now available to all and democratic in its nature but only if the understanding is taught to build narratives from disparate images.

CHAPTER 6
DEVELOPING FLUENCY

As with the learning of any language developing fluency with a visual language comes from practice and repetition. It also comes from the learning of grammatical structures, idiosyncrasies, technical requirements and forms of delivery. Photographers whose introduction to the photographic medium came through analogue education often speak of the importance in the teaching, learning and understanding of the technical aspects that were once intrinsic to the creation of consistent photographic images. They often see these as the defining aspects as to whether or not someone takes the medium seriously, whether or not the person has the right to define themselves as a photographer. I never studied photography within an institution and therefore was never taught these rules. As a graphic designer these rules of practice did not exist and therefore I have never felt any pressure to learn them as I have worked with photography. Whatever I have learnt has been on a need-to-know basis and I do not feel any less of a photographer purely because there is so much that I do not know. It will therefore come as no surprise that I have been so rigorous in my embracing of new ideas, platforms and practices when some photographers find it hard to do so. I understand these photographers' stance even if I do not agree with it, but I do have an issue with the belief that work created without this technical knowledge is somehow of lesser quality than that created with it. This is a belief that seems to align itself with the opinion that work created on smartphones is also not worthy of serious consideration.

I am not at this point either dismissing or disrespecting the importance of technical knowledge. I place great importance in the understanding of the fundamentals of any art form in allowing the creative to take control of the creation of their work. However, I am always concerned by teaching that places an over-importance on this knowledge that can so often result in work that is both sterile and repetitive, lacking a sense of the personal. Equally, work that is purely personally based and is created with no mastery of the technical requirements in creation can easily lack consistency and a sense of intention in its creation. A language needs to be mastered and used

with intention to successfully convey stories and to achieve the outcome that the storyteller intends. Many see the proliferation of easy-to-use digital imaging devices as being responsible for the 'dumbing-down' of the medium of photography and of course in some senses they are correct, but I belief that they can be used as part of a learning process that embraces the past, the present and the future. I will speak more about how a fluency can be obtained in visual storytelling with specific examples later in this chapter, but of course to focus purely on the creation of narratives without looking at the nature of reading these narratives would not only be remiss, it would be nonsensical in an environment where the ways and places in which these narratives are encountered are so multiple and varied.

Reading pictures

I have never studied the reading of pictures in any great detail or with any theoretical rigour, just like the majority of people encountering visual narratives today, but I am aware of the basic theories that inform the understanding of semiotics – the study of signs – with regard to the creation and reading of photographic language. Signs and symbols are part of our everyday lives, which have regional and national, cultural and religious interpretations attached to them, whilst others have more universal applications attached to them. Semiotics can be attached to many fields of endeavour but its relevance in dissecting a visual language has become a foundation of photographic theory and cultural studies since the beginning of its emergence amongst academics and within academic institutions in the 1970s. However, semiotics cannot be used as a translation tool without taking into consideration the broader picture of political, cultural, social and economic conditions in which work has been created. It is also debatable as to the relevance of semiotics today, but I think that it is worth being aware of the basics as many people still seem to use them as a starting point to their reading of the medium.

This may seem an obvious series of considerations to take into account when viewing an artist's body of work and I would argue that many people who have not studied the medium of photography as practice or photographic theory may well engage in this process unconsciously. Two figures to be aware of in semiotics in relation to photography are the Swiss linguist Ferdinand de Saussure (1857–1913) and the American philosopher Charles Sanders Peirce (1839–1914) who are jointly responsible for the models most

frequently used. Saussure and Peirce developed their models of semiotics at a similar time, but their models differ in structure. Saussure defined a two-part model of the sign in which a 'signifier' becomes the form that the sign takes and the 'signified' becomes the concept it represents. Peirce's model used a triadic or three-part model in which the 'representamen' is the form that the sign takes, the 'interpretant' represents the sense made of the sign and the 'object' dictates that to which the sign refers.

This discussion of semiotics and photography inevitably leads us to the French literary theorist, philosopher, critic and semiotician Roland Barthes. Barthes was sensitive to the subtle nuances of photographic visual language and recognized that when personal significance is communicated to others it can have its own rationalized symbolic logic. His book *Camera Lucida*,[1] which he began writing in 1977 towards the end of his life, has been a foundation of photographic theory education since its first publication and remains a staple text today. The book presents two central concepts to aid in this rationalization of the photographic image. The first is described by Barthes as the 'studium', the general enthusiasm or interest in the image, and the second is the 'punctum', that which arrests the attention of the viewer and which is dependent upon the individual engagement with the image.

As you can probably tell by this briefest of outlines of the theory of semiotics with relation to photography, it is a language unto itself and one that demands intellectual engagement to both understand and implement as a form of image dissection. I am not dismissive of the theoretical approach to photography but rather how an overly technical approach to the medium can have a negative impact on the work created and the discussion around the work can become impenetrable to the non-technically engaged. So an overly theoretical approach to the creation and reading of images can similarly lead to impenetrable prose based upon beliefs and contexts constructed more to confirm an academic argument than the artist's original intention.

In this sense, as with so many areas of photography, I return to music to provide an accurate and illuminating metaphor. I am always interested in reading a music reviewer's opinion of a new album, a concert or a musician's body of work that presents an informed point of view and perspective, but the true insight will always come from the person themselves explaining their inspirations, intentions and experiences concerning the music or live experience. I therefore always turn first to the photographer to inform me about their work, rather than the theoretician.

Semiotics is not the only methodology that can be implemented when attempting to decode, deconstruct, interpret, read or respond to photographs and in many ways its teaching seems based on theory that has little relevance to current student cohorts. Photographs are used for many different purposes within many different contexts, each with their own frames of reference and implied rules of engagement. If we see a photograph purely as a visual reminder of a personal experience, we are neglecting the reality of how the medium is intrinsic to so many different aspects of our daily lives and how we choose to read images when presented to us as pieces of evidence related to the photographer's intention, their process and technique, their personal aesthetics, existing art traditions and the creator's class, race and gender. Photography in its purest form is a highly personal expression of one person's viewpoint and as such the interpretation of any images created can only be subjective. This results in one image, narrative or body of work being open to multiple interpretations based not only on the creator's history and environment but also that of the viewer.

This of course presents the creator with a dilemma and it is one that creatives and artists in all areas of creative endeavour must address, and that is the decision as to what stories they want to tell and how much they wish those stories to be left open to interpretation. Within the photographic medium this decision concerning interpretation often results in the work being created falling into what has previously been seen as three separate areas of work that have now converged, a situation that has opened the door to a number of controversial discussion points. These three areas of practice are most often described as social documentary, photojournalism and contemporary photography.

Telling stories

Unlike other areas of photography, photojournalism has historically staked a claim on veracity and ethics. Honesty and accuracy of storytelling has been at the heart of the practice since the medium began to be used as a form of news documentation, of visual evidence. There is a history of scandals based around the staging and manipulation of images that have been well documented, but it is the digital space and more recent scandals that have bought the issue of believability to the front of many people's minds when engaging with the photographic image. The issue concerning the manipulated image was a major consideration for theorists writing about

the oncoming digital image at the time of its earliest development, but the realities surrounding the manipulation of the digital image are far more complex than those theorists could have imagined.

The issue of manipulation has the characteristics of a bandit country where no rules exist and where ways of acting are self-regulated and instigated. This is a situation which a number of photojournalistic organizations have attempted to address through the issuing of codes of ethics that generally fall into two categories, the first being image capture and the second being the post-processing of images. In the process of capturing an image, most codes of ethics echo that of the NPPA – National Press Photographers Association of America – which are that a photographer must be accurate and comprehensive in the representation of subject; that they must not manipulate or stage photographic situations; and while photographing subjects they must not intentionally contribute to, alter, or seek to alter or influence events. This is a set of rules that most people would see as perfectly straightforward and reasonable when attempting to document the reality of life.

However, it is the process of post-production that seems to be the most difficult to regulate, as organizations have had difficulty moving away from the darkroom analogies when addressing the digital space the medium now sits within. The Amsterdam-based World Press Photo Organization has faced a number of issues concerning images entered in their annual competition over the past few years. In response they have attempted to define what are acceptable and unacceptable forms of manipulation when it comes to judging the 'truth' within a photographic image. These include a number of basic rules of practice, such as changes in colour must not result in significant changes in hue, to such an extent that the processed colours diverge from the original colours. Changes in density, contrast, colour and/or saturation levels that alter content by obscuring or eliminating backgrounds and/or objects or people in the background of the picture are also not permitted.

These rulings on tone and colour are interesting in that they point to a number of common practices that have become prevalent within digital photography. These practices are in mind directly related to the common experience of photography online and on the back-lit screen. The rise of the desaturated image and the Photoshop plug-in to achieve flattening effects, has become a shorthand form of language for many photographers attempting to create what they perceive to be contemporary images. It is an effect that is also prevalent within filmmaking where desaturated colour

New Ways of Seeing

grading has become a similar shorthand to indicate realism. The desire to create still images that embody a 'cinemagraphic' quality and aesthetic is an interesting one to explore when discussing the photographic fluency of a photographer's language, as the belief that a language can be based upon post-production techniques is as ill-considered as putting on a false accent to convince somebody that you are in fact not the nationality that you are. It is an affectation and as such is impossible to maintain over an extended period of time.

The photojournalist who is seduced by these post-production techniques has also been seduced by the idea that to make a situation more 'real' they have to heighten the visual experience to heighten the emotional connection the viewer has with the image. In a world where all images are heightened in contrast, colour and detail thanks to the back-lit screen, the photographer is left with three options. The first is of course to leave the image as captured with no post-production manipulation of any kind; the second is to desaturate the image to make it feel more 'real' and 'believable'; and the third is to take an image and heighten every aspect of its content. When outlined in this way it should be clear that the appropriate practice is to be happy with the image as captured. Of course, this then raises the argument concerning analogue darkroom manipulation and the creation of the finished black and white print, and it is true that the art of printing would draw the very best interpretation of a scene that the photographer captured. However, the possibilities that digital manipulation offers are far greater than that of the master printer and we have to deal with the realities of now and not yesteryear.

As well as colour correction, post-production practices raise issues concerning image composites and element removal. There have been a number of high-profile photographers being called out on this in recent years, perhaps most notably the Magnum photographer Steve McCurry.[2] It is a practice that most news organizations prohibit alongside the creation of computational panoramic images and high-dynamic range or HDR images. But once again, the rate of technological progress has exceeded the rate of discussion concerning these practices. Smartphones have become a regular component of a photojournalist's kitbag and many have HDR-like capabilities turned on by default as the dynamic range of a smartphone camera is not as advanced as that of their full-frame counterparts.

Computational techniques like sharpening and blur reduction can interpolate pixels into the scene that weren't strictly recorded by the sensor. As I have previously discussed at length, computational photography

challenges our traditional conception of photography as a single exposure of light intensity captured by a photosensitive medium. Consider a digital camera sensor where each pixel is capable of a different exposure, such that you would never over- or under-expose parts of the image. Then see if you can decide whether or not this single exposure 'HDR' image is an ethical or unethical representation of what has been seen.

The ethics of photojournalism have been primarily established by comparing the finished image or artefact to what the eye has seen. But sensors have the ability to record images in the dark and virtual reality devices allow us to see simultaneously in all directions in a way that the eye cannot. Technology will always outpace philosophical and ethical concerns about its impact, but the professional photographic community has been slow to address these issues in the same way in which many have been slow to admit that photography as a medium has changed in both creation and final context.

This is not universally the case however and a number of organizations have been keen to engage with new platforms such as Instagram. The Getty Images photographic agency is one of the brands whose history began before the digital revolution and who collaborated with Instagram, by establishing an annual Getty Images Instagram Grant.[3] The grant programme was founded to support photographers, videographers and visual artists using Instagram to document stories from under-represented communities around the world, thereby further indicating this adoption of the platform as a destination for visual narratives to be showcased. One of the successful entrants for the 2017 programme was Nina Robinson (@arkansasfamilyalbum), an Arkansas-based photographer who originally began documenting the everyday life of her family in rural Arkansas but later expanded her project to include other African-American communities in the area. Her project An Arkansas Family Album focuses on an intimate exploration of loss, love and tradition in a rural black Southern community.

Robinson is a documentary photographer and educator based in Arkansas and New York who describes her work as a mixture of her past experiences that bridge documentary, personal and fine art practice. She began her photographic career shooting for *The Reporter* newspaper in Vacaville, CA, before deciding to work on a freelance basis for clients that include Netflix, *The New York Times*, National Geographic and *The Wall Street Journal*. Her work has been exhibited at the Bronx Documentary Centre, the Bronx Museum and the Mosaic Templars Cultural Centre, a museum dedicated to

telling the story of the African-American experience in Arkansas. As such she could be accurately described as a successful professional photographer, but perhaps it is also accurate to describe her as a twenty-first-century photographer willing to embrace platforms such as Instagram as valuable storytelling platforms.

This is a feeling echoed by fellow Getty Images Instagram Grant 2017 awardee Saumya Khandelwal[4] who as a student accompanied her friends studying journalism on photo shoots. She commented on receiving the award that: 'I didn't understand the kind of opportunities or career one could have in photography. But I didn't have anything to lose. In India, people don't take a woman's career seriously, so I didn't have the burden of proving myself. I could fail at it and come back to living with parents and life would still go on fine.' Now, Khandelwal shoots for Reuters and is based in New Delhi, India and her images have been published in *The New York Times, Al Jazeera, Time*, amongst other international publications. But it is her views on the importance of Instagram in building her photographic practice which are particularly interesting:

> Instagram allows me to have control over my content, which is often not the case with publishing on traditional platforms. I can build my own narrative, and also include subjectivity to it, which makes it more personal. Above all it helps me reach a more diverse crowd. It's surprising to see the kind of people who reach out to me. Normal people who are moved by the stories are the most fascinating to me, because I never thought that Instagram was a place for such serious content. But people have responded positively.

Robinson and Khandelwal are not the only photographers who are taking the Instagram platform seriously. The Magnum photographer Gueorgui Pinkhassov published a book titled *Sophistication Simplification* in 2017 in which he took his Instagram work as a point of departure, in 'an attempt to return images from the virtual world into the usual, material one'. In an article on the Magnum website[5] he states his belief that:

> Media are only bearers of information. In the past, the only ways to show your work were exhibitions and books. Things are much simpler now. No drama. You simply post the image and you get an instant response from the most unexpected parts of the world. We can like this or not, but it seems to me that this is an enormous reorganization

of the communications sphere, comparable perhaps only to the invention of the printing press. The iPhone is a magical tool. Once you master it, it becomes a continuation of yourself, the instrument of your freedom and integration into the world. You need intermediaries less and less, and thanks to it, you have easier control of your space and time.

After Anjali Pinto's husband died suddenly at thirty years of age, the twenty-eight-year-old American photographer turned to Instagram to document her loss. At the hospital, she held his hand one last time and took a picture. 'It's kind of like the camera acts as a shield – I can't process this right now, but I need to come back to it', she commented to the *Chicago Magazine* in 2017[6] about the genesis of her very personal visual narrative. On New Year's Day, she posted that image on Instagram (@anjalipinto) to inform friends and family about a memorial that was being planned. In the weeks that followed, Pinto posted images of her husband and their life together and began to write extended captions illustrating her feelings. Over the course of the following year, she posted an image a day, every day; series of posts that have become a form of documentary project that acts as a tribute to her husband and to Pinto's personal grief.

Melissa Spitz was seven years old when she first visited her mother in a mental institution, the first of many visits that inspired her visual documentary project *You Have Nothing to Worry About* (@nothing_to_worry_about). Her Instagram account is a visual diary of Spitz's mentally ill mother, Deborah, who had been diagnosed with paranoid schizophrenia, depression and bipolar disorder. The work and subsequent posts have generated a community and conversation about mental illness. Spitz, now twenty-nine years of age, was named as *Time* magazine's Instagram Photographer of the Year in 2017 and she has created more than 5,000 photographs and 100 videos over an eight-year period that inform her Instagram feed. She explained to *Time* that: 'Pictures … the idea of documenting and saving everything, having a record of it, has been important my whole life because that's all we had from my grandma's family.'[7]

When she began the project, she admits that she looked for images that contained shock value, but as the project has developed Spitz looks now for the quieter moments that are less obvious in their narrative intent. The feed now has over 45,000 followers.

This idea of the platform as a digital space upon which to demonstrate curatorial practice is something that is being explored by the American

photography enthusiast Andy Flak on his @FlakPhoto Instagram account. Flak states: 'My goal is to raise awareness of those image-makers doing interesting things with their photography and to fill your Instagram with intriguing, unexpected work, a little bit at a time. And, if it helps you see something new, all the better. Concept is simple: get your work seen.' This sense of collaboration and sharing of stories is intrinsic to the new photo community and to the twenty-first-century photographer, however there is nothing new about the idea of a mass curation of images.

The United Kingdom has a long tradition of socially engaged photographic practice and self-initiated curation. A good example of this is the Mass Observation movement dating from 1937, which included photographers such as Humphrey Spender who sought to counteract the middle-class stereotype of the working classes and worked alongside writers to record the way people talked, interacted and how they spent their leisure time. I make this point because I feel that it is important to recognize that the process of visual documentation is not new, it is not specific to this point of time and it is not defined by the digital space. What has changed are the tools with which we tell the stories we wish to tell and how and where we share them. The stories remain the same, the way we see them without a camera remains the same, but the process of capture has changed as has the aesthetic understanding of what constitutes professional photography and a professional photographic image.

What does professional mean?

The use of the word professional within academic circles comes loaded with preconceived interpretation. The idea of academic learning being directed related to a career-based outcome is anathema to some and a misunderstanding of the reasons students should continue with their education within a university or college environment. The repeated use of the same word is, however, seen as a positive by those who create photographic devices and equipment as it suggests a level of quality. It is this second use of the word that is the one that has had the most impact on the role of the photographer in the twenty-first century. When cameras are sold with the promise of putting the creation of a professional image in the reach of everyone, the professional photographer has to search for something that defines them as being professional outside the equipment they use. This dilemma has seen photographers find a variety of different

answers to aid them with this definition but there are several themes that can be clearly identified.

The first of these I have already mentioned and that is the use of post-production techniques to define a visual language. The belief that highly developed post-production skills and techniques are beyond the abilities of the casual and average photographer is valid, but to use this as the sole determining factor of what constitutes professional practice is to place the definition of the professional into the vagaries of aesthetic fashion. It also hands a challenge to software developers to create simple-to-use filters and plug-ins to allow the amateur to imitate these post-production affects with just a tap of one button.

The second is to provide a theoretical context for the work to sit within. This intellectual approach to work often requires both an academic and theoretical training in the medium and as such immediately removes this approach to a photographic practice away from the amateur. What is particularly interesting in this approach is that the word professional is dismissed by these photographers whom often prefer to refer to themselves as artists or academics rather than photographers whom they often see as being engaged in a commercial practice unaligned with their intellect-based endeavours. This work is primarily a long-or short-form project and can provide some of the most stimulating and challenging narratives currently being created within the medium. However, it can also lead to work that is over reliant on its intellectual premise, that is weak in completion and alienating to those who do not share the intellectual conversation that surrounds its creation. This work has become a dominant influence in the understanding of what constitutes serious photography today, as many photographers find themselves working within the academic arena to supplement or replace their other earnings from photography. Academia's need for what is referred to as 'research-active photographers' or 'practitioners', has led to a rise in work that is theory-dominated due to the understanding of practice as research presenting issues of acceptance amongst many academic institutions. What is particularly interesting within this environment is the reliance upon semantics to reframe what photography is and to support ways of working that exist only within the academic domain. The rejection of the word 'professional' here, when the work that is being created is in return being funded as part of the academic profession, seems to be both inaccurate and deliberately dismissive of the implementation of the medium as a form of income generation.

The third theme that seems particularly relevant with reference to the term 'professional' is that which is perhaps the most honest and recognizable

implementation of the medium, that of the commissioned photographer. It is this area where images are created in response to a creative brief set by a magazine, newspaper, brand or associated agency that we are most comfortable with the term 'professional photography' being applied to a practice that is openly understood as a form of creation for profit. Traditionally this area was divided into a series of separate practices based upon the type of client that was commissioning work from the photographer. Areas such as advertising and editorial were sub-divided into areas of subject or process specialization such as fashion, still life, reportage, food and portrait amongst others. These boundaries of practice have now converged within the digital space and embrace all forms of the medium, including contemporary art photography, social documentary and photojournalism. It is therefore these images that the camera manufacturers are seeing as the definition of what constitutes professional photography, and the expectation of these images is what they are promising to deliver through the use of the term professional in relation to their products. This provides an issue for photographers working within the commissioned marketplace which they are responding to by developing their practice through multiple platforms including social media, podcasts, live talks, workshops and self-published books. It is this community that has been the most enthusiastic in embracing all forms of capture and dissemination to retain relevance to the changing communication environment that they are engaged with on a daily basis.

It is through investigation, experimentation and considered implementation of a collection of digital space opportunities that the twenty-first-century photographer is in a position to redefine both their role within the medium, but also redefine the understanding of the communicative powers of the medium as a chameleon-like art form that is able to grow and change through the technology it is created with. The word 'professional' can then be applied in its most accurate implementation to describe the process of earning a living from the implementation of the practice rather than a description of a piece of equipment or quality judgement.

The fluency with which these choices of image-capturing devices and dissemination platforms are made and how they are connected through the work that is created, and the narratives that are shared, then become the defining elements of a practice that exists across multiple environments both personally and potentially commercially. The acceptance of photography as a profession without artificial fences of language to define areas of practice constructed to defend the past or ring fence the present, is not an issue outside the photographic community, but within its communities it is

important for a conversation to be had that questions what has been and what could be.

In a 2017 article on the Artsy website,[8] the American photographer Stephen Shore spoke up about the importance of old-school analogue education in developing an understanding of the medium, but he also illustrated how by embracing the digital space photographers can share images more efficiently. Between 2003 and 2008, Shore had turned his attention to the revolution in digital print-on-demand books, and self-published eighty-three volumes of his work during that five-year period. Interestingly, the majority of the titles consisted of just a single day's worth of digital photography. This was before Instagram, the perfect platform for this approach to image making and sharing at such speed. Shore states that he believes that the platform has proved to be a sea change in the way he thinks about photography and how he makes photographs: 'I don't see it as a side-line at all, but as the *main* focus of my activity. It allows for a different kind of picture, something that could make sense on Instagram but not on a gallery wall. I'm thinking about the size it's going to be, seen on a phone or an iPad.'

This willingness to explore how an image can be created and how it is seen within the digital space by one of the pioneers of a new way of thinking about photography within the twentieth century is an encouraging indication of how practices that have been forged within the analogue age can develop and embrace new ways of working. But Shore is not the only artist embracing the possibilities of the smartphone to explore its visual communication possibilities. Joel Sternfeld was an early adopter of the smartphone as camera, as was evidenced in his book *iDUBAI*, a work composed of only smartphone images created in Dubai shopping malls in 2008. Sternfeld visited these malls and documented them with the consumer fetish object of the moment, the iPhone, and then created a suitably garish sparkle-covered book in the shape of the iPhone to further emphasize the type of camera that was used. It is interesting to reflect on his decision to do this as his choice of camera had not impacted on the format on any of his other books created with traditional cameras, but perhaps the relatively poor quality of images that could be captured at that time with a smartphone influenced his decision.

Visual conversations

In 2017 The Metropolitan Museum of Art, New York staged an exhibition titled *Talking Pictures: Camera Phone Conversations between Artists* in which

the curator Mia Fineman invited twelve artists to play a new form of 'phone-tag' in which each artist was invited to trade a series of cell-phone pictures with another. The resulting images documented a broad range of possibilities for the medium. Artists Nina Katchadourian and Lenka Clayton engaged in a game of free association. The exchange of images between the painter Nicole Eisenman and the photographer A.L. Steiner was more political, whilst the artists Manjari Sharma and Irina Rozovsky were both pregnant when the project began and produced a pair of selfies with minutes-old newborn children. This vibrant and forward-thinking exhibition not only explored the visual language possibilities of the smartphone but also illustrated the convergence of creatives and digital communication due to its functionality. It also showcased the development of a mutually immersive visual language across artistic disciplines that can lead to creative collaborations that help the medium grow and develop.

It is our responsibility as photographers, creatives and artists to take the tools of technology and use them to our own creative ends. We cannot rely only on the tools of the past, but photography and art have always had an uncomfortable relationship with the medium's technological roots. The photographer Ernst Haas spoke of this and the idea of seeing photography as a visual language as long ago as 1969 in an article for *Creative Camera* magazine: 'Photography is a bridge between science and art. Through it you can bring to science what it needs most – the artistic sense.'[9] Through photography both artist and scientist can find a common denominator in their search for the synthesis of our modern vision in time, space and structure. With it we can write the new chapters in a visual language whose prose and poetry will need no translation. He went on to expand on this idea of the photographic language by introducing the concept of visual poetry to photographic image making and visual narrative: 'You see what you think. You see what you feel. You are what you see. If there is nothing to see, yet you see it – that is poetry. If there is something to see, and everybody sees it – that is observation. But if you can make something out of nothing and make everybody see it – that is poetry in photography.'

Haas's observations were made in an analogue age, but the logic of his comments seem even more relevant today and can perhaps be seen as a rebuff of the negativity that can be aimed against the idea of the democratization of the medium. Not everyone can be a visual poet, but everyone can experiment with the form outside the traditional form of the photographic print or artefact remaining as the final and only true outcome.

The idea of poetry in photography is not based on the implement chosen to create that poetry or the platform it is engaged with, but the resultant artefact whether spoken or read on whatever platform is appropriate. The photographic medium lends itself to poetic narratives and exclamations just as it does contemporary artistic expression. This openness to presentation leads to a change in how that work is exhibited just as much as it is created. In an interview with the online magazine *fkmagazine.lv*,[10] Quentin Bajac, chief curator of photography at the Museum of Modern Art, New York, observed that: 'The digital museum, that might be the new shift. The photography market will also need to change some rules because, for instance, there are artists who produce only for the screen.'

The concept of the digital museum is a natural progression for the digital space and the medium of photography that could be described as already being in the process of being established by some of the more forward-thinking institutions. Archives are being digitized and made available through open-source platforms and academic portals, but such work requires financial investment in both digital infrastructure and manpower. Such work is not 'sexy' and in the fiercely political environment of gallery and museum funding such investment is very much at the bottom of any agenda, especially as museums who charge for entry will see such open and free sharing as detrimental to both their audience footfall and resultant income. This situation has resulted in a stagnation of such initiatives and placed the responsibility of sharing work online firmly with the creator. In so doing it has created a new practice descriptor that many of those engaged with photography are both adopting and exploring as an area of practice. That descriptor is 'curator'. I wrote earlier in this book that rather than using the phrase that everyone today is a photographer, we should instead use the more accurate phrase that everyone is a publisher. At this point I would like to add and amend my original suggestion to this – today everyone is a photographer, publisher and curator.

The process of creating, choosing and posting is perhaps a simpler more digital appropriate description of these career-based descriptors that are widely recognized as areas of specialization and professional practice. Every time an image is chosen to be shared it is being edited from a selection of images and an aesthetic decision is being made in relation to its quality and the ability of the image to convey the message that the curator wishes to be conveyed. But it is in the repetition of the choosing and posting process that the act of curation begins as a narrative starts to develop and a visual language develops.

This idea of curation of images within the digital space is perhaps most clearly seen on the Instagram platform and on Pinterest, where images are posted and reposted based on the account holder's personal likes and interests. This form of personal curation is the ultimate in subjective curation where no consideration for the audience is given and yet if curated well an audience develops based on the images shown. This magpie approach to image use is rarely engaged in by those who have any understanding of the copyright laws that are attached to image usage and accreditation and as such is a bandit area much discussed by photographers who see their images being used without permission or payment. They are rightly indignant but the nature of the Internet and such reposting in its speed and multiplicity leaves many photographers angry but unable to take action against any of these copyright abusers.

The conversations these renegade curators are having, however, are just as legitimate as any photographer posting their own work and developing their own narratives. Just as a museum or gallery curator sets upon creating a show or exhibition based on a theme and then researching work created by those who have explored that theme, so the Instagram and Pinterest curators are deciding upon their own themes and drawing together imagery that they believe represents their relationship with a theme. This is a difficult pill for many photographers to accept, but for an image to be reappropriated it has to have been placed online at some point and it is by doing this that the photographer makes their work available to all.

Online you can take whatever you want

I do not think that there are many issues that divide the photographic community so directly based on age as that of copyright. Many of those whose careers were forged in the red-lit darkrooms of the analogue world are, in my experience, the most vociferous (although not unique) and active in the protection of the copyright of their images – an issue that becomes almost impossible to control the moment an image appears online. I have spoken with many photographers still willing to fight the online battle, either by never posting any of their images within the digital environment; by posting them at extremely low resolution; or by making their images unusable to others with large and obtrusive watermarks across them.

Attempting to protect copyright in the online environment makes sense, but for the majority of photographers who have only known digital

photography and digital sharing of images the concept of not placing your images online at a reasonable quality or with a branded aesthetic that destroys the image is not an option. And yet, the protection of copyright remains one of the most important issues for all photographers wanting to ensure that their work is appropriately used, credited and recompensed. With the Internet and online platforms being accessed globally, an additional issue of differing national copyright laws comes into play. Add to that the image-grab nature of social media platforms and some photography competitions, and it is not hard to see what a mess we are in as image makers wanting and needing to share our work. So, what is the answer?

Well, the use of a Creative Commons (CC) licence is a solution for many, whilst remaining an anathema to others. The idea behind the Creative Commons concept is that it helps you to legally share your knowledge and creativity to build a more equitable, accessible and innovative world. With a network of staff, board and affiliates around the world, they provide free, easy-to-use copyright licences to make a simple and standardized way to give public permission to share and use your creative work on the usage conditions of your choice. Sounds like a reasonable plan, but it relies upon the goodwill of those using the images to follow your rules, which in a way takes us back to the basic premise and problem of copyright. It only works if people respect the rules!

Interestingly, I know of publishing companies currently using Creative Commons-licensed images within their magazines to reduce their image expenditure to lower than what stock agencies are charging, and as we all know that can be pretty low. The devaluation of images can only be seen as a negative situation, but at least they are being used under CC licences and not being stolen!

The stealing of images is, of course, the major issue here. Many of you will be familiar with the image of David Bowie with his finger to his lips, by photographer Gavin Evans. It has become an iconic image with David Bowie's sad passing, but how often have you seen that image on t-shirts, sneakers and posters used illegally? I can help you with the answer to that: 100 times, at least! It is all over the Internet – even on my local high street – and its illegal use is so widespread that it would become a full-time pursuit for one photographer to chase down and prosecute every one of the image thieves who are seeking to profit from their work. There is all manner of advice out there for photographers to benefit from concerning copyright, and a large number of products which photographers can buy and use to find their images online through embedded metadata. But with platforms

implementing metadata-stripping software and photographers failing in creating appropriate metadata, the efficiency of any of this advice can only be limited.

So far, I may be sounding a little defeated, but stay with me on this. If we realized that the moment we place any image online we are putting it in a position of danger, then perhaps we would think twice about how, where and why we have chosen to publish that image. I have certain possessions that I would be sad if they were stolen, others that could be easily replaced and others that I protect, care for and ensure that they are as best protected as they can be. My suggestion is that you take a similar approach to your images. Of course, it is important that you understand the implications of copyright and copyright protection, so I have included some useful website addresses at the end of this article to help you. But the reality is that at some point we are all going to have at least one of our images stolen and reappropriated without our knowledge and/or permission. We must therefore be as careful as possible that the images we have stolen from us are not the ones that are most precious and/or valuable to us. Easier said than done, I hear you say, and you are right. But as a logic it does make sense.

If we use the David Bowie image by Gavin Evans as an example, it is interesting that the image was created in 1995 and lay dormant in Gavin's archive until 2013, when the Victoria and Albert Museum in London staged an exhibition dedicated to Bowie. Bowie personally requested that Gavin's image be included in both the exhibition and accompanying catalogue – he had a print of the image in his personal collection and hanging in his Manhattan office – but it was not until his death in 2016 that the image took on a new life and significance. Until this point the 'whisper' image had only been posted by Gavin on his personal website and therefore only those who knew Gavin's work and visited the exhibition knew the image. This all changed with Bowie's death.

There is no doubt that Gavin has profited from the legal use of the image at the Grammy's, the Christies Bowie auction, through legitimate print sales and in numerous editorials, but that is nothing to the income due from its illegal use. But if little can be done to prevent this widespread abuse of copyright, is it worth worrying about what could have been?

Whilst we are on the topic of David Bowie and iconic images, there can be no more iconic an image of Bowie than that which appeared on the cover of his 1973 album *Aladdin Sane*, photographed by Brian Duffy. The 'lightning bolt' image could not be better known and, like Gavin's image of Bowie, more illegally used. However, this has not stopped people wanting to own

a copy of the image and Chris Duffy, Brian's son, from establishing a strong gallery market for the image alongside Duffy's other work.

These are just two examples of images that have provided substantial income for the photographer and their estate years, in fact decades, after they were created. I'm sure that you can think of many more. But perhaps the issue here is not total protection of copyright, but controlled protection. Each photographer understood the power of the two images from each shoot that went on to become iconic and they have controlled usage of those images where maximum revenue can be generated. Both Gavin and the Duffy Estate have been strong and vocal in addressing abuse of copyright and have taken action when they can. But as we all know, there is no way of tracking and pursuing every person that uses your images without permission to do so.

When it comes to controlling the copyright of your images, knowledge is king. It is important that you understand copyright, that you retain copyright and that you implement copyright law, when possible and appropriate. But – and this is a big but – as soon as you post an image online, you have to expect it to be stolen, and if it is, for you not to be credited or paid.

The golden age of the photobook

Any photographer today who finds themselves engaged with photography and photographers online, in print or in person, will find it difficult – if not impossible – to escape the presentation, distribution and critical dissection of the photobook. Social media is full of photographers promoting their self-published works as experts reveal the 'secret' to creating, dissecting and understanding one. Websites and blogs are dedicated to showcasing them and every month another competition or festival is announced encouraging you to enter your dummy or finished book with the hope of recognition and/or potential mainstream publication. But this was not always the case. I have collected photobooks for many years, but I can vividly remember the first digitally printed photobook I purchased back in 1998. It was published by The Photographers Gallery in London and featured the work of the Magnum photographer Paul Fusco documenting the final train ride of Robert F. Kennedy's body from New York to Washington D.C. It was titled *RFK Funeral Train* and I bought it on a limited-edition print-on-demand basis – only 200 were printed on a Xerox DocuColor 100 Digital Color Press. The printing was not good; it was crude and soft, and the spine was weak. But today, due to its scarcity, it is a collector's item.

At the time, I remember being dismissive of the book. The images were powerful, and the layout of the book delivered the narrative simply and effectively. But I had to pay in advance, wait weeks for it to arrive and then make a second trip to pick it up. Most significantly, however, I did not believe that the process by which the book had been printed did justice to the images it contained. Of course, little did I know that what I had purchased would become a template for the future of the photobook. I have deliberately mentioned the name of the printer used in the creation of the first edition of *RFK Funeral Train* because it is the process of digital printing that is fundamental to the explosion of independent photobook publishing we are experiencing today. The Photographers Gallery was not an established publishing house, and neither are most of the people behind many of the photobooks currently being published. Digital printing is now the norm and paying for a book and waiting for it to arrive is an experience that none of us question.

To help me explain where we are today with book publishing, I often use the metaphor of football – soccer if you prefer – leagues, where the publishers are the teams and managers and the players are the photographers. The metaphor of league tables is not to denote quality of work but to explain an approach to the game and the medium of photography based on the financial clout of the teams involved.

The premier league includes the big-name established publishing houses that are looking for big sales, established profiles and/or a financial donation from the photographer to balance their level of risk in publishing a photobook. In the premier league, sales are king and the marketing department – amongst other various employees at the publishing house – expect to be involved in the name, cover and occasionally content of the book. However, the bigger your donation, the bigger your say will be, as the publisher's financial exposure decreases. You should also expect Amazon metadata utilization to be part of both of these decisions.

The first division includes all of those publishers who are established, but not supported by non-photobook big sellers within their portfolios. These imprints will have limited distribution power outside the photo community but may well have a level of prestige based on their previous publications which may be perceived as a stepping stone for a photographer's career path. These publishers can also expect you to make a financial donation to publish your book. Either through your own funds, via a crowd-sourcing site and/or through a grant or bursary. These publishers are serious about photography and the intentions of the photographer in achieving the finished book they

want but are often restricted by their lack of distribution and marketing power.

The second division is made up of the many, mainly American, academic and museum publishers creating books connected with archives, exhibitions, academia and research. They exist within their own worlds, reliant on independent funding and with no requirement to record substantial sales outside their immediate sphere of influence. They do not need reviews, sales or to see a profit.

All of the players in these divisions may expect a level of independent funding to publish and will risk as little of their own money as possible. Where that funding comes from depends on the publisher, the work and the expectation of the photographer of the finished artefact. The sales expectations of the publishers – whatever league they are in – will rest in the very low thousands at best, even for 'big' name photographers, and marketing spend and activity will be minimal, if it exists at all.

I live in a medium-sized UK city outside London filled with photographers, filmmakers and associated creative industries, and yet the two main chain bookstores in the city – Waterstones and Foyles – have only eight feet of shelving between them dedicated to books associated with photography. Photobook sales outside specialist book stores and galleries reside firmly online, and it is this fact that brings me to the third division, where photographers are fully utilizing the new digital tools available to them.

It has never been cheaper or easier to create and print a photobook. It has also never been easier to set yourself up as a publishing company. Choose a name for your publishing company, set up a blog, buy some ISDN numbers and create accounts with Instagram, Twitter and Facebook with which to build an online community, and slowly but surely with persistence and hard work you will be able to create a publishing profile. I'm talking about creating a publishing company here, not 'just' self-publishing your own work. The same rules apply to publishing your own work, but I want to make you think about that process differently.

A publishing company is judged by the titles they publish and the people they publish. So why not put your work in the company you want it to be seen in, whilst also showcasing the work of photographers whom you respect and admire? Two examples of how to do this have been created in the UK by Craig Aitkinson with www.caferoyalbooks.com and Iain Sarjeant with Another Place Press. Both of these photographer/publishers are one-person operations based on passions for specific areas of photography. Their books are published as small print runs, well-designed and printed and positioned

at low, affordable price points. They are self-financed, but their titles sell out thanks to intelligent online marketing and an engaged community that share the publisher's tastes in photography.

These publishers are taking control of the publishing of their own work by including it alongside that of other photographers they choose to collaborate with and who chose to collaborate with them. In the case of Atkinson, this has included collaborations with Magnum photographers Martin Parr, George Rodger and David Hurn, as well as Homer Sykes, John Bulmer, Arthur Tress and Simon Roberts, amongst many others. Sarjeant collaborates with those exploring landscape photography such as Dan Wood, Cody Cobb, Al Brydon, Lark Foord and Nicky Hirst. These books have an audience but the ease by which photobooks can be made today can too easily seduce photographers into creating and paying for books that are ill-conceived and under-developed. In this case, the expectation for such books to sell and/or raise the photographer's profile is always going to go unrealized.

What is considered to be self-publishing today was termed 'vanity publishing' in the past, and – as the use of the word 'vanity' suggests – those publications were considered to have little more reason to exist than to fulfil the expectations of their creator. Today we are comfortable with self-publishing, but it is too easy to step over the line into the vanity project without being aware of the fact, and it is at this point that the audience is lost.

I often write about the importance of narrative to today's professional photographer and the book is the most obvious vehicle for that understanding of narrative to be showcased. For the story to be told, and the construction of that story to develop through images, the storyteller requires a sense of narrative purpose. And yet this responsibility to communicate is too often ignored, resulting in non-communicative confused photobooks. A book exists away from the photographer, and therefore it needs to be able to speak for itself. If it does not do so it fails in its basic purpose for existing.

Of course, the first step in creating a photobook is ensuring that you have a story to tell. Without that, everything I have outlined in this article is irrelevant as part of your process. But it is not irrelevant in finding a story, developing a process and understanding the realities of photobook publishing.

There is no great secret to creating a successful photobook, just as there is no great mystery to publishing. Success in both depends upon a level of understanding of the hard work required to create an engaging visual narrative and the process in presenting that narrative to a potential audience. The digital environment may have introduced a number of short cuts and made the once impossible achievable, but the ingredients of a successful

photobook remain the same today as they have always been: a good story, strong images and a route to market.

It's photography but it's not photography

On meeting a landscape gardener recently, we swiftly fell into a conversation concerning photography. She had asked me what I did and of course I replied that I was involved with the medium but that I was most interested in it as a form of language. This immediately ignited her interest as she began to explain how important the photographic image was to her own practice dealing with urban environments and how colleagues of hers were now working with virtual reality programmes and tools to help with the visualization of their projects. We both agreed that what she was taking about was the importance of photography to where her field of expertise was going and yet she admitted that she had never seen what she was working with as photography. To her photography and the role of the photographer were separate disciplines and yet through discussion she began to see that this was no longer the case.

I had a similar discussion with a doctor friend who works in a general practice capacity. I asked him if he used photography in his practice when dealing with patients. Initially he said no, but quickly he began to realize that he did; he just didn't see his use of photographic images to diagnose and record as photography. Again, prior to our conversation photography was an alien practice not aligned to his profession. Working in a completely different environment my father is a master bricklayer, who at eighty years of age remains working on a daily basis. Despite this he refuses to own a smartphone or use a computer or the Internet, and yet he uses a compact camera to photograph all of his work as it progresses to provide a document of the decisions he is making and the practices he is implementing for future generations to understand how he has worked on the historical buildings he works on. Photography is now an essential part of his practice, just as it is for the doctor, the landscape gardener and many other non-photographic professions.

These personal examples are the true proof of the evolution of the photographic medium as a democratic visual language. These are people creating photographic images as documentation, illustrations and as communicative tools but not as photographs in the sense of images to be evaluated on their aesthetic or theoretical merits. They are images created by people with no photographic training or interest in the medium. And

yet they are photographers in that they are creating photographs, they are engaged with the medium, they are documentarians creating photographic images to express narratives and it is this engagement with the medium outside the photographic community that is taking the medium into unchartered waters of engagement and implementation.

To dismiss this work as not being photography either worthy of recognition or understanding is to deny the evolution of the medium to this point and its various incarnations throughout its history. Photography has long been an intrinsic aspect of our understanding of the sciences, the natural world, engineering and other planets through space exploration, but what we are now seeing is an adoption of the visual image as a form of documentary proof as part of a daily conversation that has no intention of creating art or artefacts. The fact is that photography has escaped from the clasp of the photographer and like a teenage child looking to escape its parents it is taking risks, exploring new ground and responding against any ties that contain its possibilities.

Photographic fluency today is not only defined by the way in which it is used but also in the way in which it informs and infiltrates every aspect of our daily life and the people who interact with it. This is in itself a fluid situation and it is therefore the responsibility of the photographer to see the medium not only as it was but as it is and as it could be.

What we have seen over the past years is the development of new areas of photographic practice aligned with other areas of creativity and most noticeably with writing. The evolution of the food and fashion blogger has seen a renewed interest in food photography and street-style fashion, what was once known as a 'vox pop'. This in turn has seen these bloggers become influential taste makers adopted by both traditional print media and brands as communication links to potential customer communities. This reimagining of a commercial reality of both photography and journalism firmly places the power of influence into the hands of the creator and further blurs genre boundaries of practice. The convergence of image making with associated areas of practice is seen by some as a dumbing down of the individual arts, but it could also be seen as a much-needed shot in the arm for practices needing to reassess their relevance to the commercial world.

The adoption of technology to help tell stories is not, however, confined to the commercial arena. Human rights and activist filmmakers have been adopting virtual reality technology to create increasingly immersive and empathetic narratives. Two practitioners of this form of storytelling are

former photojournalists Trevor Snapp and Sam Wolson who stated in an article for *Huck* magazine in 2017:[11]

> As photographers, we often felt forced into a box and there must be more effective ways to tell pressing stories, you can't communicate what it feels like to be hiding out in a cave or riding on a truck with a mobile rebel unit through photography, or even film. But VR makes you feel like you're in those places and gives you the freedom to experience those moments in your own way. It's powerful and immersive in a way that photography isn't.

Their award-winning film *We Who Remain* illustrates their belief that VR is a game-changing development in visual storytelling and how their backgrounds in photography informed their adoption of a new technology.

A similar approach to embracing new technologies can be seen in the Danish produced and created documentary video game for mobile devices *Cosmic Top Secret*, the winner of the IDFA DocLab Digital Storytelling Award in 2017. *Cosmic Top Secret* is an autobiographical adventure video game about a character called T in which the player follows her journey to uncover the truth about her parents' work with Danish Intelligence during the Cold War. Archival photos, film clips and documents are nestled in the game developed in partnership between Klassefilm and Those Eyes. When Trine Laier, a director at games creator Those Eyes, found out that her father might have done ultra-classified work for the Danish Security and Intelligence Service, she decided to investigate. What she discovered was first turned into a film draft before evolving into a game. The visual style came from playing around with pictures and videos of real people, from Laier's family and family friends as well as historical artefacts.

This collage approach to using photographic images connects directly with the photo-montage artists at the beginning of the last century. But by utilizing new technology and innovative formats the makers of this game and other games take the process of visual storytelling into an immersive form appropriate for the digital space we are currently engaged with. This does not mean that I am dismissing the traditional photographic artefact in print or book form, but I am willing to embrace these new forms alongside the traditional forms in which the medium has been historically associated with. It may be a stretch for some to accept these new forms as appropriate homes for the photographic image but whilst some are denying the possibilities these technologies offer, others are blazing a trail and creating a new relationship with the photographic image for the creator and viewer.

The photographic cliché

One of the most often-heard complaints from photographers when commenting on the work seen on Instagram and similar platforms is that the work is derivative and lacking in importance. The documentation of the ordinary in the everyday is often derided as being facile and overly personal in its introspection. In my opinion, this misunderstands the purpose in the creation and posting of these images. This is an issue that the photographer Martin Parr addressed in an online article posted on his website in 2011.[12] Parr began the article by stating his position clearly on the stance taken by photographers working within the environment he himself is very much part of:

> The Fine Art and Documentary photographers take great pride in thinking themselves superior to the other main genres of photography, such as the family snap shooter or the amateur photographer, as personified by camera club imagery. However, after 30/40 years of viewing our work, I have come to the conclusion that we too are fairly predictable in what we photograph.

He continues the article by listing thirteen basic genres that he believes accurately define areas of subject matter most commonly observed, a list that informed his curation on the Brighton Photographic Biennial in the same year he compiled the list. Despite the list being written before the Instagram explosion of the past few years, I think that it is worth considering in relation to the current photographic discussion: 'The above ground landscape with people, the bent lamppost, the personal diary, the nostalgic gaze, the quirky and visually strong setting, the street, the black and white grainy photo, the New Rich, I am a poet, the modern typology, the staged photo, the formal portrait and finally the long/panoramic landscape.' This list of genres that could just as easily have been curated to explain the Instagram images so derided by many photographers and yet Parr was not speaking about Instagram or images created by smartphones. He was addressing work created by photographers who are so dismissive of the Instagram generation.

Parr is open in accepting that much of his own work falls within the categories he outlines and I'm sure that many of you reading this would be able to do the same just as I am. The point that I am making is that the issue of subject matter is not defined by the tool but by the cultural, social, political and economic world in which we live. The tool helps us to see and record images, but it does not determine our points of interest and the environment

we find ourselves in. As Parr observes: 'We all need that echo of familiarity to help us have the confidence to make a body of work. We want to emulate the impact that these images had on us, and this can be as restricting as it can be liberating.'

The tsunami of images we are now met with can address any subject we wish but the choice of subject matter remains with the photographer and not with the camera. How brave we are in seeking out difficult subjects and stories to tell defines the success of the photographer in evolving the medium but difficult stories can be hard to tell.

I am often asked by photographers and students how they can make their work 'stand out'. The answer is by having a true and original voice, but that is a difficult answer to give, to explain and to understand. The choice of subject matter is a defining point in the evolution of a photographer's practice but so is the process of aesthetic decision making. In the past the majority of these decisions would have been made at the point of capture but today many of these decisions are put off until once the digital files have been downloaded. It is at this point that the often-heard term 'fix it in post' becomes a reality for many.

The in-phone filter and post-production app have placed the idea of an immediate photographic 'style' into the hands of every smartphone camera user and in so doing have instantly devalued such filters as points of differentiation in image creation and photographic practice. Style is by its definition transitory and therefore not an appropriate basis for developed fluency or practice and cannot be seen as a replacement for informed storytelling and an evolved visual language.

Putting to one side the post-production clichés that dominate the enthusiast market and the most often returned to areas of subject matter is not easy for young photographers who see these more obvious solutions to image making as acceptable outcomes of creativity. Rather than the repetitive and prescriptive solutions to creative problem solving or storytelling that they actually are. This issue is further heightened by the teaching of photography by non-photographers at the pre-further and higher education stage. Too often this overemphasis on the recreation of what already exists and an over-reliance on post-production knowledge, acts as a cul-de-sac in a young photographer's exploration of the medium. The resultant understanding of the medium is that it is one step from idea/concept to completion of that idea/concept through the pressing of one button. A step which will result in a grade or mark that defines the success or not of the step taken. But what happens when the wrong step has been taken?

Connected thinking

The use of social media and engagement with online content is often seen as a reason for the dramatic reduction in the ability to maintain an engaged level with both written and visual content. The reduction in attention span has become an accepted fact of life in the twenty-first century and content is now created with this fact in mind. The negative aspects this can have on a person's learning has been widely researched and commented on, but at this point I would like to address the impact it has had on studying the photographic medium. As I have just outlined, the idea that the successful creation of a photographic image by someone in the earliest stages of understanding and exploring the medium is not only unrealistic but also negatively detrimental to further informed learning.

The idea/concept is the starting point of visual creation, but it is not the answer in and of itself. It needs to be examined and questioned to fully evolve its potential into a successful creative solution. To do this I promote the use of a 'Who, Where, Why, How and When Strategy', five simple questions that I encourage all students to utilize to investigate the strength of any idea or creative concept they may have. In an environment where the desire to achieve high grades promotes the belief that quick solutions are an effective solution, the idea of questioning an idea can lead to anxiety amongst a student cohort eager to find a satisfying image as quickly as possible.

The idea that the creation of a photographic image can be aligned with the speed with which it can be consumed is to misunderstand the creative properties the photographic image requires as a completed artefact. It is a misapprehension propagated by social media use and the speed by which we consume visual imagery within the digital space and our everyday existence. But it is a misapprehension that needs to be addressed to ensure the creation of work that exists at a deeper level than that purely consisting of surface consideration; the equivalent of photographic candy floss, filled with instant gratification but lacking any form of nutritional content.

In his 1936 essay *The Work of Art in the Age of Mechanical Reproduction*, Walter Benjamin wrote that the ability to mass produce art meant that photographs could now 'meet the beholder halfway'. The newspaper allowed news photography to arrive at our breakfast table. But the internet places images directly into our consciousness and starts rearranging our preconceptions with an immediacy defined by the edited nature of the screen on which we experience them on. Photographic images experienced at a speed that is hard to comprehend and absorb.

The journalist Amanda Hess wrote in an article for *The New York Times* on how our relationship with news-based photography has changed due to our consumption of it through digital media.[13] In her opinion: 'We can still clip out newspaper images we want to remember and press them in albums. But today, while every photograph we have ever seen feels instantly accessible at any moment, we also rarely recall them. To pause and look back is a revelation.' I agree but I would extend this belief from the moment of engagement to also include the moment of creation.

I have spoken at length of the positive attributes that the digital space has given us as visual storytellers and it is in the utilization of these attributes as I have outlined in the process of photo sketching, that a sense of reflection can be brought to the moment of photographic capture. To structure that reflection within a series of simple-to-ask questions that cause the young photographer to stop and assess their motivations, expectations and potential achievements, placing them into a position of creative control of the images they intend to create. It also provides a creative thinking journey that allows them to develop an original idea, hopefully taking them to a place with their work that they had not previously considered or were aware of. That journey is a journey of developed visual fluency based upon rigorous research as understood within academic environments but using new tools alongside that would be considered more traditional.

This is not a process of reflection restricted to the student or enthusiast photographer. It is a process open to anyone who uses a smartphone to make photographs. However, visual fluency is not confined to the maker; it is also of vital importance to the viewer. Without it we cannot effectively engage with the visual image as a principal form of global communication and language.

Everything I have discussed in this book requires the implementation of connected thinking to make the links that form the picture of where the photographic medium is today and where it is going tomorrow, and I am sure that much of what I have said will promote heated debate and discussion. However, in a world where discussions concerning the relationship between analogue and digital photography are still held and the mention of computational photography is too often met with blank faces by many photographers, where photography could go is rarely addressed by those most engaged with the medium. We all spend time scrolling through social media feeds, taking for granted the images we are presented with, the insight they give us not only into people's lives but also what and how they see. Whilst the creation of photographs and the technology we use to capture photographic moments has changed

dramatically since the earliest days of the medium, the desire and indeed need to share images has remained consistent and the acceptance of another person's photographic perspective has remained largely unquestioned. This perspective is what constitutes a personal visual language and the sophistication by which they use that language defines their level of fluency with the visual image. The photographs we see imbue a person's intention and experience and therefore expand our view of the world by allowing us to engage in photographic empathy. But what happens when computers start to take photographs and influence both our language and fluency without our knowledge?

Artificial intelligence is a reality within photographic capture and is created through the uploading and storage of thousands of images, covering every aspect of what we are used to seeing, that are arranged into groupings known as 'training sets'. As humans, we have the capacity to create and sort our own 'training sets'. However, artificial intelligence does not have a human capacity for self-reflection, it does not have the ability for nuance and evolvement of interpretation of what it sees in the way that we do, at least not at this present time. Photography is just one process of communication that may well need to be reimagined and redefined in the years to come, but as a universal language it may well be seen as the obvious starting point to take the lead in the development of artificial intelligence. The history of the medium may have begun with pioneers such as Niépce and Daguerre, but an important new realm of image making, consuming and sharing is developing that may pass the development baton over to code writers and programmers that will dictate the ability of computers to see.

$5.00
$10.00
$20.00

RULES

1) No Leaning
2) Ball must be removed before
 second ball is played
3) No Cross Throws
4) No Rim Shots
5) 2 Balls in Wins Game

THANK YOU AND GOOD LUCK

WE RESERVE THE RIGHT TO LIMIT WINS

CHAPTER 7
SPEAKING OUT

Until this point in the book my voice has been the dominant one regarding the concepts, understandings and interpretations outlined and explored concerning the state of the photographic medium at this point of its history. By now you will also be aware of my belief in the processes I have suggested in the development of a personal visual language, but I am aware that you may well want to challenge or question some or all of the assertions that I have made. I embrace discussion and debate so what follows is a conversation between myself and photographer Derek Hudson concerning many of the issues that have been addressed in the previous chapters. I chose to speak with Derek as we have engaged with these issues previously on Twitter and not always agreed, although we have always respected each other's positions.

Derek is a British photographer whose career has spanned over forty years since an apprenticeship in London's Fleet Street. Leaving Britain for New York in pursuance of a career in magazine photography, he rose quickly amongst the ranks of leading photographers in his field, collaborating with the world's foremost magazines including *Time, Newsweek, Sunday Times Magazine, The Observer, New York Magazine, Vanity Fair, Financial Times magazine, Stern, Der Spiegel, El Pais, Correra Della Serra, Télérama, Le Monde, Paris Match, Vogue* France and the Gruner + Jahr group travel magazine *Geo*. On returning to the UK from New York he realized his teenage dream by being appointed as contributing photographer at *Life Magazine* for Europe until the title's closure in 2000.

Specializing in the fields of reportage and portrait photography, he has been awarded accolades from the World Press Photo, the Art Director's Club of New York and received many other recognitions for his work the world over. Derek is a frequent user of Twitter and Instagram and as such engages with two of the principal communication platforms for photography within the digital space. He is a well-respected photographer and commentator on photography. He therefore seemed to be an appropriate person to respond to the discussion points raised within each chapter of this book.

We spoke via Skype and what follows is a transcription of our conversations in which we challenged each other on our beliefs concerning where the photographic medium is today, how we engage with photography in the digital space and where we see it developing in the future based on our personal experiences. I also challenged Derek's belief that the smartphone is not a camera and we discuss its potential within the photographer's toolkit. In essence, we discussed the content of this book.

Derek: I remember when *Time* magazine's Director of Photography and Visual Enterprise Kira Pollack commissioned five photographers – Michael Christopher Brown, Benjamin Lowy, Ed Kashi, Andrew Quilty and Stephen Wilkes – to document Hurricane Sandy when it hit New York back in 2012 on iPhones.[1]

For me it felt like it was a kind of PR exercise just like a recent commission that Kira has given to a Brazilian photographer to photograph women for *Time* magazine, also with an iPhone. To me it doesn't matter what you use, we are talking about a tool because that is all it is, a tool. What is the most important line in those stories? The photographer? The subject matter? Or is it the tool that was used to make the photographs? By the very fact that the mention of the phone brand was included in the story it's no longer photojournalism but an advertorial.

Grant: This is where I think the interesting debate begins because what I believe the smartphone and its associated platforms of sharing and dissemination have achieved is that they have fundamentally changed the way in which we see photography. In how we see photography in new contexts and how we capture an image and why these are both so different now is the physicality of the process. In how we now hold an image-capturing device, whilst looking at a screen and how we view images on screens. We are no longer reducing the decision-making process to the use of just one eye pressed against a viewfinder. The way in which the image-capturing device is held and manipulated completely changes the images that are being created. That's a dramatic change in how the image is created based on the camera that is used.

Derek: As you say it has changed the way we see. The smartphone has democratized the business of the taking of a photograph. Before the smartphone we had compact cameras but the amount of people who had a 'proper' camera was quite limited to fairly serious amateurs and professionals so when the iPhone came along there was a revolution, something happened, and it was transformative of the way in which we looked at things, the way we perceived things. Because at that point the

phones' operating systems were quite slow, and you couldn't take a picture quickly enough as you could with a traditional camera, so you would miss the picture. Now it is quicker, still not as quick as a camera, but it is quicker than those early smartphones.

Grant: Isn't that interesting, that idea of missing the picture because we all tell young photographers to always have a camera with them to make sure that they don't miss the moment when they could make a photograph and now with the smartphone they do have a camera with them at all times as do we. So, there is no excuse for not using it.

Derek: I disagree. I always have a camera with me, I never go out without a camera. The smartphone is not a camera.

Grant: Why isn't it a camera?

Derek: Because for my purposes – and I speak from a personal perspective here and anyone like me who works in the field of photography in the way that I work – the spontaneity of the moment is impossible with a smartphone. As a photographer, from a professional photographer's point of view it's a photo-taking instrument in certain conditions and circumstances.

Grant: So, it's a camera as a camera is a photo-taking instrument.

Derek: No, it's not a camera. It's a telephone. To activate the camera utility, you must unlock the phone and fidget about with the camera app to get your exposure and focus. By that time, I've already made my picture with the camera I carry.

Grant: (Laughs) We've both been involved in the industry for a long time and during that time we have both seen a huge amount of changes within the photographic world. The adoption of the smartphone as a camera by the masses has democratized the capture and sharing of images and therefore it needs to be taken seriously by the photographic community as serious photography.

Derek: What makes photography serious is the photographer behind the camera, behind the device, let's call it a device, let's not call it a camera because I have a difficulty calling it a camera. It is a device through which I can do all sorts of things, things I like to do and things I don't like to do. Including taking the occasional photograph but I can't practise my profession with this device. I could at a pinch if you asked me to not use any other instrument to make a photograph and that I had to use a phone of some sort. I could produce a photo essay with a phone but it would not be the kind of photo essay I would produce with a Leica, but it would be photographically recorded. But it is just a tool, some people have got all sorts of gizmos like tele-photo or wide-angle lenses, rapid-fire apps that they add

to the basic phone and that is all good and if that works for them that's fantastic but at the end of the day it is only as good as the operator behind that machine.

Grant: Which is exactly where I am with it. What makes a photographer is their personal life experience, the awareness of light, of shape, of form, of their environment. However, imagine that you were eighteen again and that you had only known a world in which smartphones exist and that it was the principal tool in your introduction to photography and that Instagram had been your gateway to the photographic medium. Now, can you accept the smartphone as a tool for learning to see? Because I can't see anything better than something you have in your pocket at all times and that you are completely confident in using as a tool to experiment with photographic creativity.

Derek: I'll tell you a story. My son is now twenty-one and he has had a phone since he was sixteen and he used it to take photos of his friends and girlfriends, he has a deep interest in photography but only a mild interest in taking photographs, only taking pictures when he feels inspired and when he does that, he uses a camera. I was interested to watch him, observe him as to how he went about this, and he was using the viewfinder, so he'd closed himself off from his immediate environment. The point I want to come to which I think is very important from a photographic perspective is that he was closing himself off and entering that rectangular world in which he is seeing through one eye, enabling him to concentrate and compose an image. He was carefully composing the picture as many people do, people who have a modicum of interest in producing something that has some sense of aesthetic value. I found it fascinating to watch him get behind the camera and work with it which is a totally different attitude both psychologically and physically to taking photographs with a phone.

Grant: What I find interesting about that is that if one is able to embrace the smartphone as a photographic image-creating device alongside a DSLR or any other type of traditional camera, it is a very useful tool in the toolkit for experimentation, documentation in the way in which an artist uses a sketchbook to record ideas that may lead to a work created in a different or similar medium.

Derek: Yes, it's a sort of sketchbook if you like.

Grant: Then it should be seen as a useful tool rather than as a gimmick by those still dubious of its potential importance within professional photography. It shouldn't be seen as of any lesser importance than any other tool in the photographer's toolbox.

Derek: No, it's not. I don't think my Nikon is any more or less important than the tool I can find in my smartphone here. I refuse to call it a camera because it's not, technically speaking it's not, it's just a tool. I'm not one of those photographers who salivates over F Stops, this glass and that glass. I have zero interest in any of that. I liked my Nikon Fs and I still love my Leica M2, but it doesn't matter what one decides to use because you are a professional and you choose the right tool for the job. For example, I might go and recce a job with my phone as the right tool for the situation, I might use it as a notebook rather than writing my observations down.

Grant: What about using it on a commissioned shoot? It's something I intend to do, as my smartphone shoots RAW files at a size that would allow me to create files of a high enough quality for most editorial clients. Primarily because I recognize the different kind of relationship I have with my sitter by changing the tool which I use. I am also using that tool on a very frequent basis so my relationship with it is closer than it is with what have traditionally been my choice of camera within a professional commissioned situation. This is probably where we disagree most, on the perception of a hierarchy of the tool used. I see no hierarchy. We are now in a world where even if many photographers do not see the smartphone as a camera the mass population of smartphone users do see photography as one of its principal functions. It has a CMS sensor, it has a lens, it contains a lot of the software and firmware that exists within digital cameras. Photography has changed, and it has been taken away from photographers and placed into multiple new contexts outside of the medium's traditional understanding. This means that many of the people using smartphones to take pictures would never describe themselves as being photographers because they have a preconceived understanding of what constitutes being a photographer, and I think that is an understanding that many photographers feel the need to maintain as a differentiation of their role within the medium. Go to any event, concert, sports day whatever and it is being viewed through and captured through a digital device. Photography is now democratic. The smartphone has not only changed the way we see but also our global relationship with photography. I wonder if many photographers are fearful of that.

Derek: I'm not fearful of it. There may be people that are, but they need to address that and try to see through that fear because there is nothing to fear in what you have said. It's just a piece of plastic and metal, there is nothing to fear. I'm going to be very blunt here, the photographers who do fear this

change are probably not very good photographers, because if that is what you fear, if that is what concerns you then you are in trouble.

Grant: Maybe they are insecure? Which is natural when they are facing a situation where something that was an area of specialization that they had committed themselves to becomes available to all.

Derek: Yes, I think they very possibly are insecure. The relationship that I have with other photographers was established on a very firm basis. I assisted some famous photographers such as Irving Penn when I started out on my career in New York, but there was no snobbery based on insecurity. Today we have this appalling, pathetic, dangerous snobbery within the profession which is destroying the joyfulness of the medium and getting in the way of the fundamental process of image making.

I was thinking the other day of the photographer Leonard McCombe, the *Life* magazine photographer who in the early 1960s created a tremendous photo essay based on a very simple, normal story of a girl leaving the countryside in the States to go to the big city of New York where she starts to make a new life for herself. That body of work is a lesson in how to make a photo essay, a visual narrative. There are lessons to be learnt from this historical work, visual lessons, storytelling lessons, lessons on the importance of simplicity, human empathy and when these lessons have been learnt you can do that with any device that you choose. You can do whatever you like because you will have mastered the problematic stuff and all you will need to do is choose your preferred mode of registering the images that you wish to convey to accurately tell your story.

Grant: That fits with the premise that I have attempted to outline in this book. That to fully utilize the photographic medium as an effective communication tool requires the photographer to develop a personal visual language, which once developed allows them to tell stories visually that break barriers of language, politics, culture and geography. Without that visual language, it is impossible to construct a narrative. We need to speak photographically as photographers.

Derek: I have a good friend Julian Calverley who is a very good photographer and he created a small book filled with beautiful images called iPhone Only.[2] Julian uses his iPhone with great skill and to great advantage. The landscapes he is documenting are beautiful and are not shot with the latest iPhone, they are created with the iPhone 5 I think but in a professional capacity he also works with an ALPA and lenses that cost £8,000 so he is spanning the spectrum of equipment when it comes to choosing his

photographic tools. His photographic language is established outside of his choice of camera so in that sense I agree with you.

Grant: Joel Sternfeld did a similar thing with his book *iDubai*[3] that was also created with an early-generation smartphone and he also chooses to work with a large-format camera if the project demands it. They are both seeing the smartphone as a valid tool within their photographic armoury appropriate to different forms of storytelling. In that sense both of these established photographers within both the commissioned and gallery environments are developing their visual language thanks to the new physicality that the smartphone imposes on its user. Even seasoned photographers can embrace a new way of seeing and recording.

Derek: Okay but let me explain how Julian started working on his iPhone project. He was on a shoot one day waiting with his ALPA for some big black clouds to come into shot as part of a landscape he was photographing in Scotland and whilst he was waiting, he took out his phone and started snapping.

Grant: That's what I describe as photo sketching.

Derek: Then he discovered the post-production app Snapseed to process his images, utilizing his photographic skills to work on the smartphone files and the resulting images are remarkable. I was looking at some of Saul Leiter's images recently and it seems to me that his images are completely appropriate to the smartphone in both how they are made and their aesthetic. The smartphone is perfect for his form of composition also.

Grant: Again, that is the exactly what I am speaking about with photo sketching and I agree with you concerning Leiter's work. It is interesting that both he and Aaron Siskind are experiencing a re-evaluation of their work at the moment as is Walker Evans at the moment. Three photographers who implemented the visual experimentation of the photo sketching concept to not only evolve their visual language but to define it. The fact that they used other cameras to create their images and not a smartphone that was not available to them is of no relevance. What the smartphone does is make their sense and spirit of visual experimentation available to all.

Derek: At the end of the day it comes down to this. If Julian's book was not called *iPhone Only* you wouldn't know that they were made on an iPhone.

Grant: Exactly. So, I wonder why he chose to define the body of work by titling it after the camera the images were created with. I can't image a photographer doing the same with a Nikon, Canon, Hasselblad or Leica.

Derek: Good question. I suggest you ask him.

Grant: Good point but it does raise the issue of the perception of the smartphone as a professional camera and professional photographers' relationship with it and the images it produces. Which is an interesting issue that many photographers are currently addressing or perhaps ignoring.

Derek: It is.

Grant: We have both been involved with photography through the seismic technological changes that have affected the medium over the last thirty years and more, therefore we are perhaps in the perfect position to reflect on the work that is currently being produced and shared on platforms such as Instagram with the benefit of historical knowledge of the medium. You are very active on Instagram, posting your archive with informative extended captions and new work created on your phone. I admire the way in which you are both manipulating the platform to your own needs and using it as a narrative platform with both long- and short-form storytelling. It seems to be very much part of your wider photographic practice whilst I keep it separate from my commissioned work and use Instagram purely as a sketchbook independent of my archive.

People are using platforms such as Instagram in many different ways but there seems to me to be a unifying compositional theme that unifies much of the work which is a direct result of creating images with the smartphone and therefore our altered way of seeing. Something I have outlined extensively in this book.

This is something that both photographers and photographic education have to be aware of and engaged with. To not do so would be to deny the state of the photographic medium today and potentially tomorrow.

Derek: Sure. I'm not just a photographer, I'm a storyteller or maybe I should describe myself as a storyteller photographer or a photographer storyteller, whatever way you want to put it doesn't really matter. At the end of the day it's what I do. I've been a practising photojournalist – not a description I really like but anyway it seems to have stuck – for over forty years. As such I have a responsibility for what I produce, working as a photographer is not just about taking a few pictures for a magazine. What you present to a client or to an audience will be understood as being fact and it therefore must be fact. It must be an accurate reflection of what happened and what you saw. We could go on for hours and hours talking about this separate from our central conversation here. There is so much to address concerning fact and truth with photography. Which is why I have such an

issue with schools, colleges and universities who do not address these issues as part of their teaching of photography.

Grant: Discussions surrounding truth and fact will I think become even more relevant with the advancement of computational photography, just as they have been concerning post-production manipulation over the past few years. But these are issues that theoretical discussion does not satisfactorily address.

Derek: It must be understood and taught that you must not screw up and that you are responsible for what you do as a photographer, just as a journalist should be held responsible for the words they use, the stories they tell and how and where they are published. Unfortunately, less and less people understand what that responsibility is.

Grant: I agree. I regularly speak about the reality that whilst we can all be described as photographers now, we are actually all publishers and the skills and knowledge connected with the responsibility of the publisher are not widely understood or taught. Some publishers have even lost sight of the traditional values that title holds.

It seems to me that what we are talking about here is the importance of understanding not only of responsibility but also the need for a personal responsibility for every aspect of a photographic practice, including a responsibility to remain engaged as to where the medium has been and where it is going. And in essence that is the central premise behind this book.

There are new ways of seeing and engaging with photography if you explore the reality of our relationship with the medium today. Every image we see on a screen is back lit for example, we are actually engaging with photographic stained-glass windows. So, in this case our understanding of what is real is a false one and our expectation of what a photographic image is has been similarly altered. We are now in a hyper-real photographic environment.

Derek: Sure.

Grant: We therefore have to work with that understanding and the photographic community has to accept all photography whoever and wherever it is created as part of the medium in the twenty-first century. Rather than sticking its head in the sand and focusing purely on its perception of what it considers to be 'serious' or 'real' photography.

Derek: I don't dig this 'everyone is a photographer' corporate sell concept. Okay, the smartphone is a very nice tool, but it's not cheap, you can now buy a good camera for the price of a smartphone. I can't wait until I can tweet and email from my camera.

Grant: In that case surely camera manufacturers are letting photographers down by not responding to the need you are describing, even if I believe that you have that already be it in a different form.

Derek: They are, yes but to do that they would have to change their business models.

Grant: Maybe you have just made the most important point in our discussion and the most important point that every photographer and student of photography needs to hear and respond to. That business models need to change, and I would add to that creative and teaching models within the medium also need to change.

Derek: Exactly, in fifty or a hundred years' time where will the photograph and photographic history be? Will the digital image exist? Where will the archives of this work be, and will they be able to be accessed? Will prints exist of the work being created now? Probably not. When we talk about the smartphone, we must also be aware that there are many other associated problems for photography, which are directly related to the longevity of digital files, their storage, and whether or not the photographer has printed out his work on media which, like the classic photo print, will last as a permanent record in the annals of photographic history.

Grant: New ways of seeing require new ways of understanding and that new knowledge requires new ways of sharing and implementing that knowledge. We may not agree about the smartphone as camera, but I think it would be safe to agree that things have changed and that we need to be aware of that change to be able to use it to maximum creative and professional effect.

The first few decades of digital photography and of this century have seen the evolution of digital images evolve from grainy, low-resolution photos to high-resolution photos that can be used for virtually any assignment. More recently, though, the evolution of processors has enabled computational photography not only to enhance images as never before but to enable whole new creative and communicative media forms. They have opened up new opportunities for photographers and communicators, as well as some new challenges, for professional photographers. Smartphones have provided the most robust evidence of these profound changes.

Photographers have been forced to master DSLR still and video capabilities to meet a commercial client-based demand, and to explore the process of moving image creation as video consumption and importance has exploded. In the drive for digital engagement, virtual-reality video provides another dimension, allowing consumers multiple paths through

the media that photographers have to be aware of and be willing to engage with if they wish to remain relevant and employed. Some photographers may find that computational photography opens up new opportunities in specific industries; some may be left behind; others will retain their existing practices within a reduced or realigned marketplace.

Meanwhile, new camera manufacturers are currently beginning to borrow from smartphone technology by experimenting with the multi-lens concept as traditional manufacturers see their sales decrease and their research and development stagnate. Perhaps the next frontier of photography will extend beyond two dimensions, because light-field technology is now able to capture the positional depth of different objects in an image. The technology's original trick was enabling the change of focus after a photo was taken, a feature that has trickled down to smartphones. Today, forward-thinking companies are building commercial devices that capture real-world details to prepare scenes for photo-realistic mixed reality. As with VR imaging, fully experiencing these immersive environments will require moving beyond today's flat screens; not only will capture of the photographic image change, so will our physical engagement with it. One company pioneering light-field technology on the display side has demonstrated prototypes of a mixed-reality headset. This technology allows the company to address multiple focal points in augmented reality. Truly new ways of seeing but perhaps a more accurate term to describe this engagement with the photographic image is new ways of experiencing.

In the two-dimensional world, the short-term impact on recognized and established photographic practice as it is currently understood may be increasingly smart cameras that, via machine learning and neural networks, become ever more intelligent concerning traditionally manipulated choices such as exposure and composition. Allen Murabayashi, co-founder and chairman of the online photographic platform PhotoShelter, has argued that clients, aided by AI-equipped cameras, will increasingly have the ability to create professional level work.[4] He added to this by stating that: 'In such a world, what would set professionals apart would be their knowledge of what technology to use when, and the ability to handle all of them.' I would argue that he forgot to add the true point of difference and that is the person who is holding that piece of equipment. That has always been the fundamental truth of photography; it may be a creative practice enabled by technological advancement, but the stories we tell and the language we use to tell them has always been and will always remain personal to the person telling them.

I began by mentioning that the final sentence of John Berger's *Ways of Seeing* suggested that his book be 'continued by the reader'. I now pass this suggestion on to you. I have no way of knowing how the photographic medium will have evolved by the time you read this, I can only guess but what I do believe is that the impact of the photographic image will continue to be increasingly influential in all of our lives and that the role of the visual storyteller will become ever more important. The narrative eye will remain essential in the creation and interpretation of the image and creative tools available to us will continue to develop. All we can do is remain open to the possibilities they give us and manipulate them in ways that allow the medium to continue on its journey. A winding, criss-cross journey that never travels a straight road. Now it is your turn.

NOTES

Introduction

1. *Ways of Seeing*. John Berger. Penguin. 1972.
2. *Five Short, Dark Comedies about Smartphone Obsession*. Sarah Larson. www. newyorker.com. 11 April 2017.
3. *The Work of Art in the Age of Mechanical Reproduction*. Walter Benjamin. 1935.

Chapter 1

1. 'Note on the Art of Photography, or The Application of the Chemical Rays of Light to the purpose of Pictorial Representation', presented to the Royal Society on 14 March 1839. Sir John Frederick William Herschel.
2. *A Short History of Photography; Paris, Capital of the Nineteenth Century; and The Work of Art in the Age of Mechanical Reproduction*. Walter Benjamin. 1931.
3. *The Vorticists: Manifesto for a Modern World*. Mark Antliff, Vivien Greene, Robert Upstone. Tate Publishing. 2011.
4. *New Paths in Photography*. Andreas Feininger. American Photographic Publishing Co. 1939.
5. *Kodak's First Digital Moment*. James Estrin. *New York Times, Lens Blog*. August 2015. https://lens.blogs.nytimes.com/2015/08/12/kodaks-first-digital-moment/.
6. *The Next Revolution in Photography is Coming*. Stephen Mayes, August 2015. http://time.com/4003527/future-of-photography/.
7. IBC Conference, Marcel Hess, Canon. September 2017.
8. Ramesh Raskar is a Massachusetts Institute of Technology Associate Professor and head of the MIT Media Lab's Camera Culture research group.
9. *Apple's iPhone 8 Portrait Lighting Lets Mobile Photographers Mimic Studio Lighting*. Darrell Etherington. 2017. https://techcrunch.com/2017/09/12/apples-iphone-8-portrait-lighting-lets-mobile-photographers-mimic-studio-effects/.
10. *Inside Apple's Quest to Transform Photography: How does Apple think about iPhone Camera Design? Obsessively*. John Paczkowski. September 2017. https://www.buzzfeednews.com/article/johnpaczkowski/iphone-portrait-lighting/.

11. *Eyes of the Machines: How Will Smarter Cameras Help Photographers?* October 2017. Panelists: Dr Rajiv Laroia, CTO and co-founder, Light; Jim Malcolm, general manager, North America, HumanEyes; Steve Medina, Director, Product Management, Avegant; and Allen Murabayashi, photo industry blogger.

12. Nikon to Discontinue Operations of a Consolidated Chinese Manufacturing Subsidiary of Imaging Business. October 2017. https://www.nikon.com/news/2017/1030_01_e.pdf.

Chapter 2

1. *Beyond Self-Report: Tools to Compare Estimated and Real-World Smartphone Use.* Sally Andrews, David A. Ellis, Heather Shaw, Lukasz Piwek. October 2015. https://journals.plos.org/plosone/article?id=10.1371/journal.pone.0139004.

2. *You Probably Use Your Smartphone Way More Than You Think*, Carolyn Gregoire. December 2015. www.huffingtonpost.co.uk.

3. *Ellen von Unwerth: 'Let's photograph girls having fun'.* Richard Godwin. April 2017. https://www.theguardian.com/artanddesign/2017/apr/02/ellen-von-unwerth-lets-photograph-girls-enjoying-life-heimat.

4. *5 Instagram Lessons from Magnum Photographers.* 2017. https://www.magnumphotos.com/theory-and-practice/instagram-lessons/.

5. *5 Instagram Lessons from Magnum Photographers.* 2017. https://www.magnumphotos.com/theory-and-practice/instagram-lessons/.

6. *Smartphone ownership by age in the UK 2012–2018.* 2017. https://www.statista.com/statistics/271851/smartphone-owners-in-the-united-kingdom-uk-by-age/.

7. *Digital Imaging Reporter's State of the Industry 2018.* September 2017. www.blog.infotrends.com.

8. *3.5 million photos shared every minute in 2016: During Mobile World Congress, 20 billion photos will be shared by the world's population.* Press release, February, 2016. https://www2.deloitte.com/uk/en/pages/press-releases/articles/3-point-5-million-photos-shared-every-minute.html.

9. *How I reached 10,000 Instagram followers.* James Abbott, *Digital Camera World.* August 2017. https://www.digitalcameraworld.com/features/how-i-reached-10000-instagram-followers.

10. *The Social Photo Editor of The New York Times Breaks Down Her Job.* Deborah Block. April 2017. https://petapixel.com/2017/04/26/social-photo-editor-new-york-times-breaks-job/.

11. *The Photographers Guide to Hashtags Shows You How to be Successful on Instagram.* Ellyn Kail. April 2017. https://www.featureshoot.com/2017/04/photographers-guide-hashtags-shows-successful-instagram/.

12. *Light Readings.* A.D.Coleman. University of New Mexico Press. 1971.

13. *Witness to an Assassination: AP Photographer Captures Attack.* Burhan Ozbilici. December 2016. https://apnews.com/eadca282d5d341a79bb464bbadc4fa11.

14. *How the Smartphone Is Endangering Three Ingredients of Creativity: Loneliness, Uncertainty & Boredom.* Lynda Barry. Spring 2016. http://www.openculture.com/2017/09/lynda-barry-on-how-the-smartphone-is-endangering-three-ingredients-of-creativity.html.

15. *Deep Work: Rules for Focused Success in a Distracted World.* Professor Calvin Newport. Piatkus, January 2016.

16. *'We're designing minds': Industry insider reveals secrets of addictive app trade.* Virginia Smart, Tyana Grundig. November 2017. https://www.cbc.ca/news/technology/marketplace-phones-1.4384876.

17. *The Psychological Toll of Becoming an Instagram Influencer.* Jenni Gritters. December 2018. https://medium.com/s/love-hate/the-psychological-toll-of-becoming-an-instagram-influencer-5bbd1d9174c4.

Chapter 3

1. *How We Think.* John Dewey. D.C. Heath and Company. 1910. Revised edition 1933.

2. *Photography: A Language at Many Levels.* Robert Ketchum. *World Literature Today*, Vol. 87, No. 2 (March/April 2013), pp. 56–61.

3. *How to See: Visual Adventures in a World God Never Made.* George Nelson. Herman Miller. 1977.

4. *The Decisive Moment (Images à la Sauvette).* Henri Cartier-Bresson. Simon and Schuster/Editions Verve. 1952.

5. *Illuminating Creativity.* John Paul Caponigro. May 2015. www.johnpaulcaponigro.com.

6. *The Complete Colour Photographer.* Andreas Feininger. Thames & Hudson. 1969.

7. *Love Emojis? So Does The Rest of The World.* Study originally published at the Ubicomp 2016 conference. Additional authors include Xuan Lu, Xuanzhe Liu and Gang Huang of Peking University and Ning Wang of Xinmeihutong Inc. www.news.umich.edu.

8. *The Selfish Gene.* Richard Dawkins. Oxford University Press. 1976.

9. *Meme, Counter Meme.* Mike Godwin. October 1994. https://www.wired.com/1994/10/godwin-if-2/.

10. *Richard Dawkins on the internet's hijacking of the word 'meme'.* Olivia Salon. *Wired.* June 2013. https://www.wired.co.uk/article/richard-dawkins-memes.

11. *Photography Changes Everything.* Marvin Heiferman. Aperture. 2012.

12. *The Ballad of Sexual Dependency.* Nan Goldin. Aperture. 1986.

Notes

13. *Photography is the new universal language and it's changing everything.* Pete Brook. *Wired.* August 2013. https://www.wired.com/2013/08/raw-meet-marvin-heiferman/.

Chapter 4

1. https://blogs.haaretz.co.il/hasifa/2342/?fbclid=IwAR0sS16ZKHGiSl-maGY09mLvfU2aRCrlhYCxXSuF_Wyga5q0jgOPKRTD4QQ. English version available at https://www.facebook.com/notes/sephi-bergerson-photography/an-interview-with-magnum-photographer-trent-parke/10151910061138939/.

2. *Seeing Photographically. The Complete Photographer, Vol. 9.* Edward Weston. 1943.

3. *A Bigger Message: Conversations with David Hockney.* Martin Gayford. Thames & Hudson. 2011.

Chapter 5

1. *Finding Your Subject: Five very different Magnum photographers have found inspiration – and can help you find yours.* https://www.magnumphotos.com/theory-and-practice/finding-your-subject-magnum-photos/.

2. *Finding Your Subject: Five very different Magnum photographers have found inspiration – and can help you find yours.* https://www.magnumphotos.com/theory-and-practice/finding-your-subject-magnum-photos/.

3. *Finding Your Subject: Five very different Magnum photographers have found inspiration – and can help you find yours.* https://www.magnumphotos.com/theory-and-practice/finding-your-subject-magnum-photos/.

4. *Finding Your Subject.* www.magnumphotos.com.

5. *Crossing Paths with Niall McDiarmid.* 13 November 2012. https://www.bbc.co.uk/news/in-pictures-20166741.

6. *Wim Wenders on his Polaroids and why photography is now over.* Sean O'Hagen. *The Guardian.* October 2017. https://www.theguardian.com/artanddesign/2017/oct/12/wim-wenders-interview-polaroids-instant-stories-photographers-gallery.

7. *The Terror of War.* 1972. http://100photos.time.com/photos/nick-ut-terror-war.

Chapter 6

1. *Camera Lucida.* Roland Barthes. Hill & Wang. 1980.

2. *Botched Steve McCurry Print Leads to Photoshop Scandal*. D.L. Cade. Petapixel. May 2016. https://petapixel.com/2016/05/06/botched-steve-mccurry-print-leads-photoshop-scandal/.

3. *Getty Images Instagram Grant 2017: In Pictures*. October 2017. https://www.theguardian.com/artanddesign/gallery/2017/oct/26/getty-images-instagram-grant-2017-in-pictures.

4. *Getty Images Instagram Grant 2017: In Pictures*. October 2017. https://www.theguardian.com/artanddesign/gallery/2017/oct/26/getty-images-instagram-grant-2017-in-pictures.

5. *Mobile Phone Photography Masterclass with Gueorgui Pinkhassov in Beijing*. February 2018. https://www.magnumphotos.com/theory-and-practice/gueorgui-pinkhassov-sophistication-simplification/.

6. *A Year of Grieving Publicly*. Deborah Shapiro. *Chicago* Magazine. December 2017. https://www.chicagomag.com/Chicago-Magazine/January-2018/A-Year-of-Grieving-Publicly/.

7. *Melissa Spitz Is TIME's Pick for Instagram Photographer of 2017*. Alexandra Genova. 2017. http://time.com/instagram-photographer-of-2017-melissa-spitz/.

8. *Stephen Shore on Why Young Photographers Need to Start with Film. Scott Indrisek*. November 2017. https://www.artsy.net/article/artsy-editorial-stephen-shore-young-photographers-start-film.

9. *Views*, edited by Bill Jay. *Camera Press*. Coo Press. 1969.

10. *10 minutes with Quentin Bajac*. Elina Ruka. July 2014. https://fkmagazine.lv/2014/07/21/10-minutes-with-quentin-bajac/.

11. *Is virtual reality the new frontier for human rights filmmakers? Empathy through technology*. Alex King. November 2017. https://www.huckmag.com/perspectives/activism-2/virtual-reality-new-frontier-human-rights-filmmakers/.

12. https://www.martinparr.com/2011/photographic-cliches/.

13. *The Year in Pictures 2017*. Amanda Hess. 2017. www.nytimes.com.

Chapter 7

1. *In the Eye of the Storm: Capturing Sandy's Wrath. Time Lightbox*. Vaughn Wallace. 30 October 2012. http://time.com/3426309/in-the-eye-of-the-storm-capturing-sandys-wrath/.

2. *iPhone Only*. Julian Calverley. Self-published. May 2014. https://www.juliancalverley.com/iphoneonly/.

3. *iDubai*. Joel Sternfeld. Steidl. June 2010.

4. *What you should know about photography's computational future. PDN Online*. Ross Rubin. January 2018. https://www.pdnonline.com/gear/computational-photography/.

INDEX

Index

Index

Index

Index